The Wedding

An Encounter with Jan van Eyck

ELIZABETH M. REES

WATSON-GUPTILL PUBLICATIONS/NEW YORK

Acknowledgements

Thanks to my various friends who patiently read and reread the manuscript and provided invaluable support and suggestions. Also I would like to thank Deborah Drier, my indefatigable consultant on 15th-century fashion.

Series Editor: Jacqueline Ching
Editor: Laaren Brown
Production Manager: Hector Campbell
Book Design: Jennifer Browne

First published in 2005 in the United States by Watson-Guptill Publications,
a division of VNU Business Media, Inc., 770 Broadway, New York, NY 10003
www.wgpub.com

Front cover: Jan van Eyck (c.1390–1441), *The Arnolfini Wedding*, 1434. Oil on wood, 32 x 23.5 in (82 x 60 cm).
National Gallery, London. Photo by Erich Lessing/Art Resource, New York. Back cover: Jan van Eyck
(c.1390–1441), *Portrait of a Man* (Self-Portrait?), 1433. Oil on wood, 10.24 x 7. 48 in (26 x 19 cm).
National Gallery, London. Chapter art from *1.001 Floral Motifs and Ornaments for Artists and Craftspeople* by
Carol Belanger Grafton, Dover Publications, Inc.

Library of Congress Cataloging-in-Publication Data

Rees, Elizabeth M.
The wedding : an encounter with Jan van Eyck / E.M. Rees.
p. cm.
Summary: In 1433, fourteen-year-old Giovanna Cenami falls in love with a mysterious stranger employed
by Flemish painter Jan van Eyck, but when she defies her father, refuses to marry a wealthy family friend,
and elopes with her love, her reputation, her family's honor, and her very life are at stake.
ISBN 0-8230-0407-4
[1. Arranged marriage—Fiction. 2. Fathers and daughters—Fiction. 3. Courts and courtiers—Fiction.
4. Spies—Fiction. 5. Eyck, Jan van, 1390-1440—Fiction. 6. Artists—Fiction.
7. Europe—History—15th century—Fiction.] I. Title.
PZ7.R25476Wed 2005 [Fic]—dc22 2005010467

This book was set in Stempel Garamond.

Printed in the U.S.A.
First printing, 2005

1 2 3 4 5 6 7 8 9 / 12 11 10 09 08 07 06 05

For Richard, from here to Gallifry

Contents

Preface

The Wedding is a fictionalized story about a very real, very famous, but very mysterious painting by a Flemish painter, Jan van Eyck.

Painted in 1434, *The Arnolfini Portrait* now hangs in the National Gallery in London, England, where generations of art lovers and critics have gazed at it in awe, wondering, "Who are these people?" and "Is this painting just about two people getting married or about something else?" You might look at the painting and even ask, as I did, "Why in the world is a dog in a wedding portrait?"

Did the newlyweds in the painting hire the artist to paint it the way a modern bride and groom hire a photographer to take wedding pictures and videos of their nuptial ceremony and reception?

In some ways the answer to the question is yes, and in other ways, no. Back in the fifteenth century only very wealthy people or royalty could afford to hire an artist to paint their portrait—even for so solemn and joyous an occasion as their betrothal, which in many instances was still regarded as being as binding as the actual marriage in front of a priest. And unlike today's wedding photographs—even the formal ones taken of

the bride, the groom, and the whole wedding party—*The Arnolfini Portrait* has little to do with the actual event or occasion of the bride and groom's betrothal. We will never know if parts of this painting are in fact a visual reenactment of the real ceremony: The couple's clothing may or may not be the same clothing worn during the ritual. But it is highly unlikely that anyone was betrothed or married in a lavishly decorated bedchamber, without wedding guests or family members present and with the family dog at the bride's feet!

In a way this extraordinary painting is more like a marriage certificate, for the tiny figures of a witness (perhaps van Eyck himself) and a notary or priest are visible in the mirror behind the couple's heads. Above the mirror Van Eyck also has inscribed a Latin phrase which when translated, reads, "Johannes van Eyck was here."

Surely he wasn't just saying he was present when he painted the painting but rather that he was at the very ceremony of betrothal or marriage—critics still are not sure which event the painting commemorates.

What we do know for sure about this painting is that Giovanni Arnolfini married someone—perhaps Giovanna Cenami—in 1434. Until recently it seemed the girl in the painting was indeed Giovanna Cenami. But now scholars have unearthed court records that mention Arnolfini married a woman named Giovanna Cenami in 1447, thirteen years after the painting was completed—and seven years after van Eyck's death.

What we also know is that the couple in the painting were definitely very wealthy. Giovanni Arnolfini was one of the most prosperous merchants and cloth traders in Bruges. He serviced the Duke of Burgundy's court, as did Giovanna Cenami's father.

Not only did Arnolfini have the financial means to hire the duke's

personal court painter to execute this work, but his connection with the duke must have influenced the Painters Guild in Bruges to allow Van Eyck to accept the commission—for in those days the guild did not readily permit a court artist to work for private citizens.

Other clues to the couple's elevated status in society include their clothing: Arnolfini is dressed in the height of fashion, and his bride is wearing the equivalent of today's couturier gowns—from the fabulously expensive green dye of her dress to its lining of squirrel or possibly ermine fur (either one a fifteenth-century extravagance for private citizens). The quality of the furnishings—from the rug, to the elegant coverlet and drapery on the bed, to the chandelier, to the mirror itself, which besides being beautifully adorned with miniatures from the life of Christ was itself a luxury item during that period. Oranges, as Giovanna's maid notes in our story, were expensive in northern countries in the late Middle Ages, and only the very rich could afford them.

The Wedding however is a "what-if" story. I found myself wondering: Exactly who were these people? Had they known each other long before their marriage? What if the bride really didn't want to marry the groom? What if, on the other hand, she was crazy about him? Did they love each other or was this simply the usual arranged marriage orchestrated by two families for financial and social advancement?

Although some critics think the bride looks unhappy, to me she doesn't. She looks shy and a little reluctant whereas the groom looks serious and solemn, with a gravity that suits the occasion as well as his status in the world: He is a successful businessman, who has finally, in early middle age, taken a young wife.

Since so little is definitely known about Van Eyck outside his

paintings, or about Arnolfini and his bride, most of my story is fiction. Van Eyck may or may not have had a sister, but she is a character in this story. Royal blood indeed might have flowed through Giovanna Cenami's mother's veins. But Angelo, the Grimaldis, Emilia, and all the supporting characters in the book—including Rags, the dog in the picture—are my creation.

Van Eyck however really did serve the Duke of Burgundy, not only as a court artist but as emissary to the Spanish and Portuguese courts, where he not only successfully arranged the duke's marriage to Isabella of Portugal but also functioned as a spy.

The Duke of Burgundy, Philip the Good, was an extremely powerful man—as powerful as any king, more powerful than some. He reigned over a large area of what is now France, Belgium, and the Netherlands. After his father's death he continued and expanded upon the extravagant traditions of the Burgundian court: Sponsoring everything from sumptuous banquets, to large colorful jousts and tournaments, to supporting the arts in all forms. The duke was a prodigious collector of illuminated manuscripts and commissioned exquisite tapestries, jeweled caskets and goblets, and other decorative objects masterfully crafted with precious jewels, precious metals, and filigreed gold. His expensive tastes and habits made him a great patron of the arts, and Jan van Eyck was an official court artist on the duke's payroll for a good part of his working life.

After the death of his father, the Duke of Burgundy really always did wear black, though it is not certain his whole court followed suit.

One last "fact": The Arnolfinis never had any children, and records indicate that Giovanni Arnolfini had no heirs. Thus the question many

people ask about the girl in the painting is easily answered: In spite of her appearance, she is not pregnant; in fact, if you look at other paintings of the period, you will see it was fashionable for women to stand with their tummies out, swaybacked, holding their skirts in the same manner as Arnolfini's bride.

After Giovanni Arnolfini's death in 1472, his wife, Giovanna, received a pension from Louis IX, the French king, until she died in 1480. This is possible proof that she did have royal blood, as is suggested in my story.

As for the fiction, the story of *The Wedding* was one of many that occurred to me—and continue to occur to me—when I look at the print of the painting hanging in my studio. Maybe after you read this book, and look at the picture, you'll spin your own wonderful yarn about this mysterious couple who lived long ago in a faraway land.

NOTE TO READER: Bruges is a city that still exists in modern-day Belgium. In the fifteenth century Flanders was a medieval country that included the modern states of Belgium and parts of modern-day northern France and parts of the Netherlands. Flemish is the language that was spoken in Flanders. It is still spoken in parts of Belgium, along with French.

Prologue

FEBRUARY 1433

*B*ruges *in winter smells like a wet cat. It's about as pleasant too. I am sitting for a portrait in Master van Eyck's studio bored to tears and so cold I would not be surprised if the Master painted my skin blue. Also my feet hurt. This is because sitting for a portrait seems to involve standing for hours on end, pretending that this block of wood my fingers are resting on is my betrothed's hand.*

"Giovanna! Your shoulders—they slump!"

I would love to tell him in plain, no-nonsense terms that "sitting" for a portrait is hard work and smelly business. The pungent odor of the animal hide glue his apprentice Piet left simmering in a small pot over a brazier tickles my throat. Worse yet, the smell of the stuff Master van Eyck uses to dampen his paintbrush makes my eyes burn. Nevertheless the first time he saw me he said I would make a very good model. More than anything I want to live up to his expectations.

So I straighten up, careful not to disturb the heavy folds of my green gown. I force myself to be still and not turn to see why his apprentice

Johan has stopped sanding the panel he is preparing in another corner of the studio. Everything about the Master's studio intrigues me. Though I've spent much time here, I still find this place enchanted . . . though magic has nothing to do with making art, as the painter has told me more times than I can count: The work in his shop isn't performed by magicians but by artists, craftsmen, and apprentices very hard at work.

Master van Eyck is painting on the front of a sturdy wood panel. Even when he allows me to walk around the room and rid myself of the numbness in my legs, I am not allowed to peek at the progress he has made so far. I am only half of the double portrait.

"No, my dear young lady, do not shift your gaze. Try to focus here." He gestures with the tip of his brush to the edge of the panel. Then he catches my eye and his expression softens. "Do not be impatient. Another quarter of an hour, no more I will work today. The light grows poor."

And yet it's early afternoon. If possible the light wanes sooner here than back in Paris even on a rainy day. But rain is too kind a word for what is happening outside Master van Eyck's studio: The gray, soggy sky seems to be shedding sheets the way it did the night I first met Master van Eyck.

An Invitation

OCTOBER 1433

That day had started out with ungodly weather and glorious news: I, Giovanna Cenami, was invited to a feast at the duke's palace. Of course it was *not* really my lowly fourteen-year-old self that had been invited; it was my father, William, who had been summoned to the festivities at Philip the Good's court. My father was so honored by virtue of being one of the main suppliers to the duke's household of the velvet, satin, silk, and wool used to make the court's wardrobes.

My father sent for me during my lesson with my dancing master, Monsieur Tavers—usually my favorite morning activity, even though Monsieur was as old as time and smelled highly of garlic.

As I approached my father's study, the sound of his raised voice stopped me in my tracks. He was arguing with Zia Clara.

"I don't ask much of her. If you accompany me, there is nothing unseemly . . ."

"William Cenami, it is beyond unseemly, . . ." my aunt argued, then lowered her voice.

What in the world were they arguing about now? Ever since Mama's

death, tension in the house had been high. At twenty, Zia was Papa's youngest sister. She had become my mother's ally against his temper, his tirades, and what in the end was his ruthless selfishness. Mama was dead because my father insisted that she bear him a male heir . . . even after doctors had said she should not go through another difficult childbirth.

Zia was still furious at him and so was I, and not only because of Mama's death in childbirth. Though our household was still in mourning, Papa hastened our move from Paris to Bruges because Duke Philip, who had recently become my father's best customer, had taken up more-or-less permanent residence in Flanders. This was the self-same duke who no longer dared to show his face in Paris because of his role in the betrayal of our beloved Jeanne d'Arc, selling her to his English allies, which led to her death. Duke Philip no longer visited his family home at the Hotel d'Artois in Paris.

Now I pressed my ear to the study door and heard Zia Clara saying something about the palace. Then she mentioned my name. And, may the good Lord forgive me, as I listened I forgot all about my mother's death and my father's meanness. For my heart truly leaped up in my chest. Was I really to accompany my father to the duke's feast that evening?

I strained to catch more of the conversation, but hearing my father approach I straightened up. I raised my fist as if to knock on the door just as it flew open.

My father looked up, startled to see me. Then as I curtsied he grumbled, "Took you long enough to get here . . . dawdling as usual."

"I was in the study," I responded. "With Monsieur Tavers . . ."

My father waved his hand in a gesture of dismissal. For a moment it was as if he couldn't place the name. "Tavers . . ." Then he brightened.

"Oh, the dancing master. He says you are uncommonly graceful." My father stopped talking, put his hand under my chin and tilted my face up toward his, then moved my head first to the right and then the left. I had the feeling he was sizing me up as if I were a new horse for his stable. His eyes narrowed, and he gave an approving nod. "Ah . . . you have ripened nicely. You'll do. In fact, you'll *more* than do. Tonight you will come with me to the duke's palace. Your aunt will serve as your chaperone."

My father then dismissed me, and my aunt sent me to my room to bathe and dress.

Hearing the news, my maid, Emilia—who was also my closest friend—was as excited as I was at the prospect of me visiting a royal court for the first time.

"I just wish we could trade places," she was still lamenting a little while later as she slipped my cotton shift over my head.

"Part of me does too!" I squeezed her hand. "I'm afraid to go." I didn't admit that it seemed too soon to take part in such an elaborate public festival. My mother had died only three months before. We were officially still in mourning. Instead I added, "So many people and so much commotion frightens me. I'm shyer than you."

Emilia chuckled. "I wager not for long! Once you've gotten a taste for the world outside of this household, you'll be craving more of it."

After she laced up my overgown and arranged my headdress, she held up a looking-glass so I could check my reflection. For a moment I didn't recognize myself: My pale complexion was tinted pink from the heat of the fire and maybe the excitement, and my eyes were large and pale blue. I could see Emilia grinning at me in the mirror. Her rosy face was framed with dark curls and her brown eyes were full of mischief.

"I know what you're thinking," she teased.

"You always pretend to," I reminded, as I stood up to let her adjust the laces on my undergown.

Emilia continued blithely. "That you will always be the shy one."

"Won't I?"

"Maybe." She giggled. "In which case you'll always need me in your employ. When your Papa marries you off, be sure I'm part of your marriage contract."

"Marries me off?" I made a face. "That's at least three years from now. By then surely you will have found a husband of your own!"

While she finished helping me dress, I blocked out her chatter and silently sent up a little prayer, not for the first time, to my mother.

We arrived at the gates of the duke's palace just as the rain stopped. Still, a stiff northern wind blew, cutting through my fur-lined cloak.

Because of the weather, Zia and I had traveled in palanquins, surrounded by my father's personal guards. Papa and his aging manservant, Luigi, rode alongside us on horseback.

When our entourage came to a stop, I parted the curtains and peeked out. We had arrived at the duke's palace, where torches burned on the battlements and armored guards sporting the duke's livery guarded the gates. A man-at-arms asked for our invitation to the fête. After Luigi produced the parchment scroll, the guard let us continue into the brilliantly lit courtyard.

A footman helped me out of the palanquin. Pennants snapped against the flagpoles and heralds blew long trumpets, announcing the arrival of the more noble guests. While a stable boy led my father's gray gelding

away, I waited, amazed at the sight of so much splendor.

"Your eyes are as wide as saucers, Giovanetta," Zia Clara said. She took my arm and we joined the crowd of lavishly dressed courtiers and their ladies. Following close behind, attendants carried their mistresses' lapdogs, which, despite their jeweled collars, yapped as nosily as the hounds in my father's stable.

After servants took our outer cloaks, pages escorted us into the brilliantly lit great hall.

A long, raised dais ran across the far end of the room. On one end of the dais was a canopied throne. Long tables, heavy with victuals, stretched from the dais toward the screened-off serving area. Musicians strolled among the diners strumming lutes and mandolins. On the other side of the hall, a raised platform was framed with startlingly lifelike sculptures of beasts, gargoyles, and masked figures.

I grasped my aunt's arm. "Zia, do I really belong here?" I whispered. For though my clothing was of excellent fabric, I felt decidedly underdressed in comparison to the other women milling about the grand chamber. My form-fitting, rose-colored overgown had winged, fur-lined sleeves. But the plain fabric lacked the gold-threaded embroidery that seemed the latest fashion at court. My headdress was trailed by a modest white veil. I wore no jewels and no coloring on my cheeks or lips.

"You belong here as much as anybody," Zia Clara assured me, patting my hand. "Beneath all this splendor are ordinary people. Not everyone is a courtier, and even among the duke's advisers and closest counselors are people of the same station as the Cenamis . . . and some from even less illustrious burgher households."

"Is the duke here?" I asked.

"Yes." My aunt nodded discretely toward another corner of the great chamber. "That is he, dressed in black."

Through the sea of headdresses I spotted the duke standing on the dais, holding a goblet. His head was bent toward a lovely noblewoman holding a tiny white dog in one arm. The duke was easy to pick out for he was tall and cut a splendid figure: slender, of comely features, his pale skin set off by his black velvet doublet and hose.

"He always wears black since the death of his father," my aunt continued, "though whether from grief or because black is the height of courtly fashion in Spain I have no idea."

Soon my father joined us. He is of a stocky build and not as elegant as the young duke. But that evening he looked more like a courtier than the merchant he is. Having ordered our household to dispense with wearing mourning black, Papa nevertheless wore a somber outfit.

"Are we to be presented to the duke?" my aunt asked, adjusting the folds of her gown.

My father frowned. "My relationship with the duke and his retainers is simply that of a businessman. He has no interest in my family . . . or myself, except as a purveyor of fine cloth. But in time, if I rise further in Duke Philip's favor, we can present Giovanna formally here at court."

"Without question," Zia Clara interjected. "Don't forget her mother's royal blood."

"Not much of that to speak of," my father said. "Still, it's enough to count and allow Giovanna the opportunity to mingle with nobility."

"More to the point," Zia added, "your wife's blood will help your family to marry up."

"Marry?" I looked from Zia to my father. Needless to say I knew that

within two or three years I would be formally betrothed to someone of my father's choosing—to solidify Papa's position in society as well as to enhance the financial status of our family. I had been brought up to expect this ever since I first asked where babies came from. But the prospect of betrothal seemed so far away. Besides, I had only begun my monthly bleeding back in June.

"Of course," my father said, not even bothering to look at me. He was distracted by the crowd and kept scanning the chamber, nodding toward an acquaintance here and there. "That's about all girl children are good for."

"William," my aunt hissed, then touched my shoulder. "Don't listen to him. You are not just good for marriage."

"True, but as she's my daughter, I will see that we make a useful match. She's young enough that we can wait until the best candidate comes along, but I certainly have not raised her all these years, and cosseted her, and indulged her foolish whims, and clothed her with such extravagance just to send her and her dowry to a convent."

This whole exchange made me boil inside. I hated when the question of "royal blood" came up. Several generations ago someone on my mother's side of the family was the bastard son or daughter of a wayward Burgundian noble. And my father was determined to exploit that fact to further his business, himself . . . and of course, my marriage prospects.

My father could talk about me making a good match till the moon set in the east, but I had barely given the idea of marriage a thought. It felt too far away and I felt far too young—particularly tonight in the midst of this illustrious company.

My father made me face my aunt. "You have to admit, Zia Clara, the

girl has turned out well. Better than, well—her looks surpass her moth-er's before Maria went all wan and sickly."

"Do not speak of Maria like that!" my aunt broke in, voicing my own thoughts. "The poor woman bore you a beautiful daughter; you owe her departed soul some respect."

For a fleeting moment raw grief shadowed Papa's face, surprising me. I hadn't seen him express even the slightest bit of sorrow or regret once Mama's funeral in Paris was over.

As quickly as it appeared my father's grief-stricken expression van-ished. He continued in a calculating, cool tone. "I hope while the duke is in residence here we can arrange for Giovanna to meet Princess Isabella, perhaps even tonight." He looked back up at the dais. "She hasn't arrived yet." Suddenly he spotted someone in the crowd and waved.

"I'm to meet the princess tonight?" I gulped. But my father was already elbowing his way across the room toward his friend.

"Don't count on it!" my aunt said.

"Why not?"

Zia Clara gave me a sly look, then shrugged. "You're old enough to learn how the world works. We women are married to men who benefit our families—financially, as in my case, or in Isabella's case, politically as well. The men do their duty to their wives but have lovers."

"I've heard as much," I said, trying to sound as if I'd known this for ages. Actually it was Emilia who had told me recently about married men—and women—being unfaithful to their sacred marriage vows. The thought had horrified me, but Emilia had told me that someday when my father married me off to some very rich, very fat, exceedingly old man, I wouldn't be so horrified. She said I would yearn for a young lover of my

own. I told her I'd rather die first. Emilia's answer was a lusty laugh, followed by a cryptic comment: "Ask Signora Clara how she feels about it."

Now Zia Clara casually added, "Even the duke has his eyes on other conquests tonight."

Granted, the idea of the duke being unfaithful to his wife troubled me; still, surveying the room, I silently wondered how he picked his current dinner partner from the bevy of the incredibly lovely women milling around the chamber. Could any one of them possibly outshine the legendarily beautiful Isabella of Portugal?

Just then the crowd surged forward, bodies pressing me from behind. Suddenly the sound of horns, drums, and stringed instruments filled the air. I turned to see what was happening. A new troupe of performers was dancing into the hall. They moved boisterously to the grand chamber through the ranks of guests bottlenecked at the entrance.

In the commotion I didn't notice at first that I'd become separated from Zia Clara. I was positively bewitched by the spectacle of the masked jongleurs sporting parti-colored hose—one leg red, the other leg black—and belled, fringed doublets. They wore gaudy peaked caps and shoes with long, upturned and pointed toes. Musicians blew on their flutes with one hand and beat tambours with the other. Some strummed on sweet-sounding lutes, others plucked strident notes on pear-shaped rebecs. Their raucous tunes were as merry as their finery, and the crowd applauded their entrance.

But as they passed farther into the great chamber, I found I was alone in the crowd, unable to even see my aunt. My heart began to pound. I felt small, and vulnerable, and lost. As I was swept deeper into the crowd of revelers, I feared I might be crushed.

The Minstrel

Determined not to get caught up again in the crowd, I hugged the edges of the room. I tried to spy my father or Zia Clara, but to no avail. Then I heard a man's voice mention my father's name. He spoke in Italian. He sounded as if he was from Lucca, my family's ancestral home.

"Cenami? Here? Tonight? I scarcely thought to find him in Bruges."

I peeked around a column, trying to see who belonged to the voice. Could one of my father's Lucchese friends be here? Perhaps even one of the cloth merchants or traders I'd met dining at our old home in Paris—though the chances of someone I knew being here in Bruges at the palace seemed slim.

A second voice scoffed. "Of course he's come to Bruges like the rest of the duke's hangers-on."

I bristled at the second man's tone. My father was no "hanger-on." He was one of the duke's most favored purveyors of fine textiles. I craned my neck, but all I saw were two men, their backs toward me. Both wore elaborate, velvet, turbanlike hats, embroidered doublets with fine hose, and dark leather boots.

"The Grimaldis are here too, you know," the second voice continued. "Either Cenami's spies have fouled up or just not reported the fact."

The first voice let out a low whistle. "Interesting."

"Cenami had better be sure not to cross their path. You've heard about the accusation leveled against him."

"Which one?" The first voice laughed. "Those two clans are always hurling wild accusations at each other. No one bothers to pay much attention to either one of them."

What in the world were they talking about? No one at home had ever mentioned feuding clans—or the name Grimaldi.

The second man turned slightly over his shoulder to check who was within earshot. He seemed for a minute to catch my eye, but then he fixed his gaze over my shoulder. I ducked back behind the column. But before I did, I saw his profile: It was distinctive, with a pronounced nose and receding chin. I wouldn't forget that face, and I was sure I'd never seen him before.

Then he dropped his voice and continued. I had to strain to hear him, and even then couldn't believe my own ears. I lost the first few words, but I heard enough to make my heart almost stop. ". . . poison. An apothecary on the outskirts of Lucca was implicated in the plot. Fortunately for Cenami, Alberto Grimaldi recovered, and a physician . . ." He paused, and snickered slightly. ". . . one I know for a fact is beholden to the Cenamis, by the way, swore before a magistrate that it was only a digestive upset. But no one believes him. The wretch was probably bribed, or perhaps was even threatened if he didn't hide the truth."

"Or the Grimaldis engineered the whole thing themselves, in such a

way as to cast suspicion on the Cenamis," the other man suggested. "If anything, they're even more ruthless, with their family far flung. At least two of their sons have insinuated themselves in foreign courts. Cenami has no son, though there are nephews back in Italy, well placed among the moneymen and bankers."

"And so probably no strangers to intrigue, if not outright murderous plans to poison their rivals."

What in the world were these men implying, that my father was a would-be murderer who would use poison to gain his ends? I was horrified and at the same time furious. Part of me wanted to march up to the men and demand they take back their slanderous lies. But as hot headed as I felt, my heart grew cold with fear. Could there be any truth in this? I knew so little of the world outside my home, and the women's gossip never dealt with the intrigues of merchants, bankers, and men of trade. I leaned back against the column, hands pressed to my chest, as if somehow I could quiet the rapid beating of my heart.

"Giovanna!" The sound of my name startled me.

I turned in the direction of the familiar raspy voice. At first I saw no one I recognized in the sea of silks and velvets, ermine and elaborate horned headdresses. Then I glimpsed a gloved hand waving in my direction. It belonged to Signor Arnolfini, whom I knew from back in Paris. He made his way toward me. A lean man with a thin angular face, he was not handsome; but when he smiled, as he did now, his light eyes shone and his aspect became wonderfully pleasant. At the moment he looked as happy to see me as I was to see him.

At the sight of that familiar face my stomach unclenched and I cried out, probably louder than a proper young woman should. "Signor Arnolfini." Heads turned.

He quickly elbowed his way toward me, his eyes narrow with concern. As he neared, I dropped a quick curtsy and his thin face brightened. He laughed as he took my arm. "You look surprised to find me here."

Surprised, yes. And happily so. "I'm beyond glad to see you. There are so many strangers here, and I got separated from my aunt. and then I heard . . ." I stopped in midsentence. I was tempted to blurt out everything I had just heard just to have Signor Arnolfini laugh off the evil gossip. But some instinct warned me to keep the men's vile accusations about my father to myself, or at least not speak of them *directly*, to anyone, not yet, for Signor Arnolfini was a merchant like my father and moved in the same circles. He was the perfect person to put my mind at rest about my father. But what if those men were Signor Arnolfini's colleagues or friends? So instead I only spoke to him of my fear of all these strangers, and of getting lost in the crowd.

"No need to worry, Giovanna, now that I've found you. Together we'll brave the onslaught of revelers." He looked concerned. "You seemed overwhelmed when I spotted you. Where's your father?"

I shrugged. "Off with some business associates, I imagine."

Signor Arnolfini shook his head. "It's unlike him to leave you unescorted."

"Oh! But he didn't! Zia Clara is here somewhere. We got separated when the musicians entered the hall."

His face relaxed, and I realized suddenly how young he was. Though he was one of my father's closest confidants and business associates, he was younger by a good ten or fifteen years than Papa. I had known him as long as I could remember and thought of him as an uncle. He was practically family. When he came to dinner, he always brought me presents. When I was very young, he brought small dolls dressed in exotic

finery from the Levant, or whimsical, carved animals—camels, griffins, dragons, and elephants—I had only seen in pictures in the bestiaries my father collected. More recently, he came with lengths of lovely embroidered ribbon from Tuscany and precious lace from Spain. He felt more familiar to me than my uncle Guido and in fact was the same age as my cousin Francesca's new husband, Nardo, who was twenty-eight.

Signor Arnolfini mocked a courtly flourish, then took my arm. "It seems impossible that a lovely young woman like you should be drifting alone in a crowd like this." He patted my hand, and I gripped his arm. "Shall we be off to find your aunt?"

I hesitated, but just for a moment. I looked back over my shoulder, hoping to spot the two men who'd defamed my father. Perhaps I could casually ask Signor Arnolfini who they were. But if anything, the hall was more crowded than before, and I caught no glimpse of them.

Putting aside my worries for the moment, I nodded to Signor Arnolfini. "I'd like that."

"Here," he said, laughing." I will be your gallant escort for the evening."

I went along with his little game and pretended I was a grown courtly lady. "Escort? Perhaps we are an old married couple like those people there." I pointed to two elegantly dressed but stout figures shuffling arm in arm through the crowd, the woman as old as my nurse, Anna, the man surely as ancient as God himself.

Signor Arnolfini drew a deep, quick breath and looked down at me. There was a strange expression on his face, and his eyes suddenly had a soft look.

"Have—have I said something wrong?" I asked. Something about his countenance unnerved me. I wondered if I'd offended him.

"Wrong?" he repeated, then laughed lightly. "It's just that I can never imagine you old. Let's pretend to be a couple, and young as we indeed both are. I'll guide you through the maze, make whatever introductions. I didn't expect to find you here though I saw your father. I admit I was surprised to see him here so soon after . . ."

He stopped himself and seemed uncomfortable. "Not that it's unseemly . . ."

"Papa says it isn't, and I think perhaps Mama would have liked to see this place," I added, unable to keep my voice from quavering.

"It's all right to still feel sad, Giovanna," he said softly. "But it's also all right to enjoy all of this. You are young, and your mother would want you to take pleasure in the feast."

We wended our way across the crowded room.

"How would you like to meet the man who executed all this splendor?" Signor Arnolfini gestured with his free hand to the painted silk banners, the tapestries on the wall, and lavish table decorations.

"One person did this?"

"One person designed it all. It's possible that he also painted some himself. Certainly he oversaw the work in his shop, right here in Bruges. Perhaps you have heard of him. Ah, here he is!"

Signor Arnolfini approached a man who, if anything, was more slender than himself. His face was also angular. The deep blue of his doublet deepened his smoky eyes, which were exceptionally piercing and quick as a bird's. I sensed that these eyes saw everything more clearly than anyone else's, as if a single glance could take in every detail of whatever he looked at. His fair complexion was slightly ruddy from the heat in the room, and perhaps the wine.

Though from his looks I knew the gentleman must be Flemish,

Signor Arnolfini introduced him in Italian, for my sake. "Herr van Eyck, I'd like to present you to Signorina Giovanna Cenami. You know her father, William, of course."

Van Eyck? The name was unfamiliar. I sank into a deep curtsy, for he wore the costly clothing of a high-ranked courtier and his bearing betrayed a certain nobility, whether of birth or careful cultivation I didn't know at the time.

Herr van Eyck returned my bow, then took my hand and bade me straighten up to face him. I was surprised that though he was sweet-scented and immaculately groomed, his hands were rough as a common worker's. He studied me before he spoke. His face was serious, and I wondered if he ever smiled. When he finally spoke, his Italian was rough and harsh on his tongue but his tone was friendly.

"Ah, Signor Cenami has been hiding quite the flower from us all. Why have I not seen you in Bruges until now?"

"Because I've been in Paris with my mother. My father also does business there. We have been in Bruges for less than a fortnight."

Herr van Eyck gave a knowing laugh, and his stern expression softened. "So you must think our fair town is all gloom and storms and wild skies. Come tomorrow our city will put on its best garments, and you will begin to enjoy it here. Though surely not as vast as Paris, we here in Bruges have our share of beauty and charm."

"I'm sure," I said quickly. My upbringing had taught me that it was not a young girl's place to disagree, at least publicly, with her elders. And Herr van Eyck was indeed an elder. He was certainly at least as old as my father, probably around forty years old. But I learned there and then there was no way to fool this man.

He arched his thin eyebrows. "You are not sure, nor should you be yet. If your father permits, I would like to show you some of the treasures of Bruges. Perhaps you and your chaperone could come to my studio tomorrow when the weather promises to be fair. I will be leaving for Lyon shortly, and then I go on to Spain on business. But when I return perhaps I can have permission to sketch you, for the signorina would make a very good model for the painting of a virtuous young woman." He cast a questioning glance at Signor Arnolfini.

"I'm sure someday, Jan, you will have the chance to paint Giovanna— I'll see to that! But meanwhile, her father is here tonight. I will speak with him about tomorrow if you wish."

"*Bene*!" Herr van Eyck answered. "Good."

"I would like that." I said, never having been to an artist's workshop. "If, of course, my father permits it," I added quickly.

"I'll speak with him myself, signorina," Signor Arnolfini said. He seemed about to say more when a trumpet sounded a flourish. All heads turned toward the front of the hall, then a cheer went up from the crowd.

"What's happening?" I am of small stature, and though I stood on tiptoes I could not see over the heads and shoulders of the people in front of me.

Herr van Eyck rubbed his hands together and smiled broadly. "Ah, tonight's entertainment is about to begin. I must attend to some of the costuming." He bid a hasty but courteous farewell. But before he left, he caught the attention of a footman and instructed him to give us good seats at the long table nearest the performing platform to better view the entertainment while we enjoyed our meal. Zia Clara, joined us shortly. Then, I spotted my father's new hat, a tall round capuchon that was all

the rage back in Paris and apparently favored by many of the courtiers here in Bruges as well. He was surrounded by a small circle of men hovering beneath an open casement window. I recognized one or two of the men as merchants who often visited our house, but none had the beaked nose of the gossiping gentleman I'd seen earlier. My father's face was animated and his gestures broad. Some new business venture must be at hand to excite him so. *Just like my father*, I thought. *All he cares about is money and business, even at a feast.* And yet his aspect was open, bordering on jovial—his nose already a bit red from too much wine. Surely this wasn't the face of a man who would poison his business rivals. My father caught my eye and flashed me a warm smile, the kind of smile he had always favored me with when I was small. It was rare of him to look on me these days with such kindness. My nurse, Anna, said it was because when he saw me, he no longer saw a daughter but rather a large dowry to be paid out in the future. But tonight he didn't seem to care about the dowry. The very warmth of his expression put my doubts to rest. This man was no evil schemer, and certainly no would-be murderer.

The gaudy minstrels had faded to the edges of the hall and were cavorting with the serving wenches as they downed their food and wine. By the time I was settled at our table, with Zia Clara on one side and Signor Arnolfini on the other, I'd put all talk of feuds and poison out of my mind.

Our supper at the long table made the menu at my cousin Francesca's wedding banquet last spring look like mean, fast-day fare. There were stuffed swans, fish soup, small game birds with sprigs of rosemary, and a pie full of sparrows in savory sauce. Suckling pigs, whole and glistening with some sweet glaze, were placed on the table—one pig for every four

or five guests! Sweetmeats and tankards of ale and flagons of wine were set at close intervals down the gilded runner cloth draped along the center of the board.

But how the meal tasted I have no idea, for no sooner had I begun to sip some of my wine than the performers took the stage and I forgot to eat. As the performance commenced, Signor Arnolfini quietly explained the story behind the spectacle on stage. The entertainment began with a tableau vivant, where all the players, decked out in the most realistic costumes, held still, just like in one of the tapestries on the wall. From where I sat I could barely see them breathing—they looked like living statues. Then from somewhere out of sight the strains of a single lute playing a mournful tune started up. The opening chords were followed by a troubadour's voice singing about a recent battle with the French and Burgundians on one side and the English on the other. The singer chanted his poetic song in the purest Italian.

The music abruptly shifted, and along with the rest of the spectators I gasped as the figures on the stage sprang into action. The actor-knights parried broadswords and lances, and clever lengths of red silk sprang from their armor as they fell groaning to the floor.

At first my eyes were riveted to the action on the stage, for until that evening I'd only seen crudely attired players at street festivals, fairs, and mystery plays in church on saints' days. Street performers were awkward and coarse compared to the actors in the duke's palace.

Suddenly I became aware of a new figure on one side of the stage. It was the troubadour, half in light, half in shadow, plucking a lute. He leaned casually against the wooden structure that framed the stage. He sang a praise-song of battle won and heroes fallen to enemy swords.

But I didn't pay much attention to the words, for here, surely, was the fairest man I had ever laid eyes on.

I noticed everything about him at once: the fine cut of his deep burgundy doublet and wine-colored hose: his dark wonderfully curly hair and catlike bearing. His upper face was shielded by a black mask. At that moment I silently blessed Signor Arnolfini for his friendship with Herr van Eyck, for our place at the banquet table was so close to the stage that behind the troubadour's mask I could see the color of his eyes. They were huge and the deepest brown, and they reflected the flickering stage lights like stars in the night sky. He reminded me of one the dark angels newly painted in the chapel of St. Geneviève back home in Paris where we had worshipped.

Listening to his voice, I felt as if my heart would break. I leaned forward and touched my aunt's arm. "Who is the singer?" I whispered, unable to take my eyes off his face.

She shrugged. "Some troubadour, though from his looks I'd say one of noble blood. Perhaps from the south of France, or maybe he is from Lombardy or Tuscany or one of the other Italian courts."

I nodded, only half listening to her, for the troubadour was now performing a love song, a ballad of longing. The lyrics told of love denied: The singer's beloved belonged to the king, and the singer was a poor, wandering knight pledged to the king's service. As I watched him I felt my face flush, and a warm, curious new sensation stirred in the pit of my stomach, for in front of me was no stranger but a young angel straight out of the realms of my dreams, the kind of dreams I never shared with my confessor. But this was no dream. I felt as if for the first time in my life I was truly awake.

I leaned forward in my seat, drinking in the poetry of his song. Maybe I just imagined it, but for a second he seemed to look right back at me and he seemed to be singing to me, only to me, as if we were the only two people in the room.

". . . and listening to him," Zia Clara was still talking in a soft whisper, "I am sure he comes from Tuscany. Yes, his Italian is that clear, that perfect. Something about him is familiar, though with that mask . . ."

Before she could say more, my father appeared at the table. "We're leaving," he said in a gruff whisper.

Zia and I both looked up sharply. Papa's face was set and stony, and two little red patches burned on his cheeks. It was a look I was more than familiar with. He was, in a word, furious. But at what? Or, more likely, with whom? All at once I recalled the men discussing our family's feud with that other Lucchese family whose name had slipped my mind. Had Papa run into them? A chill coursed up my spine.

Then the troubadour broke into a new song. Just the sound of his voice erased all my concerns. I barely heard Zia as she started to protest, "Why in the world should we leave now?" She cut herself off so abruptly, I turned away from the stage in time to see my father's frown deepened. Zia pursed her lips and pushed back her chair. "Of course, if you say so."

For a moment longer I didn't move. My eyes drifted back to the stage. Leave now? The troubadour was no longer facing me, but I was sure that if I stayed put and wished it with all my heart and strength, he'd turn again and once more catch my eye. "What will the duke think? It seems ungracious," I improvised.

"The duke won't notice," Signor Arnolfini said, gesturing with his

head toward the dais. Indeed, the noble duke's attention was fixed on the lady seated to his left. As he whispered in her ear, she laughed and placed a hand coyly on his arm.

Signor Arnolfini stood up and motioned for a footman. "Of course I'll accompany you."

"No need, Giovanni," my father told Signor Arnolfini as the footman pulled back my chair. As I stood up my eyes drifted back to the stage. The troubadour was still singing. He had stepped back farther into the shadows, and his face was no longer visible.

"You stay, but I will meet with you and Gandolfi and the others in the morning as planned to discuss our strategy with the bankers. But it is imperative I leave now. I'll explain tomorrow," my father concluded, dropping his voice.

My father hustled us out of the hall and into the cold night, barely waiting for the footmen to bring our cloaks.

As we hurried past the servants and soldiers relaxing in the courtyard, I could still hear the sweet strains of the singer. Just the sound of his voice made my knees weak, and I stumbled. One of my father's men grabbed my arm. "Careful, signorina," he murmured as he steadied me, then helped me into the palanquin. Before I stepped inside, I looked back over my shoulder toward the open palace doors. Would I ever see the troubadour again?

CHAPTER THREE

The Studio

The next morning my maid, Emilia, was a whirlwind of words. I'd barely gotten out of bed and doused my face in water when she pelted me with questions.

"Giovanna, please, *per piacere*, tell me every detail of the fête! What were the ladies wearing? Is the Princess Isabella as beautiful as rumored? Why did you come home so early?"

"So many questions! Sometimes you are too curious." I couldn't help but laugh at her, but inside I felt a bit annoyed.

"And suddenly that bothers you?" Emilia eyed me skeptically. "You always want the latest news when *I* go out for errands. Besides, you promised to tell me."

I couldn't argue with that. I adored the tidbits of gossip Emilia managed to gather from who knows where every time she left the house. In her own way my seventeen-year-old servant was as eagle-eyed as the famous Flemish master I'd met the night before, and surprisingly shrewd. *Surprisingly* because with her open, rosy face and quick, warm smile, no one thought of her as worldly or wise.

"Please, it's cruel not to tell me, Giovanna. I've been waiting to ask you since I woke at dawn."

I hesitated, for I was of two minds. Part of me was strangely reluctant to share these new, mysterious feelings that haunted me at the thought of the troubadour. I was afraid Emila would laugh at me, or make him seem ordinary and lowly, like one of the baker's boys or pages or apprentices of her own acquaintance. Another part of me only wanted to talk about him so he would seem more real, less like a dream

My continued silence, however, did not sit well with Emilia.

"Come, dear lady," Emilia continued to coax, "I can tell you had a wonderful time. Your skin is glowing, and . . ."

"And I'll answer your questions in good time," I teased, angling for a few more moments to gather my thoughts. "But as for your last question, why did we come home early? You'll have to ask my father." I couldn't keep the sourness out of my voice.

"But he was so set on you going to that feast." Emilia sat me down on one of the chairs and began brushing my hair.

"Something must have happened. . . ." I broke off, for suddenly I was tempted to ask Emilia if she had heard about my family having an enemy in Lucca. Before I had a chance, though, the door to my room opened.

It was Zia Clara.

Emilia quickly curtsied. I stood up, and my aunt approached and offered her cheek for a kiss. She returned my kiss, stepped back, and gave me a cool, appraising look. I got an uncomfortable feeling she wanted to have some serious discussion with me. "I'm glad you're not clothed yet." Turning to Emilia she went on, "Giovanna should put on some sturdy garments warm enough for walking. That old gray overgown

will do, plus that warm cloak—her second best one."

"Why?"

Zia smiled slightly. "Because it seems you were offered an invitation last night from one of Bruges's most prominent citizens, and it's your father's wish to cultivate that connection."

For a moment I had no idea what she was talking about, then I remembered. I clapped my hands together. "I don't believe this. You mean my father is actually letting me visit Herr van Eyck's studio?"

"Against my better judgment he is. I should by all accounts be going with you, but I have some business to conduct with the bankers on your Uncle Guido's behalf," my aunt said. "Of course you will be chaperoned by Anna and two of your father's men. Emilia will accompany you—if she promises to still that wagging tongue of hers," she added, flashing the maid a warning look.

Again Emilia dropped a curtsy and bowed her head. "Of course, signora. I will be quiet and invisible as a mouse."

Even my aunt couldn't help but laugh at that. "Don't promise something you can't deliver, Emilia. Just try, for once, to stay in the background." Zia Clara focused her attention back to me. "As for you . . . I don't think I have to remind you to behave yourself; and, please act like a lady, not a child. I know how much color and paint please you, but you are not to touch anything in the Master's workshop."

"I wouldn't dream of it!" I was shocked at the very suggestion that I might misbehave like a six-year-old in a sweet shop.

"Good," said my aunt, as church bells began to chime nine times. "It's already terce," she said, starting back toward the door. "Herr van Eyck has sent his own escort. It's a bit of a walk from here, but the exercise will

do you good after this spell of damp weather, for in case you haven't noticed, it's finally a beautiful day in this dreary town!"

As we made our way along the chain of canals and bridges that linked the various districts of Bruges, our entourage must have made quite a sight: Emilia in her simple white hood and long dark braid and I decked in a modest headdress and a warm, if mended, second-best cloak. We were guarded front, side, and back by four men, black-handled swords swinging from hilts as they walked. The two from my father's mercenary guard were dressed in motley fashion, the two from Herr van Eyck's household were decked in tasteful but somber matching uniforms.

Anna, my old nurse, plagued by arthritic knees and for some reason today in a bad temper, drifted behind us like a scowling cloud. Behind her, bringing up the rear, was Luigi, my father's man. That my father had spared Luigi for this outing signaled two things: first, that he was depending on Luigi's keen eye to inform him of everything and anything he could learn about the duke's official court painter; second, that for reasons beyond my understanding, my father was worried about my honor.

Though I was eager to see the Master's studio, I yearned to linger on the bridges, enjoying the sun. The bright morning light and brisk air somehow managed to push the events of the previous night to the back of my mind.

We moved along at brisk pace, so brisk, in fact, that Anna and Luigi were a good measure behind by the time we reached the Guild Hall and the Chapel of the Painters Guild.

Herr van Eyck's workshop occupied a tall, narrow brick building not far from the main square. Like most of the other houses it had a steeply

peaked tiled roof and tall brick chimneys. One of Herr van Eyck's men
hurried ahead to announce our arrival. The other opened the heavy
wooden door and stepped aside to let us pass. He apologized for the
Master's wife not being present to greet us, and said that she had been
delayed while visiting a sick neighbor.

Directly ahead was the long hallway leading to the painter's living
quarters. To the left was a staircase. The stairs wound upward past the
living quarters to the painter's studio. The steps were steep, narrow, and
difficult to maneuver—especially for Anna. However, I ran up lightly,
followed by Emilia, whose plumpness, though pleasing to the men who
wooed her, made her less agile than myself.

The door at the top of the landing was ajar. A sharp, pungent odor
drifted onto the stairway. I wasn't sure if I should just walk in. Would I
disturb the famous Master? I hesitated and drew a deep breath; the strong
fumes made me lightheaded.

"Come in!" Herr van Eyck's voice beckoned in French.

When I entered, I instantly forgot the effect of the fumes on my
lungs. "Oh, the light!" I exclaimed even before I remembered to curtsy.
Though situated on the top floor where the roof slanted sharply down-
ward, the studio was airy and light. The chamber itself was large, with an
astounding number of windows: I counted five of them. Three had real
glass, and all of them were aimed at the northern sky. That day was one
of the rare winter days when the sky is bluer than my eyes and the light
was so sharp and clear it hurt to look at it.

From behind me I heard Anna clear her throat, not so subtly remind-
ing me of my manners. Embarrassed, I dropped into a deep curtsy; but
Herr van Eyck quickly took my hand and made me rise.

"Not so formal here, Signorina Cenami," he said, motioning for one of his servants to take our cloaks. "It is only a workshop, and your skirts will be ruined."

I glanced down. The floor was spotless. Apparently the Master's servants were as scrupulous about cleaning as he was about his workspace. Even my cursory glance around the room had revealed a definite sense of order. A broad table set at a right angle to one of the windows held several pottery jars filled with quills and brushes. They were lined up on one side of a wooden board that was tilted up at the same angle that my own drawing master said was proper. From where I stood I couldn't make out the drawings that filled the sheet of pale gray paper pinned to the board.

Luigi and my father's other men hung back right inside the door. Herr van Eyck motioned me farther into the studio. Emilia followed, but it was Anna who stood next to me. As she took in the room she first frowned, then her face relaxed.

I followed the direction of her gaze and could not believe my own eyes. There at one end of the worktable running along the wall was a woman, her head bent low over a square of parchment. *A woman painting in a master's studio!* Her whole body was tense with concentration as she touched the square of parchment before her with a small brush.

Did famous artists such as Herr van Eyck take on women apprentices? The answer was clear the moment she looked up. This was no lowborn apprentice, though she wore an apron over her plain blue cotton gown. Even from this distance I could see that the smoky eyes looking back at me matched Herr van Eyck's. She had the same thin face and narrow mouth. She carefully wiped her brush on a rag before standing.

"Margaret, this is Signorina Giovanna Cenami, the young woman I told you about."

Margaret dropped a shallow curtsy, as Herr van Eyck turned back to me. "Signorina Margaret van Eyck is my sister. She shares our household and helps with commissions on the miniatures that come out of our workshop. She's illuminating a manuscript now for Duke Philip."

I returned her curtsy and tried not to stare too hard. Though like most women of my standing, I had learned to draw and paint a little, I had no idea a woman could work as a professional artist. Was she a member of a guild?

Margaret sensed my confusion. She beckoned me over to her side. "Come look. Haven't you ever wondered how the pictures get into books?" Her voice was raspy and harsh like her brother's, but her smile was warm, her gestures kind.

"I—I knew people painted them."

"But you didn't think women did!" The hearty laugh that escaped her lips was surprising. "I'm not permitted to be a member of a guild, so I work here as my brother's assistant." But as she directed my attention down to the page, it was obvious that she was not assisting anyone, these tiny wonders decorating the text were her own creation, as her brother had implied.

"Oh, that's so beautiful!" I gasped, bending over to more closely inspect the pictures: Fanciful griffins and winged dragons and swans, with wings opened in full flight danced along one side of the margin. Drawn in great detail, they were only partially painted. But where color had already been applied, the tones were vibrant blues and reds and greens. The words were in Latin, which, thanks to my tutor and my mother, I could read. I recognized the Pater Noster—the Lord's Prayer—and realized this was a prayer book.

Margaret looked over my shoulder and motioned toward Anna and

Emilia. "Come, you look too. You don't need to read to understand the pictures."

Emilia caught my eye and I almost laughed. Unlike most servants Emilia could read—Italian, some French, though not Latin. Anna however was illiterate. We all bent over Margaret's worktable, marveling at her handicraft.

Herr van Eyck let us admire his sister's work for a few moments, then shepherded us away from her worktable. "Come, let me show you the rest of the studio."

He snapped his fingers. Two young men, bent over a long table running along most of the windowed wall, looked up. At the sight of me they leaped to their feet and bowed.

I curtsied, confused as to their station. They were both shabbily dressed. One, a young man of about twenty with a bad complexion and lank blond hair, wore a stained leather apron over his tunic; the other, a boy of perhaps only eleven or twelve years, seemed lost in a baggy, patched, and turned garment that was once white but now was rainbowed with colors.

Herr van Eyck looked toward my father's men, still huddled inside the doorway. "You can go back downstairs. Signorina is quite safe here. There is a tavern across the way. I have already arranged for you to take a light meal and some brew there."

The grooms left, but Luigi stayed. He folded his arms and scowled at Herr van Eyck.

Ignoring Luigi's glare, the painter turned to his older helper. "Johan, fetch the good Nurse Anna a chair and something to drink."

The older apprentice wiped his hands on his apron, then hurried to

clear a pile of papers off a chair. It was straight backed and didn't look too comfortable, but Anna sank with relief onto the seat.

"Giovanna, this is my apprentice Johan, and that scoundrel grinding my paints"—he winked at me as he pointed to the boy with the soiled tunic—"is Piet."

Piet looked up from the work table and grinned at me. I returned his smile and continued to look around the room. A large workbench was situated in front of the windows. Other, smaller tables were scattered around the room. In one corner was a half-opened trunk. A length of red silk spilled out over the top. In another corner an elaborate brass candelabra was propped against the wall. Though it had eight candleholders, only one held a candle. At the moment the candle was not lit, but it clearly had been used: The wick was charred and the candle had burned down slightly. A round mirror in an ornate gilded frame hung above the trunk.

A statue of a female saint was propped against the wall near to where Piet was working. "Herr van Eyck made this too?" I marveled.

Piet stopped grinding the paints and nodded. "Yes. He modeled a small version that another sculptor enlarged. Then Herr van Eyck applied the colors." Indeed, the statue was painted with brilliant, pure colors and gilded with gold that glinted in the shaft of sunlight spilling in through the window.

"Ah, Giovanna," Herr van Eyck said, touching my sleeve, "I see you noticed the light. You have come not a moment too late. It is a perfect time for me to keep my promise and show you how a painter works." He tilted his head and gazed at me with interest. "Remember last night I mentioned I might someday paint your portrait."

I didn't know how to respond. It seemed like such an unlikely honor.

Herr van Eyck laughed. "Don't look so embarrassed. Signor Arnolfini has even spoken with your father about it. A portrait will capture you as you are now, and in my painting you will stay forever young."

That seemed like sacrilege and not just to me, for out of the corner of my eye I saw Anna's shocked expression as she hastily crossed herself. Next to her even Emilia paled.

"Don't look so fearful, young mistress," Herr van Eyck chided with a small smile. "It only *looks* as if I stop time and capture your soul. Only the good Lord can do that. It is simply my skill and art that enable me to create a likeness. Come, I'll show you some of my tricks."

He brought us over to his drawing table. It was angled to catch the daylight. A slightly raised platform was positioned several lengths away from the table, and on the platform was a chair; a woolen cloak was draped casually over the back. A sturdy board was propped up on the drawing table; a sheet of gray paper was fastened to the board.

As I drew near, the image on the page came into focus. It was a most perfectly rendered face of a young man. The drawing was covered with lightly penciled straight lines, vertical and horizontal, making a kind of grid. I stepped closer, and gasped. For there, looking back at me, was the very minstrel I'd seen the night before at the duke's feast! The face was unmasked, of course, but I recognized his wild, curly hair, his high brow, the noble carriage of his head, the dark eyes, the full lips. My thoughts began to race. Herr van Eyck obviously knew my minstrel. More to the point, my mysterious stranger had been at this studio . . .

"Signorina, are you all right?"

Herr van Eyck's voice broke into my reverie, and I forced myself to turn away from the drawing table. I wanted to ask who the model was,

how he knew him; but something stopped me—my shyness perhaps, or more likely the fact that I don't think I could have found my voice.

I simply nodded in response to his question.

"I think the signorina was out too late last night and up too early this morning," Anna chided, fussing with my dress. "See how pale she is."

Indeed I felt faint, for my heart was pounding in my chest—so hard I feared someone would see it beating like the wings of a bird beneath my dress. But I turned away from Anna and shook my head. "I think I didn't take enough breakfast, that is all."

With that Herr van Eyck himself poured me a glass of watered wine. "This will lift your spirits, give you strength to walk home."

I took the wine but only pretended to sip it, as I had no stomach for wine or food just then. However, I didn't want to head home. I wanted to stay as long as possible in case the minstrel-model might return.

"We should leave," Anna told Herr van Eyck.

Before the painter could answer, I got up, ignoring her restraining hand. "But Herr van Eyck hasn't yet told me his secret," I protested.

The painter smiled. "The lines on the drawing, young signorina, are the trick involved here. The technique is called 'squaring up' the drawing. I draw a larger grid of lines, using the same number of squares on the surface of a prepared panel. If I copy the shapes inside each square very carefully on the bigger squares on my panel, I will get a faithful copy of the small drawing."

"That indeed seems like magic!" Emilia spoke up.

"No, young lady, it's only one of the tools painters use to make a likeness of something or someone. We have, as I told you, perhaps as many tricks as the magicians in the marketplace."

"You are painting the gentleman's portrait?" I tried to steady my voice.

"Him?" He shrugged and made a dismissive gesture with his hand. "No, but he has a fair enough face; and since he is one of my retainers who sometimes travels in my retinue, he's often available for a sitting. I will eventually use this likeness in one of my commissioned paintings."

Then Herr van Eyck shepherded us away from the drawing table. Was I imagining things, or did the painter want to avoid talking about this particular model?

Instead he directed our attention to a panel leaning face out against the wall. Part of the panel was thinly painted with the seated figure of a woman half sketched in. She was cradling something in her arms. That part of the painting was still blank except for the neat grid lines that covered the surface of the panel and that were still visible beneath the veil of paint. The squares were larger than the ones I saw on the drawing of my minstrel.

"See this panel?" The panel's surface was pure white and smooth as silk. "It's been prepared for painting. Piet has covered it with gesso, which is a coating he made from animal hide glue and gypsum, a substance bought at the apothecary shop."

Herr van Eyck motioned for us to draw closer. I forced myself to pay attention to his explanation, but my eyes kept drifting back to the image of the minstrel on the drawing board. Emilia noticed and gently poked me in the side. "Wake up!" she whispered.

I turned my attention back to Herr van Eyck. "Once the gesso is dry, we put our grid lines on the panel. You can still see the grid here because this painting is only halfway finished. See, it's a madonna. I

selected a model and drew her until I managed a satisfactory rendering, and then I squared up the drawing, as I told you. This helps me render her likeness even without the model present." Then he showed us a few more paintings.

When it was time to go, Emilia retrieved our cloaks. After saying good-bye to Margaret, I led the way down the first flight of stairs, my head reeling. My heart was pounding. To think that Herr van Eyck was acquainted with my minstrel, that he saw him to draw his likeness and paint.

Suddenly being in Bruges didn't seem like such a hardship, for my minstrel lived here, within the circle of my father's acquaintances.

My thoughts were still dancing with the chance of at least glimpsing him again when we reached the first landing. Just then the door to the street slammed and a cloaked figure hurried up the stairs.

As he rushed toward us, I pressed back against the wall and looked back at Anna, who was still at the top of the stairs. Then the cloaked figure brushed past me.

"*Scusi, signorina,*" a musical voice muttered, as the figure reached the landing. I looked up, and into the face of a young man. I barely stifled a gasp. For the man was my minstrel, only unmasked. He stopped and held my eyes for a moment, as if trying to place me. His lips parted as if he were about to say something. But at the sound of Herr van Eyck's voice coming out the open studio door, he quickly turned and continued to race up to the Master's studio, nearly knocking Anna over in the process.

A Chance Encounter

"You know him!" Emilia let out a soft, startled cry as he reached the top landing.

I heard Emilia's exclamation—the certainty in her voice. Part of me should have protested immediately. But I couldn't. Just as I had recognized him, he had remembered me from the previous night; I was sure of it. Frozen to the spot, I watched him greet Herr van Eyck in the doorway of the studio. The Master said something to the young minstrel, then bowed slightly to Anna before closing the door in her face.

Emilia hurried me down the remaining flight of steps, much faster than Anna could follow. Luigi was already waiting on the street, shivering in his cloak.

He bowed as we approached him. Emilia kept a firm grip of my elbow and, flashing Luigi her brightest smile, guided me onto the street. "Anna's coming," she told him. "We'll wait right here!" Then she steered me toward the stone balustrade of the low bridge arching over the canal.

"How do you know him?" she asked.

"I don't!" The cool air had cooled my cheeks and seemed to get the

blood flowing back to my brain. "I just saw his portrait upstairs. I was startled to see him in person."

Emilia look skeptical. "Yes, you did just see his picture; but now I realize you didn't just see his picture, you *recognized* him. That's why you blushed . . . and—" Emilia cut herself off as Anna's bulky figure emerged through the doorway.

"Don't rush so. . . . You young people rush too much. That . . . that . . . person, that rude person almost knocked me over."

"I'm sure he didn't mean to," I blurted, wanting to defend the stranger.

"He was obviously late for his work with Herr van Eyck," Emilia added quickly.

"What work?" Anna asked. Before I could say anything about him being Herr van Eyck's model, Emilia broke in. "Who knows?" she said, shrugging and flashing me a warning look. "All I know is that the weather has changed again, and the young mistress will surely take cold."

Indeed, the bright morning sky had vanished beneath a blanket of rolling, pale gray clouds and a stiff breeze blew across the canals. My blood was racing through my veins, and I felt hot as fire, not cold; but I pretended to shiver. In her own way Emilia was shielding me from Anna. It was best that Anna didn't connect my feverish appearance with my interest in the minstrel.

The next day, Thursday, Papa surprised me again: He decided I should fill in once more for my mother and accompany him and my aunt to the Merchant's Guild Hall on almsgiving day. After introducing ourselves at the guild, we would proceed to the guild's chapel or to a nearby convent

to distribute money, clothing, shoes, and some household goods.

Yesterday's afternoon showers had passed, and today a brisk wind chased sheep-wooly clouds through a pure blue sky. I was delighted to skip my lessons and spend the morning outside. I found myself wondering if the Merchant's Guild was located anywhere near the Painter's Guild, and Herr van Eyck's studio, and my minstrel. I had dreamed of him all night.

Carrying light baskets of provisions, Emilia and I trailed behind Zia and Papa toward the cloth merchants' district not far from our house. Pietro carried a heavy bundle of household goods and clothing, while Luigi brought up the rear, my father's coin purse heavy with florins hanging from his belt.

At the Guild Hall, several men were gathered outside its carved oaken doors. They were soberly but well dressed, with thick fur-lined woolen capes and fashionable tall black felt hats or turban-like *capuchons* protecting their heads from the cold.

For the first time since the duke's fête I remembered the men who'd slandered my father. Were either of them here? I'd only caught a glimpse of one of them, but then he had fixed his gaze on me, at least for a moment. What if he recognized me now?

I *did* recognize someone: Signor Arnolfini. At the sight of us, he quickly said something to his colleagues, then hurried down the cobbled street to greet us.

"William, you did come, just as you promised!" He heartily shook my father's hand and the two old friends hugged each other. Then he bowed to Zia and myself. As I started to curtsy, he took my hand between both of his and stopped me. He pressed my fingers and with a

warm smile said, "You look particularly lovely today, Giovanetta."

Coming from him the complement made me grin. "As do you, good sir," I teased, though inwardly I could not help but compare his rather pallid looks to those of my dark, dashing minstrel.

He exchanged some pleasantries with my father, who finally said, "After I introduce Giovanna to whomever you deem appropriate, I'll send her and Emilia to the convent with Pietro to drop off the clothing and to leave the food for the nuns."

Signor Arnolfini escorted our party to the door of the Guild Hall. Someone was walking out of the guild, and through the open door I could see that the large inner chamber was crowded.

"William," my aunt said under her breath, "there are no other women here. It doesn't seem appropriate for Giovanna, unmarried and not yet betrothed, to be paraded around in this company." Her unspoken suggestion was that it would be far too obvious that my father had brought me along to display me to possible suitors. Before I'd seen my minstrel at the palace, I might have been moderately pleased at the idea, for perhaps I'd have my chance to see if I fancied one man more than another.

Signor Arnolfini overheard my aunt. "Signora Clara has a point, William. Perhaps Giovanna can go with her maid and Pietro to the convent straightaway with their alms baskets."

My father nodded. "You may be right." Then he ordered Pietro to escort Emilia and myself to the convent adjoining the chapel next door.

A few minutes later we were met at the convent door by the portress, the nun in charge of greeting visitors.

"Good day," the sister said, and smiled at me. After I introduced myself and explained our errand, she said, "I'll bring Emilia and Pietro back

to the kitchen and storage room with the food. Meanwhile, you might like to visit the chapel. Then if you go through the side door you can visit the cloister garden. One of our roses is blooming in spite of the cold."

After the sister assured Pietro that I'd be perfectly safe unchaperoned in the confines of the convent, I went into the chapel. I paused only briefly to kneel in front of the statue of the Virgin and say several Aves, begging her to bless my mother and then adding humbly that if it were Mary's will, perhaps I could someday at least glimpse my troubadour again.

Then I made the sign of the cross and wandered into the cloister garden. It was chilly, but the high outer walls protected the brick-and-cobbled pavement from the wind. Trellises stretched up from the pavement of the courtyard to the pitched tile roof. One trellis bore a living vine climbing from a small bush in an earthenware pot. A foot or so up the trellis bloomed a single white rose. I left the cloister walk to get a closer look at the flower, blossoming so bravely out of season.

A fountain graced the middle of the courtyard. A stone angel pouring from a pitcher rose up from the center of the fountain. No water spouted from the pitcher, and curious as to what the inscription carved into the base of the fountain might say, I gathered my skirts and stooped down. I began to read the carved Latin words.

"'From this water the grace of eternal life . . .'," a warm baritone voice intoned from just behind me.

Startled, I straightened up and turned—to come face to face with my troubadour. I confess my jaw dropped and for a moment I just stood, confused, amazed, and wondering if I were dreaming. A heartbeat later I felt an insane mixture of joy and fear. What was he doing here?

He quickly reacted to my confusion by stepping back and bowing low.

Breeding and habit made me curtsy back automatically.

"Pardon, signorina, but I did not mean to startle you." His tone was apologetic, but his gaze was frank. I felt as if his eyes had somehow captured mine, and for a moment I was powerless to look away.

And then I remembered myself, my station, and my virtue: Here I was, a young woman alone with a young man unknown to me or my family—unchaperoned. "What are you doing here, in the confines of a convent?" I asked in Italian. I straightened up, and tucked my hands inside my sleeves to hide the fact they were shaking. I had hoped to sound firm and challenging, but instead my voice quavered as much as my fingers.

Keeping his eyes fixed on mine, he switched to the same pure Italian he'd serenaded us with at the palace. "I followed you."

A bolt of fear shot up my spine. I backed up and stumbled against the base of the fountain. He reached out and grabbed my forearm to steady me. His touch was warm, gentle, and brief. As soon as I was firmly on my feet, he dropped his hand of his own accord. It was then I noticed he was wearing a sword with a finely wrought hilt. The sword, the purity of his Italian, and the knowledge that he could read the Latin inscription on the fountain all betrayed the fact that he was no common street busker. He was, as Zia Clara had guessed the other night, if not of the nobility then at the very least of the upper merchant class, like myself.

"*Per piacere*, please signorina," he said, his fine features creased with worry. "Do not fear, I saw you at the palace the other night and never had a chance to learn who you were, or your name; but I could not forget

your face. And then yesterday, to have found you again, against all possible odds, on the stairway in the studio of Herr van Eyck. It feels like fate . . ." His words drifted off, and he lowered his eyes. "But I fear I am too bold."

I loved the fact that he was bold and had followed me. But at the same time I knew from both my mother's counsel over the years and from Emilia's stories of her adventures with would-be suitors that I must guard my virtue and my honor, no matter what my heart was telling me. "Indeed you were, good sir, too forward." This time I managed to sound as if I meant it though my heart was wild with joy—he really *had* noticed me the other night! I hadn't *imagined* that our eyes had met. I had felt he had been singing only to me, and now perhaps I could dare to believe he really was.

Looking back now, it seems strange how quickly I learned to dissemble when it came to matters regarding my minstrel. At the time, of course, I had no idea into what dangerous territory this first little lie might lead. Indeed, at that moment it seemed only right to protest his actions—for they *were* too bold. "You had no right to follow me here, and how did you get into this convent anyway? Men are barred from the cloister."

A small smile played across his lips. "True, but not from the kitchen. I simply came from Herr van Eyck's on an errand not so different from yours—almsgiving!"

"But you said you followed me here. From where, by the way?" I hadn't noticed him on the street, though I realized now his cloak was hooded.

"I followed you this morning from your house."

"How did you know where I live?"

He lowered his eyes and murmured apologetically. "I know this was wrong, signorina, but yesterday, you had barely left Herr van Eyck's house when I slipped away in time to see you hurry over the bridge. I followed you then, too. This morning I arranged to run an errand for Herr van Eyck, I waited outside your home for a glimpse of you." He paused. "But I spent a florin on bread and cheese for almsgiving on the way here—I wanted to make my errand honest."

Honest? The word troubled me. "It doesn't seem honest to follow a strange young woman to her house, good sir," I protested.

He dropped his eyes, lowered his head, and sounded penitent as he said, "I understand. I would not have had I another choice. But how else could I try to see you again?"

How else? A strange question with an easy answer, for his accent, his dress, his manners revealed he was from a background suitable to woo me. He or his family could approach my father through a go-between, maybe even Herr van Eyck.

But surely it would be too forward of me to suggest that? I glanced at him. His eyes were still downcast. His face was so perfectly formed, his skin clear and radiant with a healthy glow. In the full light of day he seemed even more well favored than in shadowy stage light, or in the dim passageway leading up to the Master's studio. I was spellbound by his appearance, but was this young man all that he seemed? The doubt began to mount, and I started to turn away from him and toward the chapel.

He reached out and caught me by the wrist. His touch was light, but it burned through my thick cloak like fire.

I caught my breath, and for a moment kept my back toward him, then he dropped my wrist.

"*Perdona*," he whispered, and stepped back quickly. "Forgive me. I do not mean to be so forward, but you must not leave me like this. Understand I do not mean to frighten you, or dishonor you—you are too fine and pure and lovely a creature."

No one outside of my family and Signor Arnolfini had ever called me "lovely" before. I turned back to face him. He looked so earnest and worried, all my doubts vanished like a morning mist.

In a low, urgent tone he went on. "I must leave Bruges soon. Had I known I would see you here I would have begged off my duties . . ."

"For Herr van Eyck."

The minstrel looked startled. "What makes you think . . ." He broke off, and then nodded. "Yesterday, of course, you saw me going into his studio." He cleared this throat. "Sometimes I am in his service." He seemed strangely reluctant to admit this. For the life of me I couldn't imagine why. Were I a young man I would practically sell my soul to be the Master's apprentice, or to serve him in any way.

The minstrel finally shrugged. "At times I travel with him, depending on where his business takes him. Other times I have to travel on business of my own. . . ."

"Other fêtes to attend in other courts?"

Relief washed over his face. "Yes." After a pause he added, "I've been called at times to courts in Lombardy, Tuscany, and Spain. Even Portugal."

"So many places, all so far away," I said.

"Which is why, sweet lady, I had to see you today. For I leave within the week with Herr van Eyck and then continue on my own to Portugal. And the thought of not finding you, seeing you again and at least learning your name . . . so I . . ."

I thrilled to his words. I told myself that surely upon his return to Bruges he or his family would formally approach my father. Then I realized that he had stepped closer to me. This time I did not back up, and not because I would have stumbled again against the base of that fountain. I wanted him to stand closer to me. Far closer than a proper young woman should permit. I found my lips rather close to his, and I could smell the sweetness of his breath. My name was on the tip of my tongue when Emilia's hearty laughter rang through the convent hallway leading toward the courtyard.

We sprang apart. "I must not be discovered here!" he cried. I saw his hand drop to the hilt of his sword. "It will look bad for me but worse for you to be discovered with me unchaperoned."

"Where will you hide?" I cried, looking around. The winter sun was low in the northern sky though it was barely noon, but the shadows in the cloister walk scarcely seemed deep or dark enough to hide him.

He didn't answer. Instead he grabbed my hand; and though we both were gloved, he lifted my hand and brushed my fingers to his lips. "Farewell for now. Look for me. I will somehow find you again . . . as soon as I can."

With that he ran across the cloister courtyard, climbed up a trellis, and scrambled over the roof. He paused, blew me a kiss, and repeated: "I will see you again, as soon as I can."

Then he vaulted over the wall, loosening several of the roof tiles. They slid down and shattered on the cobblestones near the trellis.

I stared after him and for a moment felt as if I'd had some kind of waking dream or vision. Yet when I put my hand to my face, I could smell the faint scent of his perfumed glove. Mother Mary had answered my prayer and sent me the minstrel, but how would the Virgin feel about

him sneaking into the confines of a convent? Or about him kissing my hand?

"Did you find your roses?" Emilia's voice jarred me back to reality.

I turned and saw her and Pietro sauntering toward the fountain, where I stood almost as frozen in time as the stone angel. "The roses?" I shook my head. "Yes. But there's only one."

"What happened here?" Pietro asked, skirting the tile shards that littered the pavement.

"The wind must have knocked them off last night," I suggested, then tried to divert Emilia's attention by heading over toward the single blooming rose.

"Odd," she said, after a passing glance at the blossom. She walked over and kicked at the broken tiles. "The nuns are so house-proud. I'm surprised they left this mess here."

"Probably just haven't gotten to sweeping up the courtyard," Pietro said. He shrugged and started back toward the open chapel door.

"Probably," Emilia repeated. But I avoided looking directly at her. I might be able to dissemble in front of my father or Zia Clara, but Emilia had the uncanny ability to know when I told even the smallest white lie.

Fortunately at that moment Pietro's chatter distracted her. As I followed them through the open chapel door, I glanced back over my shoulder—at the trellis, the roof , and the convent wall. The troubadour had vanished before he had a chance to learn my name.

And I hadn't learned his either. The man who kissed my hand remained a stranger.

Winter Oranges

Luigi and Zia Clara met us inside the chapel. A guard dressed in Signor Arnolfini's livery was with them.

"Your father has gone ahead with Signor Arnolfini to his house," Zia Clara said, blessing herself as we passed the statue of the Virgin. "We're to join them there for some refreshment."

"It's not far," Luigi told me, "just on the other side of the cloth market, where your father and Signor Arnolfini trade their wares and meet with other vendors."

I simply nodded, only half taking in their words, for I cast a wary eye up at the statue of the Virgin and silently prayed she would understand: The minstrel's kiss had been chaste, even though the feelings it stirred in me were not. His intentions, I was sure, were pure. He would find me again and, hope against hope, when he revealed who he was, would be able to approach my father and ask for my hand.

A short walk brought us to the square that housed the cloth market. It was not a market day, and few stalls were open.

"Is something wrong, signorina," Emilia asked, as we passed under

the arch leading from the square to a street that curved along a narrow canal. One side of the street was lined with the narrow, peaked-roof town houses that seemed typical of middle-class dwellings in Bruges.

"Wrong?" I repeated.

"You've been uncommonly quiet since we left the chapel," she said. "Did something upset you there . . . or in the garden?" Her question seemed innocent enough, but I grew wary.

I laughed lightly. "What in the world could upset me in a cloistered garden?"

Emilia just frowned. "I have no idea. . . ."

I improvised, keeping my voice low so Zia Clara wouldn't hear. "This is the second time this week I have to accompany my father in Mama's stead. It feels strange. I'm not used to these duties. I feel, well, too inexperienced, that I will behave badly, say the wrong thing, embarrass my father."

"Are you serious?" Emilia scoffed.

"I was petrified he'd make me go into that guild hall. I've never been in the company of so many strange men."

Emilia chuckled. "Not an opportunity I'd turn down, not in your shoes. You're marriageable now, you know that. Might as well see what the world has to offer . . ." She paused, then sighed. "Not that you'll have much to say about it."

"Papa promised me, when I was little, I'd never have to marry a man I didn't like."

"Promises are not always kept."

Her words chilled my very bones; but before I could respond, Zia Clara turned to us and said, "We seem to be here!" She motioned toward

a corner house. It was twice as large as any of the others and boasted a tall brick enclosure. Signor Arnolfini's man knocked, and the wooden door swung open to reveal a large inner yard. Part of it was devoted to a modest stable; part was a storage shed with bales and bundles of goods stacked alongside great wooden kegs and trunks somewhat protected from the elements by the shed's roof. Beyond was a half-opened door that apparently led to a business office.

To the left of the shed an open door revealed a stairway leading up to the next story of the house. As seemed to be customary in Bruges, living quarters were often situated above a person's place of business.

A maid stood at the foot of the steps and hurried over to greet us. She introduced herself as Mattie and said she was the daughter of Signor Arnolfini's cook. "Grete, Signor Arnolfini's housekeeper, is visiting relatives this fortnight," the young maid explained. "I usually work with my mother in the kitchen."

"It's practically a palace!" Emilia exclaimed.

Zia overheard her and shook her head. "Barely, but Signor Arnolfini is one of the wealthiest merchants in Bruges. His family moved from Lucca when he was very young, and his business is well established. He can well afford to own a house this size."

Luigi, Pietro, and Signor Arnolfini's guard went through the workrooms to the back of the house. But Zia motioned for Emilia to join us as we followed Mattie up the steep, narrow staircase.

Mattie opened the door to the house and led us into a broad vestibule. She took our cloaks and motioned for us to enter the living room. "Signor Cenami and my master will join you shortly. Meanwhile, I will bring some hot beverages. Please warm yourselves by the fire."

Immediately after Mattie left the room, my aunt exclaimed, "Though I've visited Signor Arnolfini's apartments in Paris, they did not prepare me for this elegance!"

She touched my arm. "Giovanna, that tapestry over the mantelpiece—it is as fine as anything I have ever seen."

My eyes were drawn to the tapestry, and I observed the extraordinarily brilliant dyes of the wool and silk threads, as well as the generous use of pure gold fiber, the kind usually reserved for royalty or for the vestments of bishops.

Emilia just gaped at the tapestry. "So much wealth. So much gold. So many beautiful things!" she said, gesturing to the entire room.

She was right. A thick, elegant rug covered and warmed most of the gleaming floorboards. The wainscoting was fashioned from panels of wood cleverly inlaid to depict stages of the cloth merchant's trade: peasants shearing sheep, ships bearing cargo, women spinning, weavers at their looms, tailors making garments, and even a replica of a cloth market like the one we had just walked through. Oddly enough though the furnishings were sumptuous, there was a warm, cozy feeling of home about the place.

"Why, he's richer than your father!" Emilia finally exclaimed.

"Emilia," my aunt chided sharply. "Hold your tongue. It is not a servant's place to comment in front of her betters about such things."

"Sorry, Signora. I didn't not mean to speak out of turn. I just have never—"

"Never mind what you have never," Zia interrupted. "I must say, I am quite amazed myself. Your father will be pleased to see his friend has such a wonderful home." She looked at me when she said this. I had no idea why.

But obviously Emilia did. She quickly glanced at me, her eyes wide.

Mattie returned bearing a tray bearing plates of bread and cheese and a bowl full of oranges. One of the kitchen boys followed close behind. He carried a heavy pot, which he hung from the hook over the fireplace. The savory aroma of a rich meat broth curled up out of the steaming cauldron. Another servant carried a flagon of wine, and a tray of goblets.

The trays were placed on an elaborately carved side table. As Mattie began to pour us all some warm wine, Signor Arnolfini and my father finally arrived.

"Giovanni, the description you've given me of your establishment—your office, your living quarters—don't do them justice," my father remarked, lifting his goblet to toast his friend.

"I've done well for myself," Signor Arnolfini admitted. "And I'm grateful to the Lord for what seems to have been a lucky and full life . . . in most respects."

Signor Arnolfini motioned for us to sit down on chairs his servants had drawn up closer to the fire. Emilia hung back until he offered her a chair. "It is too cold and damp outside to stand on ceremony, my dear girl—or to keep standing at all. Sit, Emilia."

Surprised, she curtsied, murmured "*Gracia*, good sir," and sat on the edge of her chair. Her eyes widened even farther when Signor Arnolfini bade Mattie offer her an orange. I wondered if she had ever tasted one. They were so dear that only the wealthy had them on feast days, holy days, and very special occasions. Servants, even in our house, seldom got to partake of such treats.

For my part, my stomach was fluttering too much for me to eat. I sipped the warmed wine and a little of the broth Mattie had ladled out of the caldron. But I couldn't have swallowed a bit of the cheese,

bread, or even the slices of orange that were offered to me.

Fortunately my aunt, Papa, and Signor Arnolfini seemed not to notice that I didn't join in the conversation. While they talked, I was reliving every glance, gesture, and word the troubadour and I had exchanged in the cloister garden.

I have no idea how much time passed before we finally took our leave of Signor Arnolfini. He saw us downstairs to the outdoor gate. "I hope to see you all again, very soon," he said.

"Would you like to come for supper tomorrow?" Papa suggested.

Zia Clara readily added, "I'll tell Matilde to expect company."

Signor Arnolfini rubbed his hands together. "Ah, I've always loved dining at your house. Your cook is a magician in the kitchen."

As my father and Zia Clara headed out the gate, Signor Arnolfini reached for my hand. For a moment I thought he would kiss it. Instead he just pressed my fingers and bowed to me.

Abruptly I pulled my hand away. He straightened up, looking confused and a little hurt.

I colored with shame. "I look forward to tomorrow," I muttered, then quickly started down the street.

Emilia materialized at my side. "What's the matter with you?" she asked in a harsh whisper. "How could you be so rude to him of all people?"

I stopped. "Emilia, it's not your place to tell me that I am being rude."

My tone didn't trouble her. She gripped my arm. "Someone has to. You didn't speak to him the entire time, and he offered us, of all things, oranges! How can you ignore him like that? He's a very rich, very well-connected man—who is exceedingly close to your father.

In your shoes I would go out of my way to court his favor."

"What *are* you talking about?" I shook her hand off my arm. "He's an old family friend. I don't need to court his favor. I'm getting too old for him to treat me like a child, and for him to take my hand."

"Treat you like a *child*?"

"As he did at the duke's the other night." Abruptly I stopped walking and faced Emilia. "I don't have to explain to you. Remember your station!" I commanded.

"My . . . my station . . ." Emilia looked crushed.

I bit my lip, wanting to bite back my words; but some inner voice warned me I could not trust even Emilia's friendship when it came to keeping secret my encounter with the minstrel until he had a chance to approach my father.

But my heart, which had been so full of joy since I'd left the convent chapel, suddenly was troubled.

Ruined!

The next morning Matilde sent me, Emilia, and Anna off with Zia Clara to the market to purchase the food for the dinner Papa had promised Signor Arnolfini.

I had resisted the trip, but Zia had insisted that it was about time I began to hone my skills as a good housewife. Even though women of my station had maids, cooks, and servants, we were expected to manage the daily household expenses and supervise the workings of the kitchen. It seemed I was even to learn how to haggle with fishmongers, butchers, and bakers.

Sandwiched between our escorts, we hurried to and from the market square beneath a lowering sky. We barely reached our front door, when it started to pour. But the cloudburst outside paled beside the tempest brewing inside my father's study

"Ruined . . . I'm ruined!" I heard him bellow as I shed my cloak.

Still clutching hers, Zia Clara started for the study, but when she realized I was still in the vestibule, she turned to me. "Giovanna, go to your own chamber. Now." Seldom had my aunt given me such a firm order.

"But, Zia, what is . . .?"

"Now!" she insisted. Her tone broached no argument. Immediately I curtsied to her and made for the stairs with Emilia at my heels. Before I was out of earshot, I heard my father's voice, even louder than before. "Ruined!" he cried. "With one stroke of his pen, he's ruined me!"

His words froze the very blood in my veins and my legs seemed to turn to stone. I stood on the stairs and looked at Emilia, her eyes round with shock.

Then the study door slammed, and we both scurried up the remaining steps and into what felt like the safe harbor of my chamber.

For a few moments we were both too stunned to speak. Emilia's hands were shaking as she removed my head gear and carefully spread the veil on a drying rack before the hearth. Then she helped me remove my damp shoes. Only after she installed me in a chair in front of the fire and rang for some hot mulled wine did she break the silence. "Signorina," she said, not calling me by my name. "What's happening? What does he mean by 'ruined'?"

Of course, I was certain that *ruined* meant some terrible financial disaster had struck our family. What if most of our household staff, including Emilia, were sent packing? And I was tempted to share my thoughts and fears with this girl who for four years had been my only friend. But I realized that for the second time in days, I had to treat her as a servant and not a friend. I had to wait and learn from my father what was really going on, what had and would happen to all of us. I couldn't contribute to the kitchen rumor mill and street gossip.

"Emilia, I think we will hear everything by and by," I finally answered.

"'By and by'?" Emilia stopped midway in pouring the wine. "Is that all you can say?"

It wasn't, but I suddenly felt protective of my family. Reminding

myself that though I loved her, Emilia was not my equal but my servant. "Remember your place," I snapped, sounding like my father.

Emilia's lips parted; but before she could utter a retort, the door to my room flew open and Zia Clara burst in. Zia's expression frightened me. I stood up and Emilia curtsied, but not before she shot an angry look in my direction.

"Leave us!" my aunt commanded. Her whole air was agitated, yet her eyes sparkled with excitement.

Zia waited until Emilia had left, then pulled a chair near to where I was standing. Before she sat, she reached out and gently cupped my face in her hands. The gesture reminded me of my mother, and unbidden tears rose to my eyes.

"Have you thought much about marriage, Giovanetta?" she asked.

Overly much the past few days, I replied inwardly. Outwardly I simply asked, "Why all this talk about marriage suddenly? I thought you agreed with Mama that I'm not to marry until I am sixteen. And—"

"Your cousin Francesca wed at fifteen; and once the betrothal is set, we can postpone the wedding for several months, if we feel it is necessary."

Betrothal? Wedding? My aunt was speaking as if my father had already selected a suitor—someone old and rich but possibly fat, possibly unkind—perhaps even cruel in the privacy of his home, once he had secured himself a wife with a generous dowry and a lavish marriage chest.

She gently touched my shoulder before she sat next to me on the bed. "Don't fear, your father has chosen well."

"My father has already chosen?" After hearing my troubadour sing the soulful plaint of unrequited love, after meeting him in the garden, after him kissing my hand, my whole being was stirring with powerful new sensations. The thought of spending my life with a man who did not

evoke the same feelings, who I did not—dare I use the word?—*love*, horrified me.

Surely this was a bad dream. Any minute now I would wake up to a new day where the word *betrothal* had not been uttered.

My aunt's smile widened. "Yes—and you are a lucky girl."

I jumped up and stared down at her. "Lucky? How can I be lucky to be married to a man I haven't met—to be *bedded* by someone I might despise, to spend a life bearing children so that some man's name and lineage might continue. I'd rather die—or join the convent."

The words no sooner passed my lips than the door flew open and my father strode in, followed by, of all people, Signor Arnolfini. I curtsied, and kept my head down so that he would not see the tears streaking my face.

My father didn't even bother to look at me. Instead he addressed Zia Clara. "So you've told her," he stated rather than asked. His voice was tight, with barely suppressed fury.

Keeping my face lowered I glanced up. My aunt looked cautious. "Not yet—not everything."

Signor Arnolfini took a step backward toward the door. "Perhaps I should return later."

"That won't be necessary," my father said, but Zia Clara intervened.

"Actually, it might be better to wait in William's study," she suggested to Signor Arnolfini.

Before he exited, he bowed in my direction, his expression troubled.

"I'm afraid the idea of marriage—so soon—was a bit of a shock." Zia closed the door behind him.

"Considering this is a day of so-called 'shocks,' I think young Giovanna here can weather it." Papa said to her.

Then before my eyes my father's bravado vanished, if only for a

moment. For the first time in my life I saw him looking tired, and defeated.

"What happened, Papa?"

He went over to the fireplace and leaned against it. When he turned around, his face was stony again, betraying little emotion. "Better you hear the truth plain and simple before the gossips get to embroider it.

"We've lost everything. Well, not *everything*, but I had invested heavily in this last shipment of dyestuffs from the East. Part of the shipment was headed for Lyon to the last fair of the season."

"You are going to be traveling there at the end of this week," I said.

"The caravan carrying our goods was ambushed on the road from Lucca. By some trick of fate—or so it seemed until an hour ago when news arrived here via another trader's vessel, the merchant ship laden with my fabrics and dyes was boarded by pirates. They looted it before it was set afire and sunk near Gibraltar." My father sat heavily on a bench, and put his head in his hands. When he looked up his visage was a mixture of anguish and fury. "Had this been the will of God, I would be angry but accepting—no one can change fate. But it was the hands of my enemies that were behind this. The proof was before my eyes at the palace, before I even received the bad news this morning. The Grimaldis are behind this. Sources in my employ have brought me evidence."

"The Grimaldis?" I gasped. I sank down onto the edge of my bed. I closed my eyes. I prayed that I had misheard the name. Were these the same Grimaldis who had accused my father of poisoning one of them?

I realized this was a chance to hear my father's side of the story. "They bear you some ill will, but why?"

Papa's reply was swift. "Because they are scoundrels at best. At worst

they are liars and would be murderers." He frowned. "I have tried to shield you from the shadier parts of my business dealings . . . coping with rival families' spies, and schemes to undermine my success."

Zia said softly, "Better to know your enemies, William, than pretend that they don't exist. If Giovanna is to associate with people at court, she will surely encounter members of the Grimaldi clan—here in Bruges if not in Paris, and certainly in Lucca, if she travels back home."

Lucca. How could she call it home? I'd never been there, or anywhere in Italy for that matter. But at the moment I didn't give a fig for Lucca. I did about the Grimaldis. If my father was ready to admit they were our enemies, could the rumors possibly be true?

I forced myself to face my father. "What have they done to you? And what in the world does all of this have to do with me?" I demanded to know.

"What they've done to me isn't fit for a young woman's ears to hear. But as for you, my lovely girl, you are money in the bank so to speak!" my father declared.

"William!" Zia Clara cried out. "Have you no sense?"

My father laughed tightly. "I'm a plain-spoken man. That's the truth—and don't look so shocked. But, let me explain. Giovanna, until today I had hoped that I might negotiate a better marriage arrangement for you. However, because of what has transpired, my creditors—among them, by the way, the Grimaldis—are at the door. They are demanding that I pay off my notes, claiming that until I can rebuild my inventory of fabrics, dyes, and raw materials I am a poor business risk. They have all called in my debts, which I must pay within the fortnight. The one hope is to move your betrothal forward. There is one suitor who will not only

guarantee my debts and loan me, without interest, funds to tide my company over this crisis. He will also accept a reduced dowry because he is already exceedingly fond of you and, I must add, of our family's lineage, which far surpasses his own."

I pressed my hands to my temples. It was all too much to take in. The fact that our family had a powerful enemy out to ruin us; the possibility that my father might be as much to blame in some kind of feud as his rivals; above all the horror of being forced into a betrothal before my father had a chance to meet my minstrel. And now Papa was set on a quick betrothal.

Finally I looked with desperation from my aunt back to my father and cried, "But there's been no betrothal!"

"Oh, but there has been a negotiation, one I have dallied with, I must admit, in the hopes of connecting you with someone from more courtly circles. But your would-be betrothed has come to my rescue and, I think you will feel, to yours as well. He is no stranger to you, nor to our family, and—"

In a flash I knew—our visit to his house, the way he touched my hand as we left yesterday, Papa formally inviting him to dinner tonight. "No, not Signor Arnolfini!" I reeled back, shocked. Then, for the first time in my life, I felt the blood rush from my head, my legs buckled, and the room spun around me.

The next thing I knew, Zia was kneeling by me, pressing a handkerchief soaked with some violently strong and vile-smelling spirits under my nose. I struggled to push her hand away and to sit up.

My father commented. "Pull yourself together, girl. I can't believe the very name Arnolfini sends you swooning."

The very implication in his voice, that I was faint because I wanted to marry this family friend, truly offended me. I pushed my aunt aside, and struggled to my feet. Gripping the back of a chair I straightened up and looked my father in the eye. "Signor Arnolfini is indeed a family friend, but if he is such a friend, then he should offer to help you without the promise of my hand in marriage—because I *will* not marry him."

CHAPTER SEVEN

A Twist of Fate

Stunned, my father's eyes widened. In the time it took for his face to register total disbelief, I scurried out of his reach. Zia Clara quickly stepped between us, for sure as the day is light his next reaction to my refusal to marry Signor Arnolfini would be to strike me.

"William!" My aunt put her hand on her brother's forearm. "Please. The girl is in shock. She doesn't know what she's saying."

He pulled away from her but did not advance toward me. He simply stared at me so hard I could practically feel the fury in his eyes. "You dare to disobey me? Or perhaps I didn't make myself clear. You *will* marry Giovanni Arnolfini. With or without your consent I will go downstairs now and set the betrothal date. It will be within a fortnight, once the banns are announced in the church."

"I can't!" I cried. "I can't marry *him*."

My father crossed his arms against his chest and said with a short sarcastic laugh, "Oh? And if not him, who?"

"I—I don't know who," I answered, which was the truth. I knew who I dreamed of marrying; but I didn't even know his name.

However, my expression must have betrayed something because Zia

Clara shot me a quick warning look. Then she ordered my father to leave us. "William, Signor Arnolfini is still waiting downstairs," she reminded him. "Let me talk to the girl. I'll explain things. "

Grumbling to himself, my father left. My aunt closed the door behind him, then motioned for me to sit down. "You do know you have little say in all of this," she said, joining me in front of the fire.

"That's not fair."

"No. It's not."

"How can you be so matter-of-fact about it?"

Zia Clara motioned me over to her. Taking both my hands in hers, she bid me sit down on the carpet next to her chair. "I am not so much older than you," she said. Her husband, Uncle Guido, was much older, nearly my father's age. My aunt continued. "So I recall the terrible feeling when my father first told me about my betrothal—to a complete stranger. I was to spend the rest of my life with a man I'd never met, who was far older than me and who, for all I knew, might not even like me—nor I him!"

"And as it turned out . . ."

"You don't have to say it. As it turned out, we have managed together rather nicely and have even become fond of each other. But no, he is not who I would have chosen either, and I had more experience in the world when I was betrothed than you do now."

"True, but couldn't you have said no?"

"I could have, but my father was as inflexible as yours. After all, your father—my brother—is my father's son. He's inherited his father's temperament. In fact, you've been lucky. I know he hasn't struck you often. My father beat me with great regularity."

I must admit my aunt was right. Somehow I had managed to escape most of my father's wrath, at least the physical part of it. He shouted at

me at times and twice he did strike me, but other girls, such as my cousin Francesca, were regularly beaten by their parents.

"But a person should have a choice as to whom to marry," I insisted.

My aunt just shrugged. "Should? Shouldn't? I don't know. Besides, how would you, at almost fifteen, make such a choice? What young men do you know except for the servants?" Her question was casual, but I sensed I must not reveal to her my feelings for the minstrel.

"I don't know any other man. But Signor Arnolfini—he's practically like a father to me."

Zia smiled slightly. "He is too young to be your father, unless he had married unusually young himself. There is good reason for men to wait until they are his age or older to wed. They must become established in their business affairs so they can support a household—certainly in the way to which you have been accustomed." She fell silent.

Before speaking again, she seemed to be weighing her next words carefully. "Since you are now old enough to marry, I will be frank about the situation of women of our station. If in time you are not happy with your—with your . . ." She paused to search for the right word, and added, ". . . with your companionship, women of your station, if they are discreet, may find other friendships with more sympathetic gentlemen."

I gasped, "Surely that would be adulterous. Surely that would be sin! You and my father would condemn me to a life of sin, and grievous punishment in the life hereafter, simply to see me wed a man because he can salvage our family fortunes?"

"It is no more of a sin than that of disobedience to your father!" she retorted. "But it would be your choice to sin or not . . . if that's how you regard such a dalliance."

I didn't want a "dalliance," as Zia put it. I wanted to spend my life

with someone who touched my heart as my minstrel did. I wanted to spend my life with him, impossible as that seemed at the moment.

I turned to Zia and pleaded for her to understand. "I've known him all my life, Zia. I can't love him—not as a wife should love a husband." I shuddered at the thought of him kissing me in any but a friendly fashion.

Zia lifted her eyebrows. "He told me that at the palace you were willing to pretend to be a married couple as he escorted you through the crowd at the fête."

I groaned and scrambled to my feet. "That was play acting. I was joking. He knew that."

"Ah, but your father had already spoken with him and he had agreed to the betrothal. All that has changed is the timing. Your mother—and I, for that matter—felt it would be good to wait another whole year, until you were at least sixteen, before marriage. Your father acceded."

"Probably so he'd make a better bargain," I countered angrily. "I will not marry that man. I want to marry someone who pleases me, whom I love, who—who—can sing. Signor Arnolfini's voice sounds like paper when he speaks and he can't carry a tune!"

"What does singing have to do with marrying someone?" Zia asked. Then horrified, I watched realization dawn on her face. When would I learn to mind my tongue? "Oh, so that's what ails you," she exclaimed. "That minstrel, the one at the fête with the big eyes. My dear girl, Cenami women don't marry so far below them, let alone you with your mother's blood. And then, considering who he is—"

"Who he is?" I grabbed my aunt's arm. "You know his name?"

Zia pulled away from me. "I told you he looked familiar, and yes, now I do know who he is; but it's up to your father to fill in the details. For now, the sooner you wipe that young scoundrel out of your mind,

the better." She paused. "Consider yourself lucky. Signor Arnolfini may not be able to sing like an angel, but he certainly has the heart of one. Your father might have chosen far worse just to make a more advantageous match. His sudden misfortune has turned out to be your good luck."

At that moment there was a knock on the door. Emilia poked her head in and said, "Pardon, Signora Clara, but Signorina Giovanna's father would like her to come downstairs now."

I gathered my skirts and marched out of my room. In my mind I quickly rehearsed what I would tell my father.

In the hall, I took a deep breath, threw back my shoulders, and yanked open the door to Papa's study. I stormed in, not even bothering to bow. I opened my mouth to speak and then realized that Signor Arnolfini was still there. He turned to look at me. The sight of the smile that lit up his thin face wiped my prepared speech right out of my mind.

I quickly dropped into a deep curtsy, more to hide the blush on my face than to appear penitent in front of my father, for though the sight of Giovanni Arnolfini had surprised me, the thought of how my decision would hurt this old friend had not changed my mind. I *would not*, I *could not* marry him.

It was Signor Arnolfini who hurried to my side and made me straighten up. "Please, Giovanetta," he said, using the old affectionate diminutive of my name. "Such formality between us is not necessary."

I freed my elbow from his hand and avoided his eyes. Sidestepping him, I faced my father. "I did not know Signor Arnolfini was still here," I told him. "You should have warned me."

My tone of voice told my father all he needed to know. "You would speak to me with such disrespect?" He glared at me, and I glimpsed his clenched fist inside the deep scalloped sleeves of his long, belted tunic. In

the half hour or so since he had left my room, his anger had intensified.

Frightened, I told him, "I mean no disrespect."

Signor Arnolfini stepped closer to my father. "William, perhaps it would be better if I leave now. Obviously Giovanna is startled by my proposition—she is young. Let's give her some time to reflect on her decision. I can just as easily come back tomorrow. In fact," he added as the church bells chimed the noon hour, "I have a meeting with a client in the dyers district. I'll return for dinner tonight, as promised, and then again in the morning. I do not ride for Lucca until the next day."

With that he bowed to me, his eyes filled with sympathy, and, something else I didn't quite understand at the time. Then he departed, leaving Papa and myself alone.

Papa waited until he heard the front door to the house thud shut before he spoke. "Today or tomorrow makes no difference, girl. You will marry him, and the betrothal will be formalized and contracts drawn up before he leaves for Lucca in two days."

I was incredulous. "You are ready to marry me off in two days?"

"A formal betrothal will be set. The wedding can wait until spring."

"A betrothal is as good as a marriage. You know that!" I started for the door. My father barred my way. Undaunted, I glared up at him. "There will be no wedding, now or in the spring."

"You have a day to think this over, Giovanna."

"One day or one year won't make any difference. You cannot force me into the bed of a man I do not want to spend my life with."

"Can't I?" His voice was quiet and uncharacteristically dangerous.

But I would not back down. "Papa, you—"

"You will be his bride with or without your consent. Still, it would be better for all of us if you were agreeable to this match. Go to your

room and pray and think about this. It's your duty as my daughter to do my will, and I *will* have you marry Giovanni Arnolfini."

With that he rang for Luigi and instructed him to take me to my room and lock me in. "I don't want that fool girl Emilia anywhere near her. If she needs something, her aunt or Anna will get it. Meanwhile tell the cook that Giovanna's to have nothing to eat or drink but dried bread and water until she comes to her senses."

"I'll starve first!" I declared as Luigi led me away.

Of course I didn't starve. Our cook, Matilde, thought bread and water was exceedingly harsh punishment for a girl my age. My aunt must have felt the same thing, for she pretended not to notice that I was well supplied throughout the day with various sweetmeats, bread, and cheeses.

I didn't see Emilia until the next morning. My aunt had convinced my father that I needed my maid to help me dress and arrange my hair.

As soon as Luigi locked the door behind her, Emilia stood at the foot of my bed. I was sitting with the covers pulled up to my chin. I realized it was the first time that we'd been alone since I'd begun speaking to her as if she were simply a servant and not a friend.

At the moment what I needed was a friend and not a maid, even though I was positively hopeless arranging my own hair. But Emilia continued to stand there, her lips pursed, her hands hidden by her sleeves. Finally I couldn't stand the silence. I felt as if I were part of some strange tableau. "Emilia, I'm sorry. I was harsh with you yesterday . . ."

"That you certainly were, signorina," she said quietly. "You've never spoken to me that way before, though I am often out of line, as Signora Clara would say. What have I done to offend you?"

"Offend me?" I jumped out of bed, grabbed my gown, and marched

over to her. "Nothing. It has nothing to do with offence. It's just . . . it's just that when it comes to my family and my father's business, I can't share everything. Besides, I knew nothing about what was happening, and even now that I do I can't share it with you."

Emilia shrugged and the shadow of a smile played about her mouth. "No need. Gossip is all over town. Your father's business rivals have done him great harm. Talk is, he'll find some way to survive it."

I closed my eyes. "Yes. He already has." But again I was afraid to share more.

"You mean your betrothal? You could do worse, Giovanna."

"So everyone tells me," I said, drawing closer. "But, Emilia, for the sake of our friendship, can we just not talk about it now?"

She looked crestfallen but took my hand. Her next words were spoken with more than a hint of her usual good cheer. "I promise, my lady, that I will swallow my questions, even though in matters of my own heart I have been more than open with you."

"A betrothal to Signor Arnolfini is scarcely a matter of anyone's heart!" I replied wryly, wishing, and not for the first time, that I had my maid's degree of freedom when it came to courtship.

As she helped me dress, we chatted lightly about the household. At one point Emilia apologized. "Sorry I couldn't bring you more than just some cheese and water this morning. The house is in an uproar. Your father is storming back and forth from the supply rooms and kitchen to his study and his chamber. It seems he is preparing to leave on a trip."

"To Lyon," I told her, as she helped me fasten my bodice over my shift. "He's planned this journey for weeks. It's the last big trade fair of the year before winter. Now, of course, he is going only to see if he can salvage his reputation with clients and the bankers assembled there."

Emilia looked up from straightening the coverlet on my bed. "What business does Herr van Eyck have there?"

"Herr van Eyck?"

Emilia nodded. "He's going to Lyon too. Johan, the apprentice we met at his studio, stopped by the kitchen to warm himself and said that his master was leaving tomorrow with his escort. He has business in Lyon before heading to Spain."

"Why is Johan in the kitchen?"

"Herr van Eyck is with your father." I had no idea what business the court painter could possibly have in Lyon and I didn't care. But the news that he was in the house now, *with* an escort, raised my hopes. Could it be the minstrel was with him?

Emilia braided my hair, coiled it on top of my head, and covered it with a modest short veil. While she talked about how attractive Johan was, and witty in spite of his hands being as stained with color as those of a dyer's apprentice, I hatched my own plan.

I interrupted her babble and asked her to take a message to my father. "Can you go to Papa and tell him that I need to speak with him and would like permission to come down to his study?"

Emilia's big dark eyes first widened, then narrowed. "What are you up to? Don't tell me you changed your mind about Signor Arnofini?" She almost sounded disappointed. I knew she thought me brave to defy my father. "He's got to be the richest merchant in Bruges. Imagine oranges in the middle of winter . . . enough to give me one too. I'd have him in a second, with or without those marriage vows," she declared. She grinned at me. "Now wouldn't that be something, to be bedded by such a man and cared for the rest of my life—me and the child."

"You have a filthy mind, and a lot of imagination," I told her.

"Maybe, but at least I know a good opportunity when I see one, unlike you, good mistress . . . unless you have changed your mind and are being coy about it?"

But just then I had no intention of indulging her curiosity.

"My decision is none of your business," I said, a bit too sharply. Emilia wore a hurt expression as she left the room to do my bidding.

I checked my image in the hand mirror and pinched my cheeks until they were pink. I only wished I had dressed that morning in a more becoming undergown of golden yellow or blue.

A few minutes later Luigi knocked on my door to fetch me to my father. I straightened my veil, then swept past my would-be jailor and marched with dignity down the steps. Halfway down, I wondered: Why was Herr van Eyck visiting my father in the first place? At the fête I had gathered that he was acquainted with Papa, but my father had never mentioned him to the family. And Papa had the very boring habit of bragging about every notable or famous person who crossed his path.

Outside the study I stopped and said a quick prayer. Before I could knock the door opened. Herr van Eyck was on his way out. Behind him, holding his fur-lined outer cloak, was a servant I hadn't seen before.

"Ah, here is the girl now." Herr van Eyck bowed his head to me, and after a second's delay, I curtsied.

"Good morning," I greeted him, craning my neck to see if anyone besides my father and Herr van Eyck's servant stood inside the entrance to the study. Indeed there was Signor Arnolfini.

After exchanging a few final words with the painter in the hall, my father bid him farewell, and came back into the room. Meanwhile I stood awkwardly just inside the entrance, trying to avoid Signor Arnolfini's eyes. Thankfully, unlike my father, he seemed to be able to read my

moods and respect them. He didn't say anything or come close to me, but the small smile that tugged at his lips did unnerve me.

"I understand, Giovanna, that you've come to your senses," my father declared as he approached the desk.

"I—no—I haven't changed my mind." I heard Signor Arnolfini sigh.

"William, I told you it was too soon." Signor Arnolfini ventured.

"It isn't too soon," Papa snapped. He took my arm and held it hard enough to hurt. I pursed my lips and met his eyes. He glared at me. "You were confined to your room until you changed your mind. What did you think to accomplish by coming down here still defiant?"

I had no ready answer. I hadn't devised an excuse in advance in case Herr van Eyck's handsome retainer wasn't there.

"Do not worry, William. I'm all patience," Signor Arnolfini said. "As I told you, I've brought Giovanna a little gift—to show we are still friends, at least. So I'm glad she came down, whatever her reasons."

Silently I thanked Signor Arnolfini, but I wouldn't give my father the satisfaction of thinking I had relented in any way, so—and I hope the good Lord forgives me now—I turned on Signor Arnolfini. "Bribing me won't change my mind, sir. I don't need your gifts."

My father still had hold of me. He shook me hard. I cringed, afraid he would strike. Instead he hissed at me. "Giovanna, watch your tongue. Apologize now!"

I was on the verge of refusing when Signor Arnolfini reached into the voluminous folds of his cloak. He pulled out something dark, fuzzy, and squirming. He walked up, and with his free hand, disengaged my arm from my father's hold and shoved the wriggling creature into my arms.

At the sight of the big eyes, my resistance melted. "It's a puppy!" I cried. It was a small affenpinscher—the kind of fashionable little dog so

popular at court. It was far from elegant, with coarse helter-skelter char-coal gray fur sticking every which way.

"I've had him three days. When you visited the other day, Marian had him down in the kitchen. Mattie named it Rags," Signor Arnolfini told me. "But you can call him whatever you wish. He's all yours."

"I—I can't take him," I said, offering back the dog, with some reluc-tance, to Signor Arnolfini.

My father stepped between me and his friend. "She's right. I don't want her rewarded for her willfulness."

"Then don't keep him. Just take care of him until I return to Bruges," Signor Arnolfini said, holding my father's glance. "Please, William. It is my wish."

My father pursed his lips together until they turned white, then nod-ded. He sent me back to my room, saying, "This changes nothing. You are to stay in your room until you learn to obey me. And no, Giovanni," he added, stopping Signor Arnolfini from interrupting, "I will not be lenient with her. She will change her mind, if she knows what's good for her. In the spring you will marry . . . if you'll still have her."

Clutching the dog in my arms, I hurried away before I heard Signor Arnolfini's response.

Upstairs in my chamber, Rags (since I was determined not to keep the dog I kept his old name, stupid as it was) successfully diverted Emilia for the rest of the morning. Between fetching his food from the kitchen, finding a ball of yarn from Anna's knitting basket, taking him outside to relieve himself, and fussing over the little creature, she never got a chance to ask me about my session with Papa and Signor Arnolfini in the study.

Around noon Zia Clara came into the room bearing a basket lined with a velvet pillow. "Signor Arnolfini left this for that creature to sleep

in." Zia Clara did not favor dogs. In fact she loathed house pets, feeling any animal's proper place was outdoors. But while staying with us she was forced to accept Mistral our cat, her three new kittens, and Lulu the house finch Matilde kept in a cage in the kitchen. "Signor Arnolfini also deposited a package of scraps from the butcher with Matilde—food that would be better given to beggars than a dog." Then, almost as an after-thought, she added, "He just left. But there has been a change of plans."

I began to smile, but Zia raised her hand. "Hear me out."

Emilia started for the door. "I imagine the signora would like me to leave."

Zia shook her head. "No reason. This partially involves you." Turning to me, my aunt continued. "Apparently you've been given some sort of reprieve—and I'm glad for it. Given time, you will see that the fate you are determined to avoid is first of all unavoidable and second of all not a bad fate at all. I would not have minded marrying that man myself."

Emilia giggled, and Zia Clara treated her first to a hard look then a grin. "You'll not be telling my husband, Signor Guido, when you see him."

She went over to the hearth to warm her hands at the fire, and began to speak. "I've managed to convince your father he's being a bit unreason-able, expecting you to accept Signor Arnolfini as your betrothed so quickly, with no warning." She paused. "With one condition."

"Which is?"

"You are going to Lucca."

"Lucca? In Italy? Why?"

"For one thing, Guido sent a messenger asking me to come home. And when I convinced your father to delay the betrothal, it occurred to him it would be good for you to see Lucca. After all, it is your ancestral

home. You've never been there and never met half your family. You bare-
ly know your Uncle Guido."

From what I'd heard of him I wasn't sure I wanted to know him
much better either; but if going to Lucca meant putting off Signor
Arnolfini a few more months, I would walk there barefoot in the middle
of winter. By spring Papa's fortunes could take a turn for the better and
marrying me off quickly would cease to be his best option. Or I might
convince him to get a richer match for me than our old family friend.

"You'll leave with your father," my aunt told me.

"With my father? But he's going to Lyon."

"You'll stop in Lyon for a few days while he negotiates with some of
his creditors and also tries to salvage some business at the fair."

"We'll stop in Lyon?" My heart soared. Herr van Eyck would be
there, and didn't the minstrel say he was part of his retinue, at least as far
as Lyon?

"It would be best during our journey if you don't try your father's
temper," she went on. "It will not hurt you to bend to his will while you
travel. I have convinced him that you will be amenable to the marriage in
a few months. That should give you enough time to see reason."

My aunt's words jarred me back to reality.

"So you must promise me, Giovanna," she went on, "that you'll open
your heart and mind to your father's wishes, for in the long run you will
have to give in to him."

"I—I can't—I can't promise you, dear Zia Clara." Then for fear she'd
change her mind and tell my father there was no point in sending me on
this trip, I lied. "But in the spring, if my father hasn't changed *his* mind,
I'll do as he wishes."

The Chanticleer

That is how, on a cold, damp evening about a week later, I, along with Zia Clara and Emilia, arrived in Lyon. Huddled beneath fur throws, the three of us, plus Rags the dog, were packed like so many bundles of goods inside the canvas-covered wagon of my father's caravan. For protection from brigands, we traveled with a motley group of six different merchant companies who had banded together as far as Lyon. There the group would disperse following the various old Roman roads that branched off either down to the coast or up into the mountains in the east, or turned south to Italy.

In spite of an icy rain and bitter wind, my father had pressed our whole retinue forward at a bone-jarring pace for the last few hours. As the cart negotiated the ruts in the ancient Roman road, my ribs felt as if they were splintering.

By early evening we had reached the gates of the city. There the band of travelers split up, with each driving their carts, wagons, and horses to different inns.

It was long past dinner time when I felt our wagon jolt to a stop. I

had drifted off to sleep, my head pillowed on Emilia's shoulder. Now I sat up and yawned. Rags whimpered, and squirmed out of my arms. "Where are we?" I asked.

"Lyon!" Emilia's ever cheerful voice announced. I looked around. The interior of the wagon was shrouded in shadows, but the play of light from torches and lanterns danced on the surface of the canvas wagon cover.

"Where's Zia Clara?" I struggled to straighten my head scarf, tucking in my hair. My dress was wrinkled and still damp. I smoothed it as best I could.

"She's seeing to our trunks. She told me to stay here with you."

Emilia lifted the canvas flap and looked outside. Stooping, I walked to her side and knelt to see what was going on. We were in the enclosed stone stable yard of an inn.

I handed Rags over to one of Father's guards so the poor animal could run a bit on his leash and relieve himself. Large, fierce-looking watchdogs cavorted near the stables, devouring a bowl of scraps from the kitchen. Rags tugged in their direction, but fortunately the guard kept him on a short lead.

The sign over the inn's door read The Chanticleer and showed a large brown rooster with a startling orange beak, his garish red comb falling rakishly over one fierce eye. Ignoring the beggers at the gate, the groom barred the heavy entrance door from the inside.

The Chanticleer's courtyard was a hive of activity: People and animals jostled each other as grooms strained to lead horses to the stable through piles of baggage. A boy with a dust-streaked face was calming our team as Luigi began to unhitch the horses. I quickly scrambled out

onto the driver's bench where Emilia had already positioned herself. She linked her arm in mine.

"You're lucky, signorina," Luigi remarked, approaching the cart. "By sending Tonio ahead, good rooms have been secured for our party. We will stay here several days." He handed his blazing firebrand to one of the grooms and lifted me down from the high seat.

With Rags tucked under my arm and Emilia at my side, I made my way quickly across the crowded yard, skirting the animal droppings and the piles of luggage. The brisk air revived me. The harshness of that day's difficult journey fell off my shoulders like a heavy cloak. I felt as if I were at last on the threshold of my first real adventure.

Inside, the innkeeper ushered us past the common room and up a narrow flight of stairs to our rooms.

I put Rags down inside the bedchamber.

"Keep that dog out of my things," Zia Clara ordered. She was transferring her clothes from the trunk to one of the chests at the side of the bed that she and I would share. Emilia along with Rosa, Zia Clara's maid, would occupy a smaller room on the floor above. Our room had one large bed of dark, gleaming wood with a menagerie of animals carved into the thick posters, headboard, and footboard. My trunk was open at the foot of the bed. Half my wardrobe was laid out on the damask coverlet. Aunt Clara had already changed into dry garments. I was surprised to see her wearing her best gown.

"We arrived late and the innkeeper is holding dinner for us. Some of your father's associates will be joining us." Zia Clara paused and held up my new pink overgown.

Emilia looked up and frowned. "But these are the signorina's finest—"

Zia Clara broke in. "Her father commands she wear it this evening." My aunt held Emilia's glance for a long moment. I felt as if there was some kind of secret communication between them. But about what?

With Emilia's help I bathed quickly, dressed, and settled Rags in his basket by the hearth. Zia Clara returned to check my outfit. She straightened the pale pink veil and tucked a handkerchief into my bodice.

"You look well—and not at all travel weary. That is good." She then led the way downstairs. Emilia and Rosa headed for the kitchen to take their meal with the other servants.

At the bottom step I hesitated. The air was stale here, not perfumed with herbs as was our bedchamber. Rough voices rose from the public rooms, which were packed because of the festival.

There were several small private rooms. My father had reserved a dining room with an adjoining chamber. The door was ajar, and my aunt ushered me in before her.

The room was small and overly warm. It was comfortably appointed, with oaken chairs, a small game table, and tapestries, admittedly threadbare and not of the best quality, covering two of the brick walls. Another wall was curtained from floor to ceiling with a thick woven arras, also threadbare but of finer workmanship. Two men stood on a thick rug, warming their hands in front of the fire. Papa was one of them; but even from the back I recognized the other, and my heart stopped.

Deceived

"Herr van Eyck!" I gasped, returning the bow of his head with a curtsy. Keeping my eyes modestly cast down, I peered up through my lashes. Present were only my aunt, Papa, the painter, and myself.

I heaved a loud sigh.

Herr van Eyck crossed the room toward me. "You're tired, signorina. The journey has been difficult, no?" He ushered me over toward the hearth and pulled up a chair.

I nodded, but as I sat down on the cushioned tapestry seat, I took heart. If the painter was here, and the minstrel was in his retinue, surely he could not be far off. Perhaps Herr van Eyck's party was even boarding at this very inn.

"Are you staying at the Chanticleer?" I asked, hoping not to sound too bold nor too curious.

"No. Most of my retinue is housed at the Hart and Hare, in another quarter of town. But your father has organized this dinner—"

"And we are awaiting the rest of our dining party," my aunt interrupted. She cast a glance at my father.

"Just another businessman," he said. "But as the dinner is in part in

his honor, we will wait. He was probably delayed on the road. I believe he is quartered on the outskirts of town."

Herr van Eyck's eyebrows shot up. He seemed about to say something when again my aunt broke in, changing the subject.

"While we wait, Herr van Eyck, perhaps you can tell us more about your work."

For a moment the painter seemed at a loss for words, then he nodded. "Ah, it's hard to *talk* about my work, but since I have already been commissioned to paint the young lady's portrait . . ."

"You have?" I looked over at my father. Surely in our reduced circumstances he could not afford the fee commanded by a court painter for *my* portrait.

Van Eyck went to the door and called for his servant. I caught a quick glimpse of his man: his hair was blond and he was tall and muscular. After receiving the painter's orders, the servant hurried off.

"Fortunately," Herr van Eyck explained as he began to look around the room as if sizing it up. "I always travel with drawing supplies—even to a dinner. So instead of talking about how I work, why not show you?"

"Is there time for this?" My father asked, pacing the room.

"Sir, I work quickly, and I can always pick up the work again when the signorina is back in Bruges in the spring."

Shortly the servant returned with the painter's equipment. By the time one of the maids had laid fresh logs on the fire, Herr van Eyck's servant had set up a clever portable table. On top of the inlaid surface was a leather drawstring pouch and a modest-sized portfolio. It was tied together neatly with black ribbons; the dove-colored cloth binding was worn and travel-stained, betraying long use.

He looked up from opening it and saw me twisting the fabric of my

sleeve in my hands. As no one but my mother had ever attempted my portrait before, I was unsure what to do. She used to draw me while I was bent over my needlework.

"Giovanna, just sit back in your chair and assume a comfortable position. Don't sit stiffly," he added with an encouraging smile. "I can draw while we all converse."

Converse! My throat was so dry I'd probably croak like a toad if I tried to talk. Swallowing hard I prayed that I might not make a fool of myself. By the time I looked up, the painter already was holding a piece of dark chalk. He had extracted a sheet of paper from the portfolio. It had a smooth, greenish gray surface.

"The paper," Zia Clara remarked, "is a strange color."

Herr van Eyck smiled. "It is, but it is a lovely soft background," he explained as he began drawing with a few quick strokes. "One of my apprentices prepares it with color, bone dust, lead, and special glue."

"A trick of the trade, I suppose," Zia Clara teased as he continued to work.

"I doubt the painters in Herr van Eyck's guild would like the word 'tricks,' dear sister," my father interjected. He paused in his pacing and peered over Herr van Eyck's shoulder. His eyes widened as he watched the painter work. "Surely there is magic here, if no tricks!"

"Officially they are not tricks. We painters like to call them 'devices.' They aid us in achieving a likeness. I already have shown some of these methods to the signorina when she visited my studio in Bruges."

"Yes, the grids you place over the drawing. I remember that." Of course what I also recalled was the portrait *beneath* the grid: that of the angelic-faced troubadour.

"Some techniques are deeply guarded trade secrets. Rules of the guild specify they are to be passed on only by masters to their apprentices. Other devices of our art, such as preparation of paper to make the surface smoother and more receptive to the chalk, are general knowledge I can pass on to you." While he talked he continued to sketch. His hand danced as light as a bird across the page. "Do you draw?" he asked me.

"A little."

"Then come and tell me what you think of my rendering." He beckoned me to his side.

I got up and slowly neared his chair. What would the Master's work reveal? He had an eerie way of capturing a person's soul on the page.

"Don't be shy," he urged. I moistened my lips, peeked over his shoulder . . . and gasped! Except for the fact that the likeness was executed in chalk—black with some white highlights—I could have been looking at my reflection in a mirror. It was that true to my own face. He had just begun to sketch Zia Clara, but somehow in a few strokes had already caught her playfulness, boldness, and wit . . . her flirtatiousness!

"Do you approve?" He teased, as his servant came up with a bowl of warm water and a towel.

While he cleaned the chalk off his hands, I stood gazing at the drawing dumbstruck. All I could do was nod—so vigorously my headdress began to slip.

I reached up to straighten it. While I fussed with my veil, Papa and Zia Clara gathered around the little drawing table. "Let us all see."

Suddenly a familiar papery voice spoke up from behind me. "Ah, the likeness is beautiful, nearly as lovely as the model herself."

Before I even turned around, I recognized the voice as Signor

Arnolfini's. He extended both his hands, in greeting.

I dropped my hands to my side and did not return his smile.

It wasn't by chance that Signor Arnolfini happened on us here at the Chanticleer. My father had planned all this, for my would-be betrothed was the guest of honor at tonight's dinner.

This was a step closer to formal betrothal. My first instinct was to flee the room.

Herr van Eyck must have read my mind for he didn't give me the chance. With a gallant bow he took my hand and hooked it through his arm, holding my hand firmly so I could not—with any dignity— squirm away.

As my father walked past the serving wench into the dining room, the painter said, "Signorina Giovanna, our meal is getting cold." With that he firmly propelled me toward the dining chamber. Behind us Signor Arnolfini escorted my aunt. Herr van Eyck bade me sit down.

Surveying the sumptuous feast spread on the table, I realized my father had probably planned this dinner before we left Bruges. Surely no innkeeper during fair week had such a grand supply of victuals, including game birds, a whole roast piglet, and even a heap of precious fresh oranges displayed with great cunning as a centerpiece.

Now I understood why Papa had spurred our horses and wagons so ruthlessly, speeding up the day's journey to cover twice our usual distance so we'd arrive on time for this meal—and my "accidental" encounter with my future betrothed.

My stomach twisted into a knot, and I sent up a fevered prayer to St. Catherine, patron of virgins, to save me. Sure as day, this feast, far beyond my father's current means, meant this was a betrothal dinner.

The very thought that I'd have to dine with Signor Arnolfini and Herr van Eyck while my father discussed my future as the merchant's wife infuriated me. I threw down my napkin and began to get up. Herr van Eyck pulled back my chair. I rose and shot a scathing glance in Signor Arnolfini's direction—and nearly lost heart.

The wounded look on my old friend's face cut through me and almost slashed through my resolve to refuse him at any cost. For the first time in my life I saw him as a *man*, not as a family friend or an uncle but as a person capable and willing to support a family in luxurious fashion and, more importantly as a kind man. As Zia Clara told me, I could do worse. My father's misfortune would have me wed a man who would be, if nothing else, kind, gentle, never cruel or demanding. And perhaps if I hadn't met my minstrel . . . For a single moment I hovered between sitting again, thus giving in to my fate, or running out of the room.

Then my father banged his fist on the table, rattling the dishes. "Giovanna, sit down—now!"

His shout snapped me out of any indecision. Instead of obeying him I pushed away the chair and swept out the door, nearly knocking over the serving wench on her way in with a tray. Fighting back the urge to cry, I fled across the antechamber and threw open the hall door.

A chorus of drunken voices, peppered with curses, resounded in the corridor. They issued from the public room—a room I'd have to pass on the way back upstairs. The rowdy laughter sent me retreating back into the antechamber. Heart pounding, I slammed the hallway door. When I turned I found myself face to face with my father. He was livid.

"Giovanna!" He gripped my arm. I could not stop myself from gasping, but I managed to face him defiantly. Surely he would not strike me

in front of Herr van Eyck or Signor Arnolfini? Then I noticed he'd closed the door to the dining room. No one would witness whatever punishment he meant to mete out.

"Sit down!" he commanded, then forced me into a chair and let go of my arm. I rubbed it gingerly but refused to avert my eyes from his. Looking down at me, he said in a gentler tone, "I don't understand you. You have known Signor Arnolfini for years, he is a good man. Like your aunt, I believe you are somewhat young for betrothal—and we haven't prepared you yet for marriage. The chest with your marriage goods is barely full. I would have preferred to wait a year at least—out of respect for your mother—before formalizing this betrothal, but I can't."

"Signor Arnolfini's willing to wait," I shot back.

"Yes, he is. But I'm not. Your behavior has convinced me the sooner the betrothal is formalized, the better. I can't risk anything endangering our whole family's welfare and reputation."

"Meaning what?" Was my father actually suspecting that I'd somehow dishonor him?

"Meaning that the sooner we are out of debt, the sooner my reputation is mended and our financial and business interests are secured. I have the whole family to think about, Giovanna. As head of the Cenami clan, I am responsible for all branches of the family business. My failure affects everyone in Paris, Bruges, and Lucca. Creditors have already contacted your Uncle Guido. Soon we will be in danger of losing our dye works in Lucca. I can't afford to wait, and your behavior convinces me that you might do something foolish."

I felt my cheeks flush. Until that moment I had no idea *how* I could escape my fate, but that my father felt I might find a way out gave me

hope. "And what foolish thing could I do?" I asked him. "I'm only four-teen. Where would I go, who would I turn to?"

"The church." My father laughed. "Develop a sudden calling to be a nun. The church would welcome even your greatly reduced dowry."

Me, a nun? Not that I hadn't briefly—*very briefly*—entertained the thought. Only six months ago when my courses began, I realized that someday I would have to bear children. Seeing my mother's suffering during her last labor, and watching her and the pitiful newborn infant die, had terrified me. Nuns at least did not have to go through the horrors of childbirth or spend their lives beneath the thumb of a domineering hus-band. The literate, more educated nuns in the convent near our house in Paris spent their time like Herr van Eyck's sister, illuminating manu-scripts, copying sacred texts, and embroidering and weaving fine vest-ments for the priests.

Nevertheless, I looked at my father now and did not lie. "I will never be a nun. I promise you that."

My father shrugged. "Promise whatever you want. My mind's made up. The lawyer and witnesses will come tomorrow to formalize the betrothal. Your wedding will wait until spring. I am sorry I had to sur-prise you like this. But Zia Clara agreed that your not knowing would make the journey easier, so I arranged with Signor Arnolfini that we would meet up here."

"And Herr van Eyck?"

"Oh, it was his idea. He has connections here in Lyon and could even have arranged a wedding in the new cathedral, but I do not like the idea of you being bedded so soon. You may become quickly with child, and your new husband has already committed himself to traveling for

his company until spring. A betrothal is as binding as a marriage under God and the law." My father then fell silent. He reached out, and with a look of incredible tenderness, he put his hand on my head. His touch was gentle, the way I remembered it as a little girl.

Fighting back tears, I told him, "You once promised that I would never have to marry someone I didn't care for."

"I have not broken that promise," he said, dropping his hand back to his side. "You have always cared for Giovanni."

I started to protest, but my father put his fingers to my lips. "Listen. I promise you, you will learn to care for him now in a new way. He is passing fond of you, and he is a patient man. He will give you time to love him."

Love him? Never. I began to shake my head when the ruckus in the hall crescendoed into a brawl. Cries went up, and I heard the approaching clash of swords. The sound must have carried through to the dining chamber, for my aunt burst in, followed by Signor Arnolfini and Herr van Eyck.

The harsh clang of swords was punctuated with loud, vulgar curses.

"That voice!" my father exclaimed, pushing me toward my aunt. "Stay here, both of you. Bolt the door!" he commanded. He hurried across the room.

"William!" my aunt cried. "Are you insane? Come back here!"

Of course he ignored her. He threw open the door to the clash of swords and clamor of a full-fledged fight. Followed by Herr van Eyck and Signor Arnolfini, Papa plunged into the fray, slamming the door behind him. Before it shut, my aunt slipped out, still calling after him.

What's in a Name?

"Zia Clara!" The door slammed in my face, cutting off my cry. "Come back!" I wailed. Where in the world was Luigi? What had happened to the men of our guard?

My father was no swordsman. Worse yet, my aunt surely had no sense: How could she rush after him into the midst of a public room brawl, leaving me alone? But what Zia Clara lacked in sense, she possessed in courage—unlike myself. I may be obstinate, I might be of independent mind, but I am deeply fearful of bandits, bears, and certainly brawling men.

I tried to throw the bolt on the door, but it was stiff and my hands were too small to manipulate the bulky lock. Keeping my eye on the door, I shrank back toward the hearth. The outcry in the corridor intensified. The melee seemed to be getting closer. What if the swordsmen burst into the room? I felt along the stone fireplace until my hand touched the wrought iron poker. I grabbed it and held it behind my back.

Not a moment too soon. A second later, the door burst open.

I stiffened as a lithe young man backed into the room. Without turn-

ing he quietly closed the door. He pressed his ear against the oak panels, listening to the scuffle on the other side.

Two thoughts raced through my mind. One was that this was one solitary man, not an entire room full of duelers. My second thought was not exactly a thought. I watched him spellbound. I noticed that his left hand was wrapped around his right arm. His right fingers clutched a sword. At the sight of blood oozing through the fine lawn of his sleeve, I gasped.

At the sound he spun around and raised his sword.

At the sight of me still pressed back against the hearth, he quickly lowered it.

"It's you!" The words escaped my lips, and for a moment, in spite of the ruckus outside the door, I felt as if I were dreaming.

For a moment we just stared at each other. His lips were parted in surprise. As he looked at me, I did not blush but felt the color drain from my cheeks. How could this be? Herr van Eyck's retainer and model, *my* minstrel, was here, standing in front of me. My heart pounded so hard in my chest I was sure he could see it rise and fall beneath my dress.

His expression shifted like quicksilver from fear to shock to something I still have no name for all these years later. But the way he looked at me that moment is forever etched in my heart. My fear vanished and I dropped the poker behind me.

The sound of the iron clattering to the floor stirred him into action. He quickly sheathed his sword and bowed low, remembering his manners. "Signorina, *scusi*! It is a surprise we meet again here, so far from Bruges."

I felt the color rush to my cheeks. To hide my blush, I clasped my hands in front of me, gathered up the folds of my gown, and curtsied

deeply. Part of me wondered if he was truly surprised—and secretly hoped he had followed me here as he had followed me to the guild hall in Bruges only a week before.

He straightened up from his bow and promptly winced, looking down at the stain reddening his sleeve. "I am sorry to disturb you this way, though I did promise I would find you again," he began. "But I . . ."

"You're hurt!" I cried, cutting him off. How could I have forgotten about his wound? I scanned the room for something to staunch the bleeding. The serving wench had already cleared the napkins. Then I remembered the handkerchief Zia Clara had tucked in my bodice. "Here . . ." I was about to hand it to him when I realized he could not tend the wound himself.

I had watched my mother minister to my father and to injured apprentices. I had even helped our cook, Matilde, bind our old spaniel's paw. Nursing and simple care of minor injuries was part of my education to be a wife—the part I dreaded most, for the sight of blood made me queasy. Yet though I had never seen a sword wound, I forgot to be squeamish and started to bind his arm.

As I touched him, he snatched the handkerchief and, fixing his eyes on mine, lifted the embroidered cloth to his lips and kissed it before handing it back.

My fingers trembled as I took it. My whole body felt a thrill of fear and expectation—of what I wasn't quite sure. It was only the sight of the minstrel's high color fading to pale that brought me back to myself.

Though my hands shook, I managed to tie the linen cloth around his arm secure enough to quell the bleeding. "Wash your wound with wine as soon as possible." I kept my voice low. What if someone heard me

talking to this man, alone in a room with no chaperone? "Wine will keep it from festering." It seemed that once my tongue was loosened I couldn't stop talking. If I fell silent I knew exactly what would happen. His eyes were studying my lips. It would not be a handkerchief he next kissed, nor my fingers. "In fact," I babbled on, "you should have wine to drink too. You are pale and have bled much and are hurt." Gathering my skirts, I turned away from him, looking on the table for my father's goblet of wine.

"Not so grievously wounded. My arm was barely grazed," he said, barring my way to the table. Taking my hand, he gently stopped me from taking another step. "Or perhaps it's my heart that is pierced."

The very drama of the words broke the spell. I knew little of men first-hand, but Emilia's tales of attempted seductions had prepared me to see how a man might sweeten his words to steal one's virtue as well as one's heart. I drew my hand away and began to laugh. "If that were so, you'd be dead by now."

He laughed back. A new sparkle came into his eyes. "Ah, you are perceptive, signorina . . . ?"

"Cenami . . . Giovanna Cenami," I told him.

He looked stricken and reeled backward. Instinctively I reached out and grabbed his arm. "You—you're weak. Sit down," I told him.

"Cenami?" he repeated, backing away from me. "This cannot be." He ran his hand across his brow, and shook his head. "I had so wanted to learn your name, and now I wish I'd never heard it."

"What . . . what's the matter?"

"Signorina . . . Cen . . . Giovanna . . ." He switched quickly from my family name to my given name.

"That is my name." I was not nearly so calm as I appeared. The sound of my name on his lips had been like a song. "And your name?"

He drew in a deep breath. "I'm called Angelo—Angelo Grimaldi."

"*Grimaldi!*" I recoiled.

"So, my family's name is as familiar to you as yours is to me!" He laughed tightly.

How could I respond to that?

"I can see in your face that you hate me, if only for my name," he said.

I suddenly found my voice. "Hate you? How can I hate you? I don't know you. All I know is that your family has somehow hurt mine."

"And yours mine!" he retorted quickly, his expression darkening. But immediately his scowl passed, replaced by a look of incredible sorrow. "I—I cannot speak for my family, but I myself would never hurt you, or anyone dear to you." With those words he took a step toward me . . . just one step, and then sounds of the scuffle intensified. Something banged against the door.

"Giovanna!" His voice dropped to a harsh whisper as he grabbed the hilt of his sword. "We must not be found here together. I must not be found here with you. Your father—he will kill me!" Desperately he looked around the room. I spotted the thick woven arras curtaining the stone wall and covering the window that looked out onto the stable yard.

"Here!" I pulled aside the curtain. What luck! The window was set into an alcove, giving just enough space for a person as thin and lithe as Angelo to hide. "Be quiet!" I told him, then dropped the curtain and raced across the room. I reached the hearth just as the door flew open.

My father burst in, Tonio and Luigi at his heels. "Where is my

daughter?" he bellowed as Zia Clara slipped into the room, visibly distraught. Signor Arnolfini was at her side. Herr van Eyck was last to enter. His sword was drawn. Quickly he sheathed it, and bolted the door.

"Papa!" Part of me was relieved to see him, unhurt, and in one of his all-too-familiar rages. Another part of me was terrified that Signor Grimaldi—Angelo—would somehow betray his presence and my father's fury would descend upon him.

"I'm here, Papa. Are you all right? What's happened?" I hurried over to him, forcing myself not to look back over my shoulder at the arras where Angelo was hiding.

My father drew me quickly into his arms. His embrace felt warm and steadied me. For the second time that evening, for a brief moment, I was his still his little girl, who until a few years ago he had showered with love.

"I see you are safe," he said. Immediately he put me away from him, and turned angrily on the servants. "How could you leave the women of my family alone—and you, Luigi, how did you manage to pick this inn, out of all the others in Lyon for us to stay in?"

"Signor, I had no way of knowing who would be staying here," Luigi protested.

"And certainly Luigi had nothing to do with that brawl . . . which, by the way, seems to be dying down," Zia Clara put her hand on my father's shoulder. Calm as she sounded, she looked shaken.

"That is because," Herr van Eyck broke in, "the night watch has finally arrived."

My father nodded approval. "At last. Luigi, Tonio, leave us now. Find out what is happening out there and keep me informed. To think those

ruffians had the gall to appear at this inn sporting the Grimaldi livery when our own guard was posted outside." As the two men left, my father strode over to the table and poured some wine into his goblet. "I wouldn't be surprised if it wasn't that Grimaldi cur who started the whole ruckus."

I stiffened. "Grimaldi cur?" Surely he couldn't mean Angelo.

My father grunted. "I can't believe that scoundrel has the gall to show his face within a hundred leagues of me."

"Scoundrel?" I repeated.

"He is just a hotheaded young man," Herr van Eyck spoke up. "I know him—slightly," he added a little too quickly. I found myself angered that he did not defend his retainer more strongly.

My father was too excited to notice. "Hotheaded? His family has single-handedly ruined me. Bad blood runs through his veins," my father muttered between sips of wine. "If the coward hadn't sneaked off in the heat of the fight, the night watch would have thrown him in the gaol."

My aunt broke in. "William, it's over. Let's forget about this unpleasant incident."

"Unpleasant incident?" Papa scoffed. Wiping the wine off his mouth with his sleeve, he stalked dangerously close to the arras. "For all I know that man and his retinue followed us here to taunt me in our family's disgrace—disgrace that they engineered."

"Why would they do that?" I asked, placing myself between my father and the arras. Looking around for something to distract my father, I took his goblet and poured him more wine, then crossed the room toward the hearth. "Tell me about it. I don't understand."

My father took the wine but didn't settle down by the hearth. Instead

he paced the room as he angrily recounted the history of the Cenami-Grimaldi family feud. "Our families have been enemies as long as anyone can remember. Some say it goes back to the time of the Romans."

"But what started it?" I stammered, half-afraid to hear the story.

"Does it matter?" my father fumed. "His family and ours have battled each other for generations. The Grimaldis are thieves, cowards, and men of no honor . . . and their women are no better!"

"Please, not in front of the signorina," Signor Arnolfini broke in. "Surely this is not subject suitable for a young maiden's ears, William."

"Besides, these long family feuds seem to contradict the message of our Lord to love even our enemies," Herr van Eyck said quietly.

"Not when our enemies are no better than sons of whores!" my father fumed.

The words had barely escaped his lips when the curtain at the back of the room rustled and Angelo leaped out, sword drawn. "Take that back!" he shouted, hurling himself at my father.

For a heartbeat my father stood stunned, then darted toward Herr van Eyck and tried to wrest the painter's sword from its scabbard.

Herr van Eyck pushed him aside and planted himself squarely between Angelo and my father. "Stop this foolishness or I will call the guard!" He was looking at Angelo, but the threat was also clearly directed at my father.

Meanwhile Signor Arnolfini had stealthily moved behind Angelo. Angelo's dark eyes were furious as he continued to brandish the sword at my father. But Signor Arnolfini tackled him from behind. I watched in horror as Angelo practically collapsed from pain as the merchant's thin but apparently strong hand gripped Angelo's wounded arm. Angelo dropped his sword and crumbled to the floor.

I rushed over and knelt down beside him. He grasped my hand hard and, leaning on me, managed to regain his feet.

"What have you done?" I shouted at my father.

"What have *I* done?" My father was staring at me as if I had suddenly sprouted two heads.

My aunt hurried over and pulled me away from Angelo. I ignored her. "Are you all right?" I asked him.

"More to the point," Signor Arnolfini said, "Are *you*? If this man has in any way . . ."

"Stop it," Zia Clara intervened. She shot me a warning look.

Please don't tell my father, I silently begged as if my very thoughts could stop her.

Apparently she thought it better that Papa not know I recognized Angelo from the duke's feast. She said, "Obviously the boy is wounded. He ducked in here to escape the fray." I watched as Zia Clara noticed my handkerchief wrapped around Angelo's arm. I prayed my father wouldn't. My aunt positioned herself between Angelo and my father, so Papa couldn't get close enough to see that the bandage was made of fine embroidered cloth.

"He waxes pale!" Herr van Eyck said, gripping Angelo's good arm. Angelo tried to shake off the painter, but Herr van Eyck didn't let go. Turning to Angelo, he said, "I'll escort you outside; we'll find your manservant. And then, young man, you'd best find other lodgings where a physician can attend to your wound before it festers."

Still holding his arm, Herr van Eyck bent down, retrieved Angelo's sword, then steered Angelo toward the door. I saw him whisper in Angelo's ear.

Whatever he said didn't seem to faze Angelo. He continued to try to

resist, to come back into the room. All he could manage was to turn and glare at my father. His lips were white, but his sonorous voice was surprisingly strong. "You owe me an apology. You have defamed my family and myself. And *I* have done nothing to dishonor yours. Nor would I."

"Bah!"my father raged. "Get that piece of no-good humanity out of this room. Take warning, Grimaldi. If I ever find you within a hundred leagues of my family again, *any* member of my family, you won't live long enough to regret it."

As Herr van Eyck herded him to the door, Angelo caught my eye. They say you can read what a person is thinking or feeling in their eyes. I never have been able to do that. But there was a tenderness in his expression that conveyed his message quite clearly. Somehow, someway, in spite of my father's threats, he would see me again.

The Letter

As soon as Herr van Eyck carried Angelo away, my father turned his fury on me. "What is the meaning of this? You alone in here with a stranger—unchaperoned." He stopped himself and cast a quick glance at Signor Arnolfini.

"I don't think the girl was compromised," Signor Arnolfini said, but the way he spoke of me as if I wasn't present made me angry.

My father however was even madder—at me! He stalked toward me with one hand upraised, but then perhaps he recalled that Signor Arnolfini was still in the room, for he lowered his hand.

Before Papa could reach me, Zia Clara barred his way, putting a protective arm around my waist and firmly bustling me toward the door out of his reach. I sagged slightly against her, but she forced me to straighten up. Zia might protect me from my father, but I was dismayed to realize she was as angry at me as he was. She nudged me toward the hall, then turned around and said, "I'll deal with this, William. Giovanna has been through a fearsome experience just now."

Fearsome! Not fearsome. It was a *wondrous* experience finding

Angelo again. Angelo—he bore the name of an angel. If only I could change his surname, or my own. During the few minutes we'd been alone so far I felt as if an angel had descended into my life.

Upstairs in the bedchamber, Zia Clara shooed her maid, Rosa, away. My aunt was too distracted to ask Rosa where Emilia had gone. She didn't even chase away Rags , who was dancing around her feet. I scooped him up, held him close, and hugged him as if somehow he could help me find some way out of this terrible mess.

"Do you realize what you've done?" she said, forcibly sitting me down at the foot of the bed. She was a small woman but she towered over me as I sat there.

"I've *done* nothing!"

"Don't play the fool with me," she countered, her color rising. "And don't you dare speak with me in that tone or I'll let your father punish you. Tonight you nearly disgraced our family."

"What's disgraceful about binding a young man's wounds? Surely that was the Christian thing to do," I added, remembering what Herr van Eyck had said about feuds being against the Lord's command to love.

"Fortunately your father didn't notice the wound was bound with *your* handkerchief." Zia paced over to the window and drew aside the curtain. "I only hope that fool has enough sense to take Herr van Eyck's advice and put some distance between himself and your father as soon as he is able to ride again."

"How? He was sorely wounded." I wanted Zia to pity him as I did.

"Not deeply enough," she grumbled. When she turned and faced me, her expression was still stern. "You *are* young, Giovanetta. Your father, who has been so eager to educate you in Latin, philosophy, and

mathematics, has failed to teach you the ways of the world."

"What does the world have to do with it? Why do we have to be ene-mies because our parents hate each other?" Then a thought occurred to me. "You've lived in Lucca most of your life. You must at least know of this young man. Have you heard tales about him in particular—*not* his family—that prove he's a dangerous man of ill intent?"

At first Zia's frown deepened, but after regarding me for a moment, she shrugged. "No, I don't know anything about him. But the minute he spotted that boy, your father left the feast. If I had known that a Grimaldi was part of the entertainment, I would never have let you hear him sing." She stopped and eyed me shrewdly. "And don't pretend you don't know what I'm talking about. You are nursing some foolish notions about this good-for-nothing scoundrel, and as I warned you, you'd better forget all about him."

"But, Zia Clara, you don't *know* that he is as bad as the rest of his family. You just admitted you don't know him."

"True. I know nothing firsthand or otherwise about this particular young man. He's probably one of the Grimaldi brothers who were placed in service to the duke of Milan when he was a little boy. Word of him in particular, either good or bad, has never reached my ears.'"

At these words my heart soared. "Then why should he be judged by whatever his family has done in the past?"

"Because that is how the world works." Zia Clara shook her head in frustration. I jumped up, and Rags leaped out of my arms. He shook himself, then went and settled by the fire. I had only had him a short time, but I had learned he hated the sound of loud voices. "Just now that boy could have attacked you."

"Angelo wouldn't have hurt me!" I blurted.

My aunt's eyes widened. "*Angelo*? You call him by his given name? Never let me hear you do that again. In fact, if you have your wits about you, you will never mention that boy again to me, to your father, to *anyone*."

She stopped talking and stared at me long and hard. After a moment she seemed to come to a decision. Heaving a great sigh, she sat down next to me and took my hand. "Tell me exactly what he said to you, what you talked about."

"We only spoke of his wound. He was very courteous. Then I bound it for him. It was natural to exchange names. We were both dismayed to learn our families were enemies. It makes me wish I had any other name than Cenami."

My aunt groaned. "Don't be ridiculous! Your name is Cenami, and until you marry Signor Arnolfini it will stay that way."

I realized there was no point in arguing. I would never be Giovanna Arnolfini, even if I couldn't marry Angelo.

Looking at my aunt, who seemed so sure of herself, so satisfied with her own comfortable but unromantic marriage, made me want to shake her. Didn't she understand. If I had never seen Angelo, then maybe learning to love Signor Arnolfini over the years would have been possible. Now that I had tasted the kind of love that lived in poems, I could never settle for anything less.

Exasperated by my silence, Zia Clara finally threw up her hands. "I should send your father in to deal with this. Instead I want you to stay here and think things over. And to be sure you don't leave, I'll lock you in! And where is that maid of yours anyway?"

"How should I know?" I snapped.

"Never mind. I'll find her and send her up. Meanwhile I'll lock the door."

Then my aunt left. The metal bolt clanged like a death knell. Terrified, Rags jumped onto the bed and shivered.

For several seconds I stood at the foot of the bed, paralyzed by the knowledge that my fate was sealed. The cruelty of the situation was unbearable. I had heard tell of dying of a broken heart. The way my heart hurt at that moment, I was sure any minute I might die.

But die without seeing Angelo again? The thought shocked me into action. I hurried over to the window. Pushing back the thick woven curtains, I unlatched the shutters and let in a blast of cold damp air. The window had no glazing and looked out over the courtyard. I leaned out slightly and could hear the soft voices of servants and stable boys gossiping outside the kitchen door. Even if I had a ladder or a rope to help me down from my second-floor room, climbing out the window would attract too much attention. Then I heard my aunt's voice rise up from the stairwell, soundly scolding Emilia.

Footsteps approached the room, and Zia Clara unbolted the door, then marched into the room, followed by Emilia. She more or less pushed my maid in my direction. "Get your mistress ready for bed. Luigi will be posted outside. I'm locking you both in the room until I am ready for bed." My aunt did not spare a word for me. She swept out into the hall, where she gave orders to Luigi. The door was again bolted.

As soon as my aunt left, I asked Emilia, "Why are you wearing your cloak?"

"I—I went downstairs to the kitchen and stepped outside with one of the other maids for some air."

I didn't believe a word of it.

Emilia waited as my aunt's footsteps faded down the hall, then down the stairs. She put her cloak on top of one of the trunks and approached as I sat down in a chair. Her hands shook as she began unpinning my headdress. Her fingers were cold, and for the first time since I'd known her, she actually looked scared. "So it's true?" Her question startled me.

"What's true?" I did not want to believe that what had occurred downstairs between Angelo and myself was already fodder for servant gossip.

"That your father and one of the Grimaldis came to blows."

I shook my head. "No, not quite." I hesitated, not sure how much I could trust Emilia to keep her mouth closed. I needed her friendship now more than ever, but could I trust her? "Herr van Eyck stopped the fight."

Emilia bit her lower lip, then stopped to fold my veil. She opened the travel trunk and laid the veil carefully on top of my other clothes. I waited for her to say something. But for once the girl seemed to have lost her tongue. She kept her back turned toward me.

Finally I couldn't take one more minute of her silence. "Emilia?"

"Signorina," she started.

"Signorina?" I repeated. "Why are you being so formal?"

Emilia hesitated. "Because I have to know before I speak if I am speaking to a friend or someone who does not trust me."

I decided to trust her. "Tell me, as a friend, where you were just now."

The flush that came to Emilia's cheeks told me all I needed to know. "You've made some new conquest." I wasn't in the mood to hear details of her latest romantic exploit.

"I—I have met someone." She looked so woebegone. "But I had no idea, Giovanna. None at all who he was."

My mouth went dry. For one awful moment I was sure she was going to tell me she'd somehow encountered Angelo and he had succumbed to her rather loose morals. Before I could work up courage to ask who she was talking about, Emilia, as was her wont, revealed all.

"His name is Rodrigo." My heart soared. *Rodrigo*, not *Angelo*. Whoever Rodrigo was, I blessed him.

Emilia bent down to put away my shoes. She looked up at me. I was still grinning with relief. "Giovanna. Stop smiling. This is serious . . . it's *his* servant."

"Signor Arnolfini's?" I asked.

"No, not Arnolfini—Grimaldi. Rodrigo is Signor Grimaldi's man-servant."

"You—you met Angelo's, I mean Signor Grimaldi's, servant? Where? How?"

A familiar flirtatious smile lit Emilia's face. "Oh, outside. In the inn yard. I was talking to one of the kitchen maids. He was idling nearby. We exchanged some pleasantries and dallied a little. That's all," she added quickly, seeing the shocked expression on my face.

Though what right did I have to be shocked? My aunt had virtually accused me of the same thing. I had a good idea what Emilia's dallying could lead to, and Lord knows Angelo and I hadn't dallied one bit.

As she turned down the coverlet on the bed, she continued, her voice hushed. "All of a sudden, Signor Grimaldi came out—more likely was shoved out—through the back door. I didn't get a good glimpse of who pushed him out but I think it was Herr van Eyck. I did notice that he wore a sword and cut the figure of a courtier.

"Anyway, the gentleman practically threw a cloak at Signor

Grimaldi, called for Grimaldi's man, and then said something about keeping away from this inn if he knew what was good for him."

"You heard all this?" I was shocked and grateful all at once. "Where were you?"

"In the shadow of the kitchen door," she mumbled. "But that doesn't matter. Rodrigo slipped past me and ran up to his master. The courtier handed over another sword to Rodrigo. He himself called the stable boy to fetch Signor Grimaldi's horse.

"When he went back inside, I crept out of the shadows, intending to slip in through the kitchen door. But Rodrigo called me over. 'You're one of the Cenamis' servants?' he asked. I told him, yes.

"His master hurried over to me."

I clutched her arm. "Oh, how is he? He was wounded, and perhaps Herr van Eyck manhandled him and made his wound bleed again." I shook her a little. "Tell me, how did he look?"

Emilia scrutinized my face, and shook her head slowly. "You poor girl. You're the one sorely wounded here." She tapped my chest. "By Cupid's arrows." She knit her brows. "Oh, he's fine. And of course in the torch light I recognized him. He's that fine painter's model . . . one of his retainers, I believe Herr van Eyck said."

She paused to see my reaction.

I nodded. It was all I could do not to shake her. "Tell me quickly. What happened next?"

"He asked Rodrigo to fetch writing material from his saddlebag. He wrote you this." She pulled a note out of her alms purse. It was not sealed. It was addressed to 'Signorina Cenami.' Emilia held it fast.

"Give me the note, Emilia."

"If I do," she said, "you must promise never to tell *anyone* I passed it on to you. I'll deny it. I'll say you met him downstairs yourself."

"You'd lie?"

"To keep my position, or to be able to find another similar one, I'd do anything. The worst that happens to you for not behaving according to your station is you get married off to someone you don't care for. For me, one mistake and I am out on the streets, having to fend for myself."

I nodded and reached for her hand.

Reluctantly Emilia handed the letter over. "Giovanna, please, be careful. You don't know what you are doing here. You will incur more than the wrath of your father. This man works for Herr van Eyck, and yet Herr van Eyck didn't seem to want to advertise the fact. In the inn yard he was downright rude to him. There is more to this Angelo Grimaldi than meets the eye."

I pretended not to understand her. I wanted to kiss the very paper Angelo had touched, but I had to restrain myself in front of Emilia. "Now go, let me read this alone."

Emilia propped her hands on her hips and scoffed. "Oh, so I am now to walk away through a locked door."

I had forgotten neither of us could leave the room. "Then turn around. Busy yourself with something. Let me read."

She obeyed and began getting ready for bed. She went over to the washbasin and noisily splashed water on her face.

I took care to turn my back on her and with trembling fingers opened the note. It had been written in haste, and yet a part of me was pleased to see Angelo had a fine hand. But what pleased me more and thrilled me to the very marrow of my bones was what he wrote:

Signorina Giovanna, do not give up hope. Rodrigo will contact your maid about our plans. Try to find a way to leave the inn—run an errand or go to the fair. One of my men will be on the lookout for you and will find a way to communicate. I was to leave for Lucca tomorrow but will certainly delay my departure until at least we can meet again. Though our families are enemies, I hope it is not too forward of me to trust that we are not—and never shall be. Your faithful servant, Angelo Grimaldi.

I carefully folded the note, then, ordering Emilia to keep her back turned, I tiptoed over to the trunk. The lid was still propped up. Inside was a modest jewelry casket that held my few precious ornaments. It had been my mother's. Zia Clara gave it to me after the funeral. It had a false bottom, a secret compartment. Inside was a thin sheaf of blank paper. When Zia showed it to me, she said, "Sometimes a girl has private thoughts it might please her to write down, or keepsakes. Here is a place to keep them." That was all she said. She never spelled out a promise not to look in the casket, but I knew that she never would.

So now, with my back to Emilia, I kissed Angelo's note, and lay it in the bottom of the compartment. When I closed the box, I felt as if it held a bit of my heart.

The Apothecary

The next morning I was awakened from dreams of Angelo by the sound of my aunt moaning and Rags whimpering outside the bedroom door. Before going to bed she had banished him from our room. And now Zia Clara had, it seemed, acquired a toothache. Not just an ordinary toothache, but one of monstrous proportions.

When I tried to speak to her, she just moaned louder and invoked the help of St. Apolonia, whose specialty is curing toothaches. I scrambled out of the bed we shared and was horrified to see one side of Zia Clara's face swollen to almost twice its size. Her cheeks were flushed and her hand, when I touched it, was burning with fever. The poison in her tooth was spreading through her body.

I threw a cloak over my chemise and opened the door to find Tonio, one of my father's guards, lounging against the wall, playing with Rags. My father had posted him in the hall to be sure Angelo didn't get into our room or as likely that I didn't venture out. At the sight of me Tonio straightened up and attempted a stern look.

Elated to see me, Rags nipped at my feet and tugged at the hem

of my cloak until I scooped him up and showered him with kisses. Looking up at Tonio, I asked. "Where is everyone?"

Before he could answer, Rosa came bustling down the hall bearing a lidded clay vessel. Sage-scented steam wreathed out from under the lid. A moment later Emilia hurried up the stairs, carrying a large white cloth.

Tonio frowned at me. "Go back inside. Dress and I'll escort you downstairs to break your fast. Your father has already left for the fair with Luigi. Except for meals, you are to remain in your room for the day."

Locked in my room, my chances of glimpsing Angelo again were beyond slim. I retreated back inside, handing Rags over to the guard.

Under my aunt's watchful eye, I dressed hurriedly. Zia Clara moaned as Rosa made her sit up in bed. Then Rosa arranged a board across my aunt's lap and put a tray with the steam bath on top of the board.

"Here, signora, put your head over the steam. It will loosen the evil humors," she assured my aunt, as she draped the cloth over her head. "Now breathe through your mouth."

Zia Clara obeyed.

As my aunt was breathing in the steam, Emilia whispered in my ear. "Giovanna, the betrothal has been put off—your aunt is too sick. Your father has gone to inform the lawyer and set a new date."

I swallowed a cry of joy and gripped Emilia's hand. "There's hope, Emilia!" I murmured, just as my aunt let out an even louder groan. In something between a prayer and a curse she called again on St. Apolonia. Unfortunately, the steam-and-herbal cure made Zia feel worse, not better.

With his usual foresight my father had sent for a medical help, for just as I was adjusting my head scarf, Rags began to bark furiously outside the door. Tonio led a bent man in a patched doublet and mended hose into the bedroom. His apprentice followed, carrying a large black satchel with

a crudely painted tooth on its side. I realized this man was the local bar-
ber, who, like the one back home, specialized in tooth pulling and blood-
letting. The thought of what was inside his bag made me shudder.

At the sight of his bag, my aunt did more than shudder. She sat
straight up in bed, shoving the steam bowl into Rosa's hands. She
couldn't open her mouth to speak, but violently she waved the man away.

He tried to explain to Zia Clara that pulling her tooth would let the
poison humors flow out of her body and she would feel better in a day
or two. But Zia Clara, through an elaborate pantomime, made it perfect-
ly clear to everyone that she refused to have her tooth pulled. I wished
my father were there to convince her otherwise, for her pain was a terri-
ble thing to witness and her fever seemed to be mounting.

Eventually she and the barber settled on a simple bloodletting, herbal
poultices to take the heat away, and a special compound for pain. The lat-
ter two remedies had to be fetched from a particular apothecary whose
shop was inconveniently situated nearly an hour's walk from the inn.

The barber was unable to spare his own apprentice for the errand, as
he had another patient, who was possibly sick with the pox, to attend. He
wrote the prescription, handed it to Tonio with directions to the apothe-
cary's establishment, then left.

Tonio looked at the prescription, turning it upside down as he tried
to make sense of the letters.

Distressed by my aunt's suffering, I inwardly cursed the stupidity of
the barber. He'd written the note in Latin, a language not commonly
taught to servants. My father, though, had made sure that I was taught to
read it since it was used as a kind of common currency when traveling
and when men of science or letters conversed.

Tonio bowed apologetically to my aunt. "Forgive me, signora, but—"

"I can read it," I said, taking the prescription from him. I perused the page and realized that even the directions to the shop were written in the ancient tongue.

I had hated learning Latin, but now I was grateful for my father's passion for education. For as I read, a plan formed in my mind that would help my aunt and at the same time afford me the chance to leave the inn. It was the memory of Angelo's dear note, lying safely in the heart of my jewelry box, that gave me the courage to defy my father's orders.

Putting on a thoughtful face, I looked up, "Tonio, is Luigi here?"

"He's with your father. What's that got to do with the apothecary?"

I cast a pitying look at my aunt. "The surgeon writes here that we must fill this prescription exactly, but how will you know whether the apothecary gives you the right compounds when you can't read this?" I waved the prescription at him. "Luigi has a passing acquaintance with Latin, but I'm not sure any of the innkeeper's boys do." I sighed and turned to my aunt. "Her pain is too great to wait for my father's return."

Zia might have been in pain, but she still managed to give me a look that warned me I must dissemble well if I was to fool her. I sighed again and turned my face away from hers. "Rosa should not leave her."

"Nor would I!" Zia's maid looked askance at the thought.

I paced the room two times, forcing myself to walk with a heavy step. I muttered to myself, hoping I looked more thoughtful than insane. Finally I shrugged, and announced with exaggerated reluctance, "Then there's nothing more to be done than for me to go myself!"

My aunt sat up again, practically upsetting the steam pot, but Rosa quickly settled her back down. "Signora Clara, you must not move. The signorina is right. She is the only one of us here reliable enough to pur-

chase your medicines. Luigi reads Latin, but he's with Signor Cenami."

"That's impossible!" Tonio cried. "My orders are that the signorina is not to leave this inn . . . under any circumstances!"

I tried to muster up some tears. As one trailed down my face, I pleaded with him. "Tonio. Don't you understand? This is an emergency. My father would certainly approve, as there is no other way to obtain this medicine." I bit my lip and managed a worried look. "Of course you and Emilia will come with me. No harm will come to me, particularly since there are so many town soldiers patrolling the streets during the fair."

Tonio frowned and looked toward my aunt. I followed his gaze. I had heard of people staring daggers at other people. She was staring scimitars at me! But she couldn't speak enough to protest. I hurried to her side. "Dear aunt. You can trust me with this errand." And that was the truth.

The bell had barely struck the half hour when our little entourage set off through the streets of Lyon to the apothecaries' district. The barber had directed us to a particular shop that he swore had the most reliable herbs and the best prices, even during the weeks of the fair when Lyon shopkeepers tended to fleece the public.

Our party was made up of Tonio and two other of my father's burliest guards, Emilia, myself, and Rags, who was so delighted to be outside that he didn't seem to mind being leashed.

From the moment we left the inn, I tried to spot Angelo's man. I had no idea what Rodrigo looked like, though of course Emilia did. However I hadn't shared the content of Angelo's note. It felt sacred to me, and private. And besides, I still wasn't quite sure how far I could trust her. So she had no idea that one of Angelo's party might be shadowing us.

It was a gloriously sunny day though the November air was cold

and the wind brisk. Still I felt every pore of me thrilling with life.

The streets of Lyon differed little from the streets of Paris back home. They were as crowded, though perhaps more than usual because of the fair. Pockmarked beggars shoved filthy hands in our faces as we worked our way through the jostling assortment of merchants, courtiers, pages, servants, messengers, monks, nuns and pilgrims. Men of all stations leered at Emilia and me as we passed and made comments I tried not to hear. Staying safely back at the inn began to seem wiser than my foolish hope to get Angelo's message from a stranger in this throng. The crowds were so rowdy, I found myself grateful for my father's guard.

Of course, as we huddled near Tonio and the other men, Emilia and I took care only to talk of casual things, remarking on the rosy sandstone buildings unlike those in Paris. We negotiated the cobbled streets, lifting our skirts to avoid the refuse and the foul water rushing through the gutters after yesterday's storm.

Our escort shepherded us quickly through each one of the narrow, dark passageways called *traboules* that connected the streets and buildings. Gargoyles and animal figures, some of fearsome, some of humorous aspect, surprised us as they peered down in stony silence from the cornerstones of buildings. I was glad the day was bright and the sun high. I had always feared gargoyles, which I believed came to life between the hours of dusk and dawn.

Eventually we reached the apothecary shop, nestled on the ground floor of an aging stone building. Its windows opened onto a small square, where grimy children splashed through dirty puddles. Women gathered at the well, which was set into a corner of the courtyard.

Leaving the other two guards outside, Tonio opened the door for us. I tucked Rags inside my basket. Immediately we were greeted by a heady

mixture of scents dominated by the acrid, medicinal smell of valerian and the sweet aroma of sage. To my surprise, who should be hovering over the counter but Herr van Eyck. He was with a big-boned, blond young man whose bent nose looked as if he'd been on the losing end of too many brawls. They were in deep conversation with the apothecary.

As we entered, the three men looked up.

Herr van Eyck's face registered surprise as he bowed. "Good morning, Signorina Cenami. What brings you here?"

"Good day, sir." I curtsied, coloring slightly.

Emilia sensed my dismay at finding the courtier here and spoke up. "The signorina's aunt is ill, and we've come for medicine."

I regained my composure and explained about Zia Clara's tooth and the barber's prescription, which Emilia handed to the apothecary.

He wiped his hands on his apron and quickly read the note. "This compound will take only a short time to prepare." He looked up at Herr van Eyck. "I trust you won't mind if I attend to the young lady's request first?"

"Of course not," Herr van Eyck replied. "Meanwhile my apprentice and I can examine your stock of lapis stone."

The apothecary went behind a curtain into the back room, and Herr van Eyck turned to me. He behaved as if absolutely nothing untoward had happened the night before. I was surprised and suspicious.

"Your aunt's illness explains why your father cancelled today's betrothal ceremony. I should introduce you to one of my journeymen, Hans. He traveled here before our retinue to arrange accommodations," Herr van Eyck said calmly.

Hans bowed awkwardly. I noticed his big hands were rough and stained with color, like the hands of the dyers who worked for my father.

"We're here to purchase materials to make my paints."

"You're able to paint while you travel?" Emilia spoke up.

Herr van Eyck didn't seem to mind being spoken to directly by a servant. "No, though I always sketch and draw on my journeys. Court business won't leave me enough time to paint, nor will I have a workshop or any helpers but Hans when we sojourn in Spain. However, whenever I'm in Lyon I try to visit this shop. Today we're in luck. Hans overheard rumors that a new shipment of lapis lazuli has arrived from the East. As I suspected, this apothecary has a goodly supply of it."

He motioned us closer to the counter. Tonio, Emilia, and myself all joined him. "Within these vessels lay the secrets of the painter's craft," he told us, and began explaining that a painter's colors were made from various materials: plant, insect, or mineral. Some were purchased in their pure natural state, some had already been rendered usable by alchemy.

"Look, signorina," Herr van Eyck said, touching my arm drawing me back to the present.

Hans had lined up the vessels, each filled with colored substances, some brilliant, some dull, others powdery, and even one small pile of little stones. How did the master transform these powders and stones into the lovely colors in his paintings?

I already knew something about colors, plants, and dyes because of my father's trade, though I had never seen the raw materials up close before. "See these blue stones?" Herr van Eyck picked up a wide-mouthed jar and shook a few into his hand. "These make the blue in the Virgin's robes when I paint a madonna," he told me. His eyes sparkled with enthusiasm as he talked. I was surprised to see such a sophisticated man as excited as a child at the prospect of making colors.

"You turn those into paint?" Emilia sounded doubtful.

"Hans does. He grinds these stones into the finest of powders—

the finer the more beautiful the blue, verging almost on violet."

"It sounds like magic," I remarked, amazed. What miracles there are in the world! Imagine rendering hard, cold stones into the lustrous blue of the Virgin's cloak or veil.

Hans laughed. "It is not magic, signorina. It is hard work. Very hard work to grind lapis lazuli into powder to make ultramarine blue paint."

"A color, by the way, that, when tempered and lightened some, matches the blue of Signorina Cenami's eyes. Maybe when I paint your portrait I will use pigment made from these very stones, Giovanna."

Emilia knowingly squeezed my hand. With her other hand she touched a jar of brilliant red nuggets and asked, "Does this red come from stone too?"

"That's vermilion. It comes from a stone called cinnabar that through alchemy, becomes the brilliant red you see here." Herr van Eyck smiled. "But here, bring it into the light." He carried the jar to the window. We all followed. Hans blocked my view of the street, but I saw Emilia chance a glance past the jar in the painter's hand to the street. Her eyes widened.

"The color, isn't it beautiful? And this," he said, lowering his voice, "isn't even the best vermillion. That is only obtainable from a tiny shop in Bruges. It's rumored that painters from as far away as Milan send their helpers to obtain the powders from that particular alchemist's."

Emilia abruptly put her hand on her head. "Forgive me, Signor van Eyck, but I suddenly feel poorly. The aromas in this shop are very strong and are making my head ache. I must step outside for a moment for air."

Tonio frowned. "Stay near the guards. And take the dog."

Emilia made a face. "It's not the likes of me they're guarding, Tonio. Not that I feel well enough to go far," she said. "I'll get some water from the well. The cool air will refresh me. I'll be fine." With that she

relieved me of Rags's basket and walked slowly toward the door.

Wrapping her cloak more tightly about her, Emilia slipped outside. She stopped long enough to murmur something to the guards. Out of the corner of my eye I noticed Hans watch her leave. He followed her progress onto the street and looked half inclined to join her. Had she made another conquest? But he chose to stay behind with his master.

Sturdy, curvy Emilia was not the fainting type. A tiny hope stirred in my breast. Was it possible her sudden case of the vapors was prompted by something—or someone—she saw on the street? Would she return with another note? Heart in my throat, I watched Emilia walk slowly over to the well, putting her hand on her brow as if she felt poorly. I waited to see what she would do next, but the apothecary diverted my attention. He had emerged from the back room with his mortar and pestle.

"I have mixed the dentist's compound." He shook the contents of the mortar into a square of paper and folded the sides together. "Have your aunt take a finger thickness full of this in some warm water three times a day." He spooned a white substance out of another jar and told me it was for pain. Then handed me a third packet he'd already prepared for Zia Clara to put on her gums. It was costly, as it contained myrrh, but it would help draw the poisons out from her tooth.

Tonio took coins from his leather pouch and paid for our purchases. Herr van Eyck wished us well and sent regards to Zia Clara.

By the time we were ready to leave, Emilia had returned looking as healthy as a midsummer's day. "Ah, that felt good, mistress," she said to me, taking me by the elbow and leading me to the door. "But better we don't linger here or my vapors might return!" She forced a small cough.

The apothecary warned her to beware, as her sensitivity to scents was a symptom of a weak chest.

Emilia cast her big eyes up toward him and curtsied her thanks.

Herr van Eyck again wished us farewell and offered to send Hans back with us to the inn. To my surprise Emilia instantly demurred. She suggested that perhaps with the fair in progress and so many thieves about, it was best that a courtier such as Herr van Eyck should himself not travel unescorted.

The men laughed off her concern, but Hans remained with his master.

"You seemed to have caught Hans's eye, dear Emilia. I'm surprised he didn't take up Herr van Eyck's offer to accompany us!" I said as we left the shop.

"With good reason," she huffed, lifting her skirt to avoid a pile of indefinable but putrid refuse. "He's not what he seems, signorina."

Who is? I wondered, but waited for Emilia to go on.

"He is a chip off his own master's block, that's what he is."

"Stop talking in riddles, Emilia. What in the world are you trying to tell me?"

"Herr van Eyck isn't just one of the duke's court painters." Dropping her voice even lower, Emilia continued, "He's also the duke's spy."

In spite of my anxious mood, I started to laugh. "Then surely I have nothing to fear from him. I'm scarcely knowledgeable about politics beyond the world of our household." The thought was ironic. Until last week I hadn't even known about my own family's feud.

"Don't play the fool, signorina," she warned, sounding almost stern. Emilia stern? She hooked her arm through mine as if to help me step over a drainage ditch still rushing with last night's storm's waters. "His man— Hans, he's already tried to chat up Rodrigo. Asked all sorts of questions about Rodrigo's master."

My heart almost stopped. "And exactly how do you know this?" I whispered.

"Rodrigo. He followed us from the inn. He had intended to wander into the shop, but when he saw Hans and Herr van Eyck, who of course he knows through his master, he hid in the shadows of the *traboule* across the way. I saw him and feigned illness."

"Ah, as I suspected!" I held my breath. "What did he say?"

"He told me about Hans."

I broke in. "This is unbearable. I don't care a fig about Hans, or Herr van Eyck. What did he say about Angelo?"

Emilia studied my eyes a moment, then shook her head slowly. "I'm not sure any good can come of this and I'm of half a mind just to get you back to the inn, but . . . but your Angelo is a pretty parcel of a man, with a nice turn of leg." Her face melted into a teasing grin. "So I'll bear the news, though only the good Lord knows it may lead to some terrible woe. Tell your father you need to go to confession tomorrow first thing to be shrived of your sin of arguing with him last night."

"The only woe from confession will be a year's worth of aves!" I wailed.

Emilia giggled. "You truly are new to the arts of love, signorina. Of course you will *really* go to confession, but to do your penance you will ask your escort to leave you in a side chapel of the cathedral. There your Angelo will meet you . . . and in the confines of the church will be sure to do neither you nor your honor harm."

Oh, but in the even more guarded confines of a convent cloister he had done me great harm. He had kissed my fingers, and that kiss had sealed what promised to be a difficult, dangerous, glorious fate.

Confession

That afternoon, back at the inn, my father was beyond furious.

"How dare you disobey me and leave the inn?" He was shouting at me, but Tonio, Emilia, and even my aunt's maid, Rosa, were lined up in front of the cold hearth for their share of a sound scolding. How had he learned so quickly of our excursion?

As Papa stormed back and forth across the Chanticleer's private sitting room, his face waxed red—so red that I was sore afraid he would have an apoplectic fit. The thought that my disobedience might cause the demise of my own father made my heart freeze in my chest. I feared some vengeful angel would strike me dead, and I would deserve it, especially because I knew it was his very anger that would afford me the chance to beg to go to confession at the cathedral. The truth was, I needed and wanted God's forgiveness for disobeying my father.

Papa ranted. "I should have left you at home. I also," he added, half to himself, "should never have agreed to travel with *any* women, including Zia Clara. It seems on caravans, as on voyages, they bring exceedingly bad luck!"

"Signor." Rosa finally mustered the courage to speak up. It helped that she was employed by my aunt and uncle and not by my father. Unlike Emilia or Tonio, she could risk offending Papa without great fear of losing her position. "Signora Clara's toothache is not bad luck. It's just an illness. And she will eventually be fine. Already the apothecary's compound has eased the pain."

"Bah!" My father waved off Rosa. "Her face is still as swollen as a camel's bladder. As for you"—he turned on Tonio—"How could you disregard my orders? Your young mistress was not to leave this inn."

Tonio shifted from foot to foot. "I tried to dissuade her," he started.

Rosa interrupted. "Signor, I beg your pardon, but Tonio could not stop her, for this was truly an emergency. The only solution was for the signorina herself to go, with a strong escort."

Rosa went on to explain that not only had I been well guarded on my foray into the streets of Lyon but that I had performed my errand of mercy for my aunt perfectly—meaning that I had not strayed from lady-like behavior or conversed with strange men.

"So I've heard," my father said, his tone caustic.

"From whom?" Curiosity and anger made me find my tongue.

"Herr van Eyck."

"Ah," I said. *He's the one who told my father about my little expedition.* Herr van Eyck immediately sank about forty fathoms in my estimation.

"I saw him on his way to the fair with his journeyman in tow," he continued with a frown, "Apparently he spoke with you at some length in the apothecary shop."

"Yes, we talked. He showed us the substances that make up his colors, while the apothecary fetched Zia Clara's medicine."

Papa's frown deepened.

"You can't possibly object to me speaking with a well-mannered, *married* gentleman such as him?"

"Manners and marriage do not make a man a gentleman," my father replied sternly. "It is not proper for a maiden about to be betrothed to be speaking alone to men. Besides, I barely know this Van Eyck. He may well be a courtier but that doesn't make him trustworthy."

At his words I recalled how my aunt—also married—had dalliances with other men. Whatever illusions I had about love, faithfulness, and men were rapidly fading.

"Sir." Emilia's voice quavered. I cast a quick, sidelong glance at her. She was pale and her knuckles were white. Her hands gripped her skirt so hard, I knew she was terrified of losing her position. What if her fear made her break her confidence? What if she told my father about Rodrigo's message and the plan to meet Angelo at the church? I was afraid her fear would outweigh our friendship.

But Emilia remained true to me.

"Herr van Eyck behaved in a very courteous, seemly manner. He even offered to send his apprentice back with us to reinforce our escort."

"It was never necessary." Tonio seemed to take courage from Emilia's words. "Signor Cenami, I swear on all that is holy, your daughter came to no harm while under my protection and that of your hired men."

Papa's anger subsided somewhat. "Nevertheless, Giovanna and you, in particular, Tonio, disobeyed me."

"I know, dear Papa." I cast my eyes down. "I'm sorry. I was truly willful and sinned against your wishes. But please don't blame Tonio. I virtually ordered him to accompany me. Still, it was wrong. With your permission, I will go to confession to ask the good Lord's forgiveness."

I braced myself for my father's response. He started shaking his head,

no, then surprised me. "Yes, I think some prayer and contemplation would do you good. In the past week, you have been disobedient, willful, and disrespectful. I'll call the guard and you can go now."

"*Now?*" That would spell disaster. Emilia caught my attention; her eyes flashed a warning. I thought quickly. "No, no. Not today. I should stay here with Zia Clara. Besides I'm woefully tired after this morning. We walked two hours, Papa, on these hard, cobbled streets. Tomorrow would be better—early, first thing."

"Tomorrow." My father drummed his fingers on the table, then sighed. "Why not? Your aunt is too ill to travel, and Signor Arnolfini and I have arranged the betrothal ceremony to take place three days from now. I have already reserved our rooms and these private chambers for the rest of the week. Now go upstairs and redeem yourself with some kind work: Help Rosa nurse your aunt. At the very least, you could read to her if her pain has lessened."

Never has there been such a long, slow, tedious afternoon and evening. It seemed I passed a whole winter season in that inn, relieving Rosa, bathing my aunt's hot forehead, and reading passages from a precious small Book of Hours—prayers illustrated decades before by the likes of Herr van Eyck's sister. It was a most costly wedding gift from my father to Zia Clara and Uncle Guido.

Morning finally dawned. Exhausted from a fitful sleep next to my aunt, I reluctantly let Emilia dress me in my most somber, penitential garb, half afraid Angelo would not care for me without my finery.

My father had left word the night before that I was to stop by the dining room before going to confession. As usual he would have been up

since dawn, tallying his accounts and receiving couriers while drinking his mulled cider and breaking his fast.

Downstairs, outside the private parlor, I took a moment to compose myself. I asked Emilia to wait in the corridor with Rags while I visited with Papa. I closed the parlor door behind me and headed toward the entrance to the dining chamber, hoping nothing in my bearing would betray the fact that I was about to meet Angelo.

The dining room door was ajar. I was not surprised to see my father had a visitor until I drew closer. It was Herr van Eyck.

What in the world had brought him here so early in the day? He was neither a merchant nor a client or banker or moneylender. The carpet muffled my footsteps as I approached the half-opened door.

"The Grimaldis are at it again," Herr van Eyck said. His whole posture bespoke urgency. He stood at the table, leaning toward my father. I only was able to glimpse his profile, but I saw enough of his face to see he was frowning, and worried. "Mercenaries are poised to waylay the caravan bearing your last shipment of silk from Lucca."

"You're sure of this news?" My father surprised me at how calm he sounded. His brow was furrowed and he pursed his lips.

"My source is—how shall I put it—is well placed and in deepest confidence of the family."

"The *Grimaldi* family?" Father's fingers drummed against the wooden table. "It's unlike them to attack again, in the same manner, so soon. How do you know these reports aren't lies planted to divert our attention from some other scheme?"

Herr van Eyck nodded slowly. "I wouldn't put it past them. But in this case I have confirmation from another source. These days I am wary

of taking only one informant's word for anything. At this time of year there are only two passes open over the mountain. My men are watching one of them—on the duke's business. I can have them watch out for your people, at least as long as they are in the area. Perhaps you can persuade some of your fellow guild members to help you hire more guards. If the shipment makes it through, you will be at least partly on your way toward recouping your losses."

"And you said there is more?"

Herr van Eyck hesitated. "Yes. You are right about them hatching another scheme. Apparently they are still infuriated by that attempted poisoning—"

"Alleged attempted poisoning," my father quickly pointed out.

Herr van Eyck shook his head. "William, I am no fool. You are as much to blame in these vile dealings as the Grimaldis."

Overhearing this, my heart sank. So this was the answer to my prayers? Was I to believe my own father capable of such evil deeds? But even Herr van Eyck had as much as accused him of attempted murder. How could I possibly face Angelo now?

Herr van Eyck's next words caught my attention. "The only reason I am trying to help you avoid total ruin is that you are forging ahead with this betrothal between your daughter and Arnolfini. He is a dear friend, and the duke favors him. Otherwise I would, as is my usual practice, steer clear of the twisted plots and schemes of you traders."

"I admit to nothing," my father said gruffly. "Besides, you have no proof that I've ever instigated anything against that vile tribe."

"Ah, do not deceive yourself, Signor Cenami." Herr van Eyck's tone was icy. "You forget I am in the Duke of Burgundy's employ. My duties extend far beyond being *valet de chambre*—a painter and artist in the

court. You know that. On the Duke's behalf, I have in place several of my own men—dyers, weavers, craftsmen—in Milan, in Florence, in Rome, and of course in Lucca. They report back to me. Intrigues springing from the House of Cenami are as well known to me as the Grimaldi's plots."

For a moment I heard only silence, then my father uttered a low, sharp laugh. "I have heard there is more to your paintings than meets the eye. And more to you, Herr van Eyck, as well." Another pause, then my father continued. "So are you going to tell me what you've learned about this other Grimaldi intrigue, or do you intend to keep me guessing?"

"I myself know nothing other than what I've told you. All my other information has come from reliable sources, as I said, deeply in confidence with the family. But they swear there is nothing else brewing. However, I overheard something at the fair yesterday that was troubling. One of your other business rivals—"

My father started to speak, but Herr van Eyck stayed him with his hand. "Who it is doesn't matter. He said Grimaldi's hatching some devious plot calculated to ruin your family forever. He felt sorry for you and hoped one of your spies would be able to stop it before it went too far."

"What spies?" my father scoffed. "The few I had in my employ left once rumors surfaced that I was fresh out of florins!"

"I already have my own people trying to ferret out information. So far"—the painter shrugged—"nothing."

My heart was heavy with despair. I was tempted to turn and go back upstairs, and drop the pretense of going to confession. But then I thought of Angelo waiting, and of how he would feel if I didn't turn up.

Just then my father went to the sideboard to pour himself some water. He saw me standing in the doorway and motioned for me to come in.

"You're late!" was his only greeting.

I curtsied first to Herr van Eyck and then to him. I could barely meet my father's eyes. I avoided Herr van Eyck's glance entirely. Whatever I thought of him now, he was still a most perceptive person. I feared he could read the state of my heart in my face.

"Yes, Papa."

"I inquired," my father informed me. "You should be at confession before today's mass. The Weavers Guild is having a procession in about an hour. I want you back here before then."

"You're going to the cathedral?" Herr van Eyck asked, pulling on his gloves. "I will be walking that way myself. I will escort you if you wish."

"Oh, my father's guard will be with me, and . . ."

"There's no need, Jan," my father said. "I would like to speak with you further, if you can stay a bit longer. There is another matter."

"Of course," the painter replied. He smiled at me, but his smile did not go as far as his eyes.

After leaving Rags in the kitchen with the inn's cook, Emilia, my guard, and I left just before terce. My mind was churning: How could I face Angelo with the knowledge that his family was once again hatching a plot that would ruin my father once and for all? And that my father planned to retaliate.

These thoughts were still reeling in my head when we reached the cathedral square. The final and ninth chime of the new astronomical clock struck as the sun burst through the morning clouds, showering the cathedral with light. My heart lifted. Perhaps there was hope, and I could convince Angelo that he had to stop his father before it was too late.

I silently prayed that God would forgive me for using his church to defy my father's wishes. Perhaps my sin of disobedience, and lying, would

be forgiven if I could prevent more violence between our families.

Before entering the cathedral I paused, humbled by the huge stone edifice that seemed massive and at the same time insubstantial. It made me think of angels' wings, of holy things. It seemed suddenly the most ill-favored place for a secret tryst.

I stared at the streams of worshippers: pilgrims, monks, nuns, and Lyonnaise citizens of all walks of life poured in and out of the massive doors. How would we speak even two sentences unobserved? How alone would we really be when surely the Lord inhabited this sacred place and could hear our every thought and word? How would I find the words to tell Angelo what I knew about his family's plans to ruin mine?

"Come, signorina." Emilia took my elbow and steered me across the broad square. "Your father won't be pleased if we linger here too long."

"Yes . . . you're right." Flanked by Tonio and my father's guard, I braved the cathedral steps, entering under the round rose window.

We walked from blinding sun into the deep shadows of the church. The air was heavy with frankincense and candle smoke. The huge cathedral seemed to swallow up the worshippers and made me feel as tiny as an ant. I clutched my veil closer and gripped my prayer book as I headed across the nave toward the confessional.

I felt the hypocrite as I entered inside. If my father's men had waited outside the cathedral, I would have bypassed the curtained confessional. But they kept close, so I had to go through with my charade.

Inside the confessional box I knelt on the hard wooden *predieu*, crossed myself, and thanked God that the priest on the other side of the screen wasn't Père Martin, my regular confessor back in Paris who knew me and my whole family.

"Bless me, Father, for I have sinned," I began shakily. Indeed I *had* sinned: I disobeyed my father; I'd lied to him; now I was about to commit a more grievous offense—one I was unable to confess, at least until after the fact.

I continued as far as "It's been ten days since my last confession." Then I couldn't go on.

"My daughter," the priest said encouragingly. "Don't be afraid. In his wisdom God forgives all."

Even a false confession? Or at least one enacted only to deceive my father? "Yes. I . . . I was disobedient. My father forbade me to go out and I did." That much was truth.

The priest might have been anonymous, but he was no fool. "You sound like a young girl . . . is there more to tell me?"

I blurted the truth, just not all of it. "My aunt was sick. I went to the apothecary with my maid and with a guard. I came home. But my father is grievously displeased with me, for he had told me not to leave our inn. I *am* willful. I try not to be."

"At least you recognize the error of your ways. Is that all that is troubling you, my child?" I could hear the suspicion in the priest's voice.

I took a deep breath. "Father, I do have one question."

"Speak child."

I gripped my prayer book hard and prayed for courage. "Is there a way to chase hatred from a person's heart?"

From behind the screen of the confessional, I heard the priest draw a quick intake of breath. "You hate someone?"

"Oh no! Not at all." *I love someone* is what I wanted to tell him. "Someone I care for is filled with hate for someone else."

"Then pray for that person. And ask the Lord and his Virgin Mother to show him the path to love."

Pray? God forgive me, but I doubted prayer could change my father's heart.

"Is that all?" The priest's voice interrupted my thoughts.

"Yes, that's all, Father."

He hesitated, perhaps sensing I wasn't telling the whole story. When I said nothing more, he went on to my penance. He reminded me that my father on this earth was a representative of Our Father in heaven and deserved perfect obedience, respect, and honor. To my delight he gave me enough Paters and Aves so my penance would take at least an hour.

Leaving the confessional, I kept my head lowered, trying to look penitent. I rejoined Emilia and whispered, "Which chapel?"

"Mother of Sorrows. Rodrigo said it's a small side chapel, a chantry off the apse behind the altar."

I lifted my head, and motioned toward Tonio to follow me. "We made our way down the side aisle, past carven wood or stone images of saints perched in their niches, most with offerings of candles, sweetmeats, and even dried rose petals.

With every step my heart beat faster. Dare I hope Angelo would really be there? A small part of me hoped he would not, prayed that he had lost courage or that his note was part of a passing fancy. I was, frankly, terrified. I was meeting the enemy of my father—no, the son of my father's rival. A man who would ruin my father. A man my father would ruin. How could a girl like me hope to right all these wrongs?

And in spite of my fears, of my doubts, I yearned with my whole heart and soul to see Angelo. It seemed this strange new stirring in my

heart and limbs would surely lead to sins far worse than disobedience.

At the chapel entrance, I told Tonio, "Stand guard. I need to say my penance alone. Emilia may come in, but she too must wait just inside the doorway." My words echoed against the stone walls. I spoke loud enough to warn Angelo that I was not alone. "I need to pray."

I stepped farther inside the entrance. No one seemed to be inside. With a sinking heart I proceeded into the chapel. Where in this small space could Angelo hide, safe from the watchful eye of my father's men?

An altar flanked by two small alcoves graced the center of the chantry. The shallower niche held a carved wooden image of St. Ann, mother of the Virgin and my own mother's favorite saint. Dripping candles and offerings littered the shelf in front of her statue. The other alcove was deeper. Toward the front stood a tearful stone image of Mary herself. It was a tall statue and looked to my unpracticed eye freshly carved. Smoke from incense and the bouquet of candles at Our Lady's feet hadn't yet discolored the smooth stone surface. Though she was sorrowful, her whole being was calm, at peace with herself and her fate.

I only wished I were.

Wary that one of my father's men could still see me, I forced myself to walk slowly to the *predieu* in front of the statue of the Virgin. I knelt, bowed my head, and closed my eyes. Silently I began the first Ave of my penance: *Hail Mary, full of grace, the Lord is with thee.*

"Signorina!" The whisper issued from the recesses behind Mary's stone garments. I could barely hear it. When I opened my eyes, I spied a cloaked figure half in shadow. It could have been anyone: young, slim, back as straight as an arrow. But though I spent so little time alone with this man, I knew from his voice, and the gentle beauty of his profile, that true to his word, Angelo had risked his life to come.

A Daring Plan

"Angelo." I rose and almost rushed toward him. Then I remembered the guard and sank to my knees on the predieu. Dropping my voice to a whisper, I begged, "Angelo. Don't move, please. My father sent a heavy guard. He doesn't trust me. The escort can see us from the doorway. Stay back. Tell me what you will, but I must pretend to pray."

"What I *will* is that you say my name again." His whisper was so filled with passion that it sounded like a shout. "You make my very name 'Angelo' sound like a prayer."

"Ah, but my father would make it sound more like a curse," I said, and my voice broke.

"Giovanna, what has happened?" He stepped farther out of the shadows. He seemed about to touch my shoulder. I motioned him back. He stood partly shadowed, but candlelight illumined his face. "The guards," I warned, then I took a deep breath and went on. "It seems your father has hatched a new plan to ruin mine. He is planning to waylay the caravan bearing the last of my father's goods on the way from Lucca to Bruges."

Angelo stared at me. "This is not possible."

"You've spoken with him lately then. You know his mind?"

Angelo let out a tight laugh. "We do not speak. I am, shall we say, banished from the family for this very reason," he added.

"What reason?"

"Feuds. Eternal scheming. Your family versus mine. Other families versus mine or yours. The intrigues of merchants make Duke Philip's most tangled conspiracies seem like child's play."

How does a troubadour know about Duke Philip's conspiracies? The thought seized my mind. His next words erased them entirely.

"I wanted no part of it, any of it, ever—even before I met you. And now . . ." He paused. "Dearest lady, all this evil threatens to keep us apart."

I bit my lip and lowered my head. "It's worse than you think," I murmured. "My father will retaliate, you know."

"He has already tried to poison my father." Angelo sounded resigned. "Someday one of them will succeed in killing the other, and then our families will surely be at open war. They have the means to hire bands of mercenaries to fight for them."

"Is there no way to stop this?" I looked up at him. My tears blurred my vision.

He reached down and wiped them away with his hand. He wasn't wearing his gloves, and the touch of his fingers against my skin made my whole body tremble.

"You're cold," he whispered.

I shook my head. Before I could answer I heard a commotion at the chapel entrance.

At the sound, Angelo ducked back into the shadows while from the vicinity of the door I heard Emilia's voice. She was arguing with Tonio.

No, not exactly arguing. She was wheedling, pleading, actually *flirting* with him, a young man she considered one step above the rank of fool. "Don't worry Tonio! What harm can come to our mistress in church? I heard that a fragment of the Holy Shroud is housed in the chapel behind the apse. I long to see it with my own eyes. Come with me, please."

I couldn't hear Tonio's response, but Emilia continued to plead. "The guard can watch outside the door. It'll only take a few moments to see it."

Emilia must have used the full strength of her charms; first her voice, then the sound of footsteps dwindled into the distance. I checked over my shoulder. Indeed, Emilia had left. *A few minutes!* That was Emilia's coded warning that I had only a little time left with Angelo.

I turned to call him out of the shadows, but quiet as a cat he'd already emerged. He was standing right there in front of the *predieu*. The expression on his face was so intense that it took my breath away. He reached out and lifted my face toward his. For the briefest instant I thought I would melt like candle wax under his touch. The next moment I came to my senses.

"There's no time, Angelo. We must find a way to stop your family from sabotaging my father's goods. He cannot face another loss. He is already beyond ruined."

"What's the point of even trying," he said, his shoulders slumping. He was the picture of despair. Suddenly he straightened. "Wait." He reached out and touched my lips with his fingers. His eyes reflected the soft candlelight. "There is one thing. Herr van Eyck."

"I don't want to speak of him. He above all people must not know we've met here."

"Of course he must not. I'm in his employ, and he will resist my plan. However, he has a kind of wisdom. The other night, when he said that feuding was against the Lord's command to love one another—you see, that's the answer."

"I don't understand."

"Love. *Our* love can stop the cycle of hate and plotting and evil schemes."

Love. In any other place at any other moment the word on Angelo's lips would have thrilled me. Now it made my heart as heavy as stone. "How?"

He took both my hands in his. "I know a priest. Unfortunately he is not in Lyon. He lives halfway between here and Lucca. But he is Lucchese, and he knows both our families and has begged from the very pulpit of the church for them to end this feud. He will help us"

"How?"

"By marrying us and then finding us safe passage back into Lucca. When we arrive, wed under the eyes of God and his church, our families will have no choice but to accept us and to accept the fact that they cannot war against one of their own."

"Marry?" I gasped dropping his hand. "Have you lost your mind? My father will never permit this. He'd kill you first . . . maybe me too!"

"By the time our fathers hear of this, we already will be married. We will leave Lyon as soon as I can arrange safe passage. Once we reach the abbey where this priest resides, we can wed. From there we can proceed to Lucca."

He made it sound so simple. Just up, leave the Chanticleer, leaving everyone I loved behind . . . and somehow elude my father's guard and just ride off in the night to be wed at some distant place. A place . . .

"Where is this abbey?" I asked, afraid to hear the answer.

"Several day's journey hence," he said. "But between here and there are other abbeys and convents and places where you and I can stay—with no dishonor, sweet lady."

He didn't need to spell it out. We would travel, over night—over several nights—alone, unchaperoned. If we failed to reach the abbey, or if my father's people or his family caught us on route, I would be as ruined as my father's textile empire.

"For this you will have to trust me," he said.

I closed my eyes. I felt as if there were a chasm. If I took the first step, I might fall down into the darkest regions of sin and despair. But if I didn't take the first step, then . . . then what? I'd be forced to marry Signor Arnolfini, true. Worse yet, there'd be no chance to prevent my father from being ruined.

"When does your father's caravan leave Lucca?" Angelo asked.

"I have no idea. I got the impression it was leaving soon."

"Still there is a chance to stop my family's planned attack. If not, they will pay your father for damages when we arrive in Lucca, married."

"Angelo, what if . . . what if we wed and both families turn us out. My father is beyond stubborn and proud and full of hatred for anything bearing the name Grimaldi."

"When you bear my name, will he not be forced to change his mind? When you bear his grandchild? I know my father. He is as hard-hearted as yours. As set, as fixed against the idea of ending this feud as any Cenami could be. And yet I know that when he lays eyes on you, all he will see is a reason to love you and to learn to accept, if not love, your family's name."

I swallowed hard. I needed a moment to think. Angelo had a point.

It seemed like a crazy scheme, and yet wasn't love supposed to conquer all, as it did in his songs? Didn't St. Paul himself say the greatest virtue of all was love? Even Anna, my old nurse, once said that love is the greatest healing power on earth—more than her poultices and herbal brews. If love can heal physical wounds, what miracles might love work on injured souls?

Then before me, Angelo knelt down. "Giovanna Cenami, will you marry me?"

His question hung like incense in the air.

I nodded. "I will." Because I believed that the Virgin Mary would bless us.

He reached for my hand to bring it to his lips.

"Not here. Not in front of the Virgin!" I whispered, then touched his arm gently to push him away.

He flinched.

"Your wound!" I cried softly. "I've hurt you."

"It's nothing. It's almost mended. Your nursing was nothing short of miraculous." He made a fist, then let his hand relax and swung his arm around. "It's a little sore, but otherwise I'm fine. Ready for our journey." He touched my chin and lifted my face toward his. This time I didn't pull away.

He didn't try to kiss me. Not yet. Instead he simply smiled. "Perhaps I should return this." He pulled a crumpled square of embroidered cloth out of his leather pouch. I recognized my handkerchief. It was stained with dried blood. Before he handed it to me, he kissed it, keeping his eyes locked on mine.

My fingers trembled as I took it. "Thank you" was all I could manage. I quickly tucked it in my bosom.

"I will make all the arrangements for our journey tonight."

"You must hurry. I am to be formally betrothed in three days."

"I promise we will put our plan into action before then. We must make haste if we are to end this madness between our families."

"Promise me one thing," I said. "Do not mention this to Herr van Eyck. He is, it turns out, a spy, mainly for the Duke, but he also has been spying on us. I do not trust him."

"Nor I," Angelo said his expression darkening. "I know him well, and betraying my family's secrets to your father, and probably your father's secrets to my clan, seems to be his latest contribution to all the intrigue."

"For which, I supposed, we must be grateful, Angelo. Otherwise . . ."

Angelo took my hand again. "Otherwise we would not have learned of the latest plots in time to avert at least some of them. Nor would we be wed before your betrothal was formalized."

Wed. I trembled to hear the word. "You are sure you will be able to contact this priest?" I asked, unable to keep my voice steady, for suddenly fear gripped my heart. "If you fail, if we set off and are unable to find someone to bless our union . . ."

"I would never put you in that position. I would die first, Giovanna. I need to know you trust me in this—with all your heart."

I didn't need to answer with words. Angelo's dark eyes searched mine and read the answer there. Before I drew my next breath, he leaned down and let his lips brush mine. I knew I should protest. I knew my very honor was in danger should anyone chance upon us kissing in the chapel. Instead I allowed his lips to linger on mine.

I was powerless to move. Feelings—powerful, deep, inescapable, and totally unexpected—stirred in the depths of my being. It was Angelo who had the presence of mind to draw away.

"Try to come to the fair tomorrow. I will get you a message as to where and when. And should anything happen between now and then, get a message to me. Your maid, Emilia, has stolen my man Rodrigo's heart. You can trust her. If you can't write, send the handkerchief." He kissed my hand before melting back into the shadows behind the statue of the Virgin.

I had no time to kneel down again. I had barely grabbed my prayer book when Emilia entered the chapel. The guard accompanied her, along with Tonio and van Eyck's man, Hans.

"Ah, signorina, it seems you have finished your penance," Emilia said, glancing from the *predieu* to my prayer book.

"Yes." I finally managed to utter the lie, hoping some saint in heaven would forgive me. I stood tall and straightened my veil, but inwardly I shrank back at the frank look Hans gave me. His gaze traveled slowly from me, taking in the rest of the chapel.

His eyes rested on the statue of the Virgin, on the shadows behind her. To distract him I fussed with my skirt and looked up at him with big wide eyes, hoping that the fact that I'd been kissed for the first time didn't somehow show.

The Potion

Fool that I was, I was still dreaming of that kiss over dinner that evening.

And because I was lost in daydreams, I never suspected the trouble brewing as my father conversed with my aunt—a decidedly one-sided conversation. My aunt still couldn't open her mouth wide enough to swallow gruel or even sip lukewarm broth, let alone talk.

I was in such a flighty state of mind, I barely noticed that my aunt, who was understandably vain about her good looks and extensive wardrobe, was showing herself in a semipublic chamber wearing her shabby gray overgown with her jaw cosseted in a flannel cloth. She also reeked of the herbs in the apothecary's poultice.

My reveries were broken by my father's voice. "Giovanetta, are you listening to me?"

"Yes . . . of course," I lied. My cheeks began to burn. I caught my aunt staring intently at me.

"Good! The decision has been made. Everything is finalized except for signing papers in front of a notary."

"Signing papers?" Abruptly the light, feathery feeling in my stomach turned to lead.

"Your betrothal contract, of course. Since both Signor Arnolfini and our witness, Herr van Eyck, must leave Lucca early tomorrow, we agreed to go to the notary first thing."

"Tomorrow?" I jumped up, nearly upsetting my plate.

"Giovanna!" My aunt's warning was mumbled through her swollen jaw.

Papa looked past her, toward me. "I trust your confessor advised you this morning that you are to do my will in this as in all things."

"My confessor?" I frantically racked my brain. My father had tricked me once again. I had to put off this betrothal. But how? I had believed I had two more days, at least, to give Angelo time to contact the priest and arrange our departure from Lyon.

Then I decided that one more lie wouldn't matter, as I already had sinned grievously in the eyes of God. I faced my father squarely. "The priest did not tell me I must marry someone I did not love." I stood at the table, wrapping my napkin around my hands. I realized later I was holding on to that piece of cloth like some kind of lifeline. "He—he told me to pray for guidance."

Papa's voice was ominously quiet. "And exactly what guidance did you get? I hear you spent quite a bit of time praying to the Virgin in her chapel. Did the good Lady have an answer for you?"

"No," I said quickly, fearing heaven itself would punish me if I lied in Mary's name. "I received no answer. Undoubtedly more prayer is called for. Meanwhile I will not agree to the betrothal."

"Apparently confession didn't humble you." Papa rose. As he pushed

back his chair he upset a goblet of wine. The red liquid spilled and dripped like blood onto the floor. I stepped back and held up my skirts. For sure the ruddy pool at my feet was an evil omen.

"What you *will* or *will not* do is not up to you, young woman! You will obey me." And he sent me back to the confines of my room.

I was on my bed sobbing into Rags' side, when I heard the door creak open. It was Zia Clara's maid Rosa, followed by Tonio and Luigi. A look of pity crossed her face.

"Sorry to disturb you, signorina, but your aunt has arranged for you to sleep upstairs with Emilia this evening. Signora Clara's tooth still aches and she is restless in her sleep. I will stay with her tonight. Tonio and Luigi are here to move your trunk."

While Rosa talked, she picked up Rags' bowl and basket, and I gathered up Rags. Feeling defeated, I followed her upstairs.

My new room's sole virtue was that it did not stink of the apothecary's potions. Otherwise, it was a cramped, colorless room. I sank heavily down on the floor at the foot of the bed. I sat perfectly still, barely aware that Rags was licking my hand. My head was pounding; my brain was in a whirl. How could I avoid this betrothal? Would I ever see Angelo again? When his man arrived at the fair and didn't find me, what would Angelo think: that I had grown faint of heart and had lost courage? How could Angelo's man get a message to me? More to the point, how could I get a message to his man? The thought made me laugh out loud. How in the world would I even get within ten feet of the fair?

I now saw the folly of my outburst at dinner. Yes, I was twice the fool my father thought I was. Perhaps I should have asked to speak alone with Signor Arnolfini, begging him to delay the betrothal until spring. Surely

my old friend would have tried to help me but no, he too seemed in a
sudden rush to wed.

At the very least I should have pretended to submit to Papa's will.
Then I would not be locked inside this room. If there were some way to
take back my words I would—if that would gain me my freedom and
somehow allow me to go to the fair. Perhaps I could have bartered with
my father, begged him to postpone the betrothal one more day. I had no
idea what excuse I could conjure up—what *believable* excuse. Perhaps a
lie about wanting to buy some small bit of finery or lace at the fair to cel-
ebrate my betrothal would have served the purpose. Maybe it wasn't too
late. Maybe I could send a message to my father that I had reconsidered.

I rose from the floor and was about to call out for Tonio when I had
a terrible thought. What if my father believed me but did not give me per-
mission to go to the fair?

At the sound of the bolt being thrown, I jumped up, afraid it would
be my father. Instead it was Emilia. Her demeanor was serious, but I
glimpsed a familiar sparkle in her eyes.

She walked in, bearing a pitcher of water and several candles. "Good
night, Tonio," she said, as he closed the door again and latched the lock.

She put the candles on the dresser and splashed some fresh water into
the washbasin.

"Emilia, you look like a cat that swallowed a bird!"

She shook her head and put a finger to her lips. Then in a loud voice
she announced. "Signorina, I brought up some bread and cheese, as I saw
you ate little at dinner." Going to the door, she pressed her ear to the
wood, then motioned me to move toward the window.

I realized that she wanted me to feign hunger. "I was too upset to eat

then," I answered, also in a clear, loud voice as I moved away from the door. "But I'm hungry now."

She looped her arm through mine and whispered in my ear, "He has sent a message."

I gripped her arm and lowered my voice to a whisper. "How? How did he get a message through?"

Emilia gave a wicked little laugh. "Rodrigo, of course. He is wooing me. I am not sure if I favor him yet or not, but for the moment he serves our purposes."

I closed my eyes so as not to view the self-satisfied smirk on Emilia's face. The fact that she was letting Rodrigo court her to help my cause made me uncomfortable. Yet I thrilled to the idea that he had brought word from Angelo. "So what did he say?"

"Rodrigo? Oh, that I have eyes like stars and hair like silk and—"

I grabbed Emilia by both her arms and actually shook her. "Stop it, Emilia. I don't need to hear a catalog of your charms worthy of a troubadour's songs. This is a matter of life and death. My betrothal is set for tomorrow."

"Tomorrow?" Emilia caught her breath. "Then there is no way for you to get to the fair." Her face mirrored my own despair.

"None at all," I said quietly, trying to fight back the tears that pressed like cruel fingers behind my eyes. "We're both stuck here."

"Your friend Signor Grimaldi is rather clever—perhaps too clever," she added. Then a note of caution crept into her voice. "Giovanna, what has he promised you?"

"That we will wed," I answered easily.

"And you trust him?"

"Why wouldn't I?" Then I realized what she was suggesting and my face grew hot. "Of course I trust him. He is a gentleman. His family and my family are equals back in Lucca, as well as in Bruges. He would not— dishonor me."

"We should both pray to the Virgin that you are right about that before we make our plans."

"What plans? I see no way out of my betrothal tomorrow."

"And your connection to Signor Arnolfini is not legal yet—you're sure of that?"

"Of course not. Zia Clara was sick today, and my father called on the notary while I was at church. I suppose he arranged to change the date then."

"Good that the matter is not concluded, for then what we are about to do would be a matter of law and I might be imprisoned." I could see her wavering in her resolve, but she finally threw up her hands. "I believe in the course of love, signorina, though I fear that we will both get into terrible trouble here. Your Signor Angelo gave something to his servant besides a message." She reached into her sleeve and pulled out a small, stoppered vial she had tucked into the loosely stitched hem.

Now, I've heard it said that when people are on the verge of commit- ting some terrible or dangerous or evil deed, they can feel the brush of their guardian angels' wings against their spine, warning them. The sight of the amber-colored vessel sent such a chill down my spine that I felt as if I were in a tomb. I recoiled from the very sight of it.

"What is that, Emilia?" Terrified to hear the answer, I held my breath.

"You needn't look so tragic, signorina!" Emilia said with a nervous laugh. "It's not poison. It's merely a sleeping draught—a very mild one."

"And exactly what are we supposed to do with it?" I asked, not feeling particularly reassured.

"Rodrigo gave me this note. It is in a language I cannot read. I think it is Latin." She handed me the little square of paper. It was, to my dismay, not sealed.

"You did try though."

Emilia nodded. "I suppose I should apologize, but I was as fearful as you that it might be something—well, very dangerous. However, Rodrigo told me what it was and that it would not hurt a soul, even if perchance we accidentally dropped the whole contents in one person's beverage."

She offered me the vial. I pushed her hand holding the draught away from me. "I do not like this scheme, whatever it is. I will have none of it, Emilia. Throw this evil potion away."

"Read the note," she urged.

More because Angelo had written it than because I wanted to know the contents, I obeyed. I took a candle from the mantelpiece and read the note by the flickering light.

The message was brief, penned half in Latin, half in Italian; but the meaning was very clear. Angelo said that after seeing me, he knew he had to save me from a marriage to a man I loathed. The note went on to say that he had gone to the apothecary and purchased the mildest of sleeping potions in case I had need to escape the inn and had to be sure my guard would sleep deeply enough for me to make my exit. He hoped I would not be afraid to use it.

That was all the note said, except that he would see me at the fair and that arrangements would have been made for me to escape Lyon. He

promised to love me forever, and honor me, and bring me to a safe haven where we could wed.

Reading these words, my blood went from cold to hot to cold again. Angelo had arranged somehow to *wed* me after such a short acquaintance. My courage was failing me. How could I defy my family by running off with not just a near stranger but one whom my father hated more than anyone in the world? What if our families didn't forgive us and end their centuries, long feud? What would happen to me? To us? To whatever children we might have?

In the next moment, my heart began to race and all my doubts washed away. I reread the note out loud to Emilia, then with great regret consigned it to the fire.

"You're burning it!" Emilia exclaimed, horrified.

"No one must see this note, Emilia." I took a deep breath and then with my next words sealed my fate. "Angelo plans to wed me. He wants me to meet him at the fair for that very purpose."

"Except we can't get to the fair," Emilia reminded me, though the fact suddenly didn't seem to bother her at all. "Which means we have to somehow meet him tonight."

"Yes, tonight." I took her by the arm. "That's impossible." I went over to the door. The din from the publish room rose up into the hall outside. "We're well guarded."

"Not so well. It's Tonio, thank goodness." Emilia pursed her lips. "He is easier to trick."

"And how do you propose to trick him." I was beginning to believe the girl had lost her mind.

"This potion, of course."

I had to laugh. I marched across the room and mimed her handing him the vial of liquid. "Tonio, *per piacere*, would you please, pretty please drink this draught."

Emilia chuckled and flung her veil back over her shoulder. "All right. Make fun of me. But I have a plan, or at least part of one. I'll tell him you are hungry and I am to fetch you dinner and certainly some food for that dog," she added, pointing toward Rags, who was actually for once not yapping for food. He must have heard mice or rats scampering behind the stone wall, for he lay sprawled on his belly on one side of the hearth, with his tiny ears up and alert, staring at the wall.

"I'll tell Tonio," Emilia continued, "that if the dog doesn't eat he will yap all night and no one on this floor or below, for that matter, will get a minute's rest. On the way back I'll bring him wine, nicely laced with Angelo's potion; and then . . ."

I playfully batted her on the head. "And then what? You'll convince him to unbolt the door before he dozes off? And yes, what about Rags? I won't let you try to slip him a sleeping draught."

"Rags is the easy part. The cook is enamored of the beast. I'll fetch enough scraps and bones from the kitchen to keep him busy gnawing for hours. Then he'll be so stuffed, he'll sleep all night and into the morning."

I had to admit Emilia was clever, but not quite clever enough. "But the bolt, Emilia—how do we get the door unbolted?"

"That's easy too. I'll come in and deposit a tray of victuals for you and the dog then pretend to have forgotten something and run down-stairs again. Meanwhile I'll tarry below long enough for the wine to take effect. When I come back up, Tonio will be sleeping like a baby. I'll open the door, and we'll leave . . . which reminds me. We should get a satchel

and pack some things for the road." She concluded with a smug confidence that gave me a chill. Emilia seemed oddly at ease with schemes and deceit.

Even so I eyed her with newfound respect. I applauded her softly. She grinned at me. "See, I figured it all out for you."

"Not quite," I told her. "Once you unbolt the door and I gather up my satchel and Rags, we'll both merrily descend the stairs, pass by the public room, and go out the front door and into the inn yard—two young women, unescorted, at night. Even if we can get past the gatekeeper, we will certainly have at least some difficulty dealing with the riffraff huddled just outside the Chanticleer's walls."

Slowly Emilia's smug expression faded. "Oh! I hadn't thought that far ahead."

"And," I added, feeling a bit smug myself, "How do we find Angelo? How will he even know about our change of plans?"

"His man. He told me he'll have Rodrigo or one of his other men posted right outside the inn all night, keeping watch. I am to go and tell them exactly when we will meet them at the fair. But since we won't be meeting them at the fair, I'm not sure what I'll tell him now," she concluded, looking utterly despondent.

It seemed cruelly unfair—to have such a good plan and then no way to execute it. Emilia touched my hand. "I'm sorry, signorina. I thought it might work."

"Only if we could somehow wax invisible, or—or . . ." Then inspiration struck. "What we need is a disguise."

"A disguise? A mask wouldn't help much, signorina. We'd still look like women in our skirts and be prey to any scoundrels prowling the inn yard or the streets beyond."

I laughed out loud. I felt positively giddy with hope. "Not a mask. A whole disguise. We need to dress in such a way that we won't draw attention to ourselves. And then we need some way to get out of Lyon, past the gates, before dawn."

"But how?"I didn't answer. I hurried over to my trunk, then pulled out my writing desk. I set up my ink pot and paper, grabbed the quill, and proceeded to write a hasty note. "Bring this to Angelo's man. And don't even pretend that you don't know how to slip outside to get to him. You're very good at wheedling the stable boys and whoever else lurks around the inn yard." Then I remembered the handkerchief tucked in my bosom. "Have him bring this to Angelo." I handed it to Emilia. "He'll know it is not one of my father's spies who is trying to trick him into coming to the inn tonight."

Emilia took the sealed note. "I see I'm not the only person around here good at scheming." Her eyes glowed with excitement. "I only hope Signor Grimaldi is worthy of you, my lady," she concluded as we proceeded to gather a few necessities and a change of clothing.

Then she called for Tonio. He opened the door. She explained about my needing food and Rags being starved. Tonio let her pass. Armed with the sleeping draught, she headed downstairs to execute the first phase of our plan.

A Clever Disguise

And so it was that several hours later Emilia and I were finally ready to escape the Chanticleer. As the evening progressed, I had grown increasingly reluctant to proceed with our plan.

It seemed to me at times the foolish scheme of characters from a tale of romance, and yet it was those very tales that had inspired my disguise. Angelo's man had provided the items needed. Now, after much confusion about how to fasten the points on the top of my hose to my doublet and bouts of nervous laughter, I was clothed as a young man in the slightly worn and patched, dark-hued garments of a gentleman's servant. Because I am thin, and with my hair tucked up beneath a close-fitting cap, I truly resembled a young beardless, man, even without the further camouflage of a voluminous hooded cloak.

With her full-busted figure and plump hips, Emilia could no more pass for a young man than I could for a horse! However, either Angelo or Rodrigo had foreseen the problem, so I who was disguised as an apprentice was accompanied by a rather bright-eyed, rosy-cheeked-monk, a true friar in a loose burlap robe. To hide her hair, Emilia had

tucked it back and wore the hooded cowl of her outer garment up.

"It's best we leave now," I suggested after checking over our costumes one last time. I bent down and patted Rags, who stirred lazily in his sleep. As Emilia had predicted, an overly hearty portion of that night's ham, complete with large bone, had sated the poor creature. I longed to take him but only hoped that when Signor Arnolfini learned of my departure, he would remember that, after all, Rags was only on loan from him.

We each shouldered a neatly tied bundle of clothing along with a small packet of journey cakes and light provision Emilia had procured. Then, stopping just inside the door to the room, we exchanged a glance. The bravado was gone from Emilia's eyes. She looked as frightened and anxious as I felt. On impulse I hugged her, and she hugged me back.

"It's not too late, mistress, to change your mind," she whispered.

I forced myself to ignore the plea in her voice. "To change my mind is to mean that in twelve hours from now or so I will be pledged for life to a man I can never truly love."

Before my newfound resolve could weaken, I cautiously opened the door. Outside, Tonio was snoring loud enough to wake the dead.

We closed the door behind us, and as Emilia started down the hall, I had the presence of mind to bolt the door again. Should anyone from my father's retinue pass by, they would see Tonio asleep but presume that Emilia and I were still locked inside.

Emilia led me to the back, servants' staircase. When we reached the ground floor, we avoided the hallway leading to the kitchen. Instead we boldly passed right by the public room.

"Ave, Brother!" Someone called out to Emilia as we passed. She quickened her pace, but I tugged on her robes and hissed, "Bless him, but

don't let him see your face. You must act the part of a humble friar or we will be suspect!"

Emilia traced the sign of the cross in the air but averted her eyes from the public room. "God forgive me for this," she murmured.

We got as far as the inn yard without incident. Just as we approached the gate, one of the stable boys sauntered up to us. The smell of beer was on his breath, and he brandished a flickering torch in one hand.

"Good night to you, good friar," he said. I thought I detected a mocking tone in his voice.

"*Benedicte*," Emilia mumbled, then put her hand to the boy's lips.

She cast a panicky glance at me. I cleared my throat and tried to lower my voice. "Sorry, the good friar has taken a vow of silence as a penance."

"That's dull. Well, anyway, there are some men with horses outside that asked if we'd seen a friar and his servant."

Oh, Angelo is here, I realized, and my heart soared. "We are expecting them. They are accompanying us on the next leg of our journey." As soon as I spoke, I wanted to kick myself, for failing to lower my voice.

The stable boy noticed. "You seem young to be an apprentice." He raised his torch to better light my face.

Instinctively I raised my hand to shield my features. Fortunately the boy was drunk enough not to notice that my hands were smooth and delicate and had never seen a hard day's work, or that I had forgotten to take off my filigreed ring.

Emilia took my arm and practically dragged me toward the gate and mimed that we needed to make haste. "Please, can you open the gate for us. Our companions have been waiting and we are late. We must journey far before tomorrow night."

A shout from the stable distracted the boy. "They're calling for me," he said, and hurriedly unlatched the gate.

In spite of the hour, a crowd of beggars mobbed the gate, practically knocking Emilia and me to the ground. A figure swathed in a heavy, dark cloak roughly swept them away from the door. "Make way for the friar, you scum!" His tone was arrogant and I almost pitied the beggars, but the sonorous voice blinded my heart.

"Angelo!" I murmured.

I felt his hand firmly grip my arm. "I cannot be seen to escort you here," he whispered back. "Just stay close and follow me," he instructed. "Remember, you're my servant—one of my *male* retainers." I detected a flicker of amusement in his voice, and despite my nervousness I was barely able to suppress a laugh.

Angelo cut a path through the sea of upstretched hands. My stomach turned at the stench rising up from the unwashed supplicants. I pressed my sleeve over my mouth and nose to quell the odor. Behind me, I heard Emilia gag.

Bringing up the rear was a handsome, fresh-faced man wearing the Grimaldi livery. Though I hadn't met him before, I was sure this was Emilia's Rodrigo. While Angelo was lithe and slender as a cat, Rodrigo was brawny, tall, and muscular. I felt even safer in his presence though part of me feared that the outcry of the disorderly medicants would rouse the innkeeper and our flight would be discovered.

Fortunately the commotion soon died down. Seeing they would receive no charity from our party, the beggars gradually dropped back to huddle around a paltry campfire burning near the Chanticleer's gate.

Free of pursuit by the motley crowd, Angelo was able to guide us

quickly away from the torchlit street in front of the inn into the shadows. Nearby, a horse neighed, and I heard Angelo breathe a sigh of relieve. "Good. We've gotten this far without incident. That is a good sign." A groom, again sporting the Grimaldi livery, emerged from a narrow side street. He was leading two saddled horses and a pack animal.

"Only two horses?" I gasped. "But there are four of us—or five."

"Not to worry, signorina," Angelo spoke up, turning to face me for the first time. He bowed slightly, though I could tell he was as tempted to take me in his arms right then and there as I was to kiss him. "Tomorrow we will have more horses. I sent a messenger ahead to the Abbey of St. Ives. Fresh and additional horses, and provisions for our further journey, will be supplied by my contacts there."

"And where exactly are we journeying to?" Emilia put herself between me and Angelo, and I noticed she neglected to curtsy.

Angelo favored her with a gallant bow. "Italy of course. To Lucca, where I have friends and family who will support this union between myself and your mistress."

Emilia cast a nervous glance at the horses. "Where's your wagon?"

"Such vehicles would only slow us down," Angelo said. "But there is no time to discuss that. We must reach the city gate before the changing of the night guard. I have arranged our passage out of Lyon, and we have far to ride before we reach the abbey tomorrow." With that he motioned for Rodrigo to mount the larger horse. As soon as the servant was seated, Angelo made as if to lift Emilia up behind Rodrigo.

Emilia resisted. "But I've never ridden a horse, let alone in these robes and the hose you had me put on beneath." Panic-stricken, she looked to me for help.

I must say, I did feel for her. As for myself, I adored riding but had never straddled a saddle like a man. It felt, well, embarrassing, and I had some doubts if even I, an excellent horsewoman, could keep my seat.

"I won't let you fall off," Rodrigo spoke up. "Once you're up here, just hold onto me." I saw Angelo looking back toward the street.

"There's no time for this," he grumbled. "Tell her to obey you now!" he ordered.

A little part of me resented his commanding me, as perhaps my own father would; yet I forced myself to ignore Emilia's plight, for Angelo's fears were all too real. "We can't dally here, Emilia. Soon the night watch will pass and we will be discovered. Just do as Rodrigo says. Look, riding like a man is new to me too," I said, reaching out for Angelo's hand. I motioned for him to put me on his horse. "I'll mount Angelo's horse first. You'll see that riding like a man is not so fearful a thing."

Emilia continued to look skeptical as Angelo put his hands around my waist to lift me up.

His touch sent the blood coursing faster through my veins. His hands continued to hold my waist as I settled down onto the saddle. Slowly he stepped back, but only reluctantly let go of my fingers.

I found it hard to swallow but suddenly was conscious of Emilia and Rodrigo watching us.

I slipped my feet into the stirrups and, holding onto the saddle horn, tested my seat. Avoiding Angelo's eyes, I smiled bravely at Emilia. "This far surpasses riding sidesaddle, Emilia. It will be easier to learn to ride as a man does."

"There's no choice for it now, is there. I'd be sacked anyway if I went back to the inn," she grumbled. Rodrigo reached down for her

hand as Angelo hoisted her up in front of his servant.

"It'll be easier for you to keep your seat in front than behind." With those words, Angelo slung himself up on his horse behind me. He bent down and gave some last instructions to the groom, then spurred his horse and we were off. Rodrigo led the pack horse behind us.

Angelo wrapped one arm around my waist and held the reins with the other. He had muffled the hooves of the horses by putting burlap booties over their iron shoes, but even so I feared the racket from their passage over the cobbledstones would alert the watch. However, we progressed without incident to the eastern gate of the town. There Angelo paused only long enough to hand over a bribe to the guard, who let us through without any questions.

As the heavy gate clanged shut behind us, Angelo spurred his horse on to a slow canter. The road was wide at first, though pitted Rodrigo rode up beside us, with the packhorse, only lightly laden, easily keeping pace. It was too dark to see Emilia's face, but I was sure that the poor woman's first experience riding a horse—in the dark, on a rutted road—had to be terrifying.

We stopped only once that first hour. As soon as we passed through the last of the tiny hamlets that ringed the town, Angelo made us all dismount. He and Rodrigo quickly tore the burlap booties off the horses' hooves. When the men went to relieve themselves, Emilia reached for my hand. Hers was even icier than mine. "Signorina, has he told you yet exactly where we are spending the night?"

"Only that we ride through the darkest hours and continue until we reach a monastery, where he has arranged for us to stay."

Emilia frowned. "Will there be a padre to perform the ceremony?"

"Not tonight."

"Good lady!" she gasped.

"No, you misunderstand. He has arranged for a priest to marry us. The priest is resident at an abbey outside the duke's territory and is from Lucca. I can't explain more now."

Emilia's expression remained skeptical, but before she could say more Angelo and Rodrigo returned to us.

"I pulled these out of our packs," he said, handing each of us a pair of fur-lined gloves. "Just remember, Friar—shall we call you Friar Louis?— to hide them well whenever we meet any fellow travelers. Fur-lined gloves are not a wandering friar's usual garb."

The men then helped us back on the horses, and we took off again at a brisk canter.

The cloudless sky was dark, but the moon was near full, casting eerie shadows across the roadbed. Despite the warmth from Angelo's body, and the fur lining of my cloak, and my new gloves, I was beyond cold. The night had grown frigid, and the clear air was damp with the promise of snow on the morrow. From my geography lessons, I remembered that to get to Italy from Lyon we had to ascend into the mountains, where we would surely freeze if we did not have adequate shelter.

We continued to travel the next half hour or so in silence. Angelo seemed intent on putting as much distance between ourselves and Lyon during the darkest hours of the night. The road was rough and lit only by the moon. From time to time he reached for my hand, as I gripped the saddle horn, to reassure me; but he did not volunteer any information.

Left to my own thoughts the enormity of what I had just undertaken threatened to overwhelm me. Had I been mad to think that Angelo's

dream of uniting our families through marriage would actually work?

My heart waxed more fearful that we would fail the farther we traveled from Lyon. We were about three leagues from town when I sensed someone was trailing us. From time to time I thought I heard the muffled clop-clop of one, or two, or several horses. But whenever I tried to turn around, my view was blocked by own hood and Angelo's shoulders.

Finally, I broke the silence. "I saw riders," I whispered. "I'm sure of it. I've heard horses not so distant from here. We are being followed."

He quickly dismissed my fears. "It's just a trick of the moonlight. The sounds of the night are confusing and mysterious at times, but I hear no hoofbeats. I am sure a sweet young girl like you has seldom ventured abroad at this hour—certainly not through the countryside, for you are city born and bred." After a moment he added, "Perhaps you need to rest a little. We've put some distance between us and town. I worry about your maid; she is putting on a brave face, but I'm sure this pace is hard on someone who's never ridden before."

I shook my head. "I'm afraid my father's men will find us. And Emilia will survive. She's as fearful as I am of being discovered before . . . before . . ."

"Before you and I are formally wed in the eyes of the Lord," he finished for me. There was such sincerity in his voice. "Believe me, dearest signorina, I will not let any harm come to you. But as you suggest, it is better to press on if you are able."

As we continued to travel the miles, Angelo and I began to discourse. He told me a little about himself, how he was somewhat estranged from his family: "Because," he confided, "I refused to enter into their various nefarious business schemes. Besides, I favor the courtly life."

"How did you become a minstrel?"

"I was sent to the Spanish court when I was just a boy—my family looked forward to forging a strong business relationship. As it turned out, I haven't the head for business, but I do have a good singing voice and an ease of fashioning words to my music. People at court support such talents."

"Was it there that you met Herr van Eyck?" I asked.

"Yes. Now I wish I never had. It seems he is more treacherous than I thought."

"Treacherous?" I shrugged. "I am not sure I trust him, but as I told you in the chapel today, were he not a spy, we would never have learned of your father's plans."

Angelo said nothing.

Finally I asked, "What do you do for him? Your hands are not those of a painter's helper." Sensing his confusion, I told him about my visit to the Master's studio.

"And what exactly did he say was the nature of my work for him?"

His voice held a note of caution, which surprised me. I shrugged again. "Only that you are sometimes in his retinue. I know Herr van Eyck is traveling to the Spanish court, I imagine to execute some commissions for tapestries or paintings. Though you said you were going to Portugal the other day back in Bruges." I straightened up and turned so I could see his face. "What will happen to your business there? Was there some special reason for you to play your music at the Portuguese court?"

Angelo shook his head. "I was asked to join a troupe of musicians for the winter season. When I don't turn up, they will find another minstrel."

The Road to Lucca

As we rode through the night, Angelo continued to regale me with stories of his travels and tales of his childhood pranks while being virtually fostered to royalty at the Spanish court. Eventually I drifted to sleep lulled by the musical quality of his voice.

The tolling of a bell woke me. I opened my eyes to bright noonday sun and a steep landscape dusted with snow. In the distance high, snow-capped mountains towered against the clouds. Angelo had slowed our horse to a walk. The road was in bad repair, and just ahead a monastery loomed, its gray stone walls bleak against the bright winter sky. While we were still a quarter of a mile or so from the imposing structure, Angelo brought the horse to a standstill. The air was so cold, the horse's nostrils gave forth tiny puffs of steam when it snorted.

"How long have I slept?" I asked, conscious that my mouth was dry and my breath was probably not at its sweetest. Out of habit I reached up to straighten my veil and instead touched the fur trimmed hat beneath my hood.

"Since just past midnight, which is all to the best. Now you must

resume your role as my servant," he said. "My courier reported back to me. The good monks at the abbey are expecting us. *Us* being myself, Rodrigo, a friar vowed to silence from a mendicant order, and of course your good self—my servant." He touched my hand and breathed a kiss on the back of my neck. "Remember now, you are a young man. And I'm afraid, as my servant, you will have to walk. Emilia, as proper to a friar traveling in company such as ours, can still ride. Do not fear, Rodrigo will approach the monastery with you. Let him do the talking, as the high pitch of your lovely voice will surely betray your identity as a girl."

He helped me down from the horse. The men's hose that served me well on horseback felt restrictive now, and though I needed to relieve myself, I had no idea how to manage with these unfamiliar garments. Emilia, looking sleepy, guided me behind a stance of pines and helped me undo the points that laced the top of my hose to the bottom of my doublet. When we both finished, she helped me straighten out my clothes and I tucked her hair more securely under her cap and adjusted the cowl of her brown, coarsely woven robe. It was then that she pointed to the device embroidered on my doublet. "To think a Cenami is wearing the livery of a Grimaldi servant." She sounded almost wistful. "It's a strange thing. Good your father cannot see this."

"Ah, but, Emilia, the next time he sees me I will be wearing Angelo Grimaldi's ring. More to the point, I'll be wearing his name for the rest of my life."

"The sooner this wedding happens the better," Emilia mumbled as Rodrigo called out to us, urging us to hasten. "We must hurry. By now surely your family will be searching for you."

Our arrival at the abbey went smoothly. Fortunately I had a way

with horses so that when Angelo dismounted and handed me the reins I was able to manage the animal and pass him over to the young novice who hurried up to tend to our animals. And, miracle of miracles, Emilia managed to keep her mouth shut while Rodrigo spoke to the monk who was keeper of the door.

We were quickly shown to our quarters in the abbey's sparsely furnished but clean guesthouse.

"Signor Grimaldi, I'll show you your rooms and then perhaps you'd like to dine with us. Your courier told us you have come all the way from Bruges and need to leave before dawn. Let me show you your quarters for the evening. I have saved your usual room for you and your servant. The friar and your other man can sleep in the next chamber." I waited for Angelo to protest. Surely he could not expect me to sleep with him before we exchanged our marriage vows—we were not even formally or legally betrothed.

When Angelo didn't immediately object to this arrangement, Emilia forgot she was supposed to be under a vow of silence. "No!" she said, managing somehow to deepen her voice to at least a low tenor. "This young man is still doing penance for disobeying his master. He and I will share a room so that I can pray with him and help him see the error of his ways." She grabbed my elbow and steered me into the room.

As soon as she closed the door, she threw back her cowl and actually scowled at me. "Of all the nerve. He cannot believe that you could spend the night with him before your vows are solemnized."

"I'm sure he would have arranged something, Emilia," I said, wanting to defend him. I could not believe Angelo would so blatantly compromise my honor. Surely he had intended for us to switch rooms later

so I would spend the night with Emilia and he with Rodrigo.

And indeed that was his explanation. He didn't want to cast suspicion on our disguises. "That's why my courier said we came from Bruges, not Lyon. It's best that no one we meet on route knows where we really started from. As for sleeping arrangements"—he brushed off my concerns—"the room assignments were no ploy to dishonor you or Emilia, my dear Giovanna."

After freshening up some, we all dined in the refectory. The holy atmosphere of the monastery made me uneasy. No part of me was sure the path I had rashly chosen was right. I felt that under the eyes of God I had sinned against my father. And yet would not the graver sin be to marry a man I could not love as a wife, only to live as apparently my aunt did—taking on lovers that pleased my heart and body more.

After dining Angelo suggested we walk together in the monastery cloister, which through some miracle of heat, light, and perhaps the friars' holy prayers had burst, even in November, into blossom. The scent of the trees was heady; and as we walked, though we were very careful not to touch, our eyes spoke eloquently to each other of kisses and caresses and pleasures to come.

It was then that Angelo finally revealed the rest of his scheme. We'd set out early the next day, at first light. If the weather held, we would achieve our first major destination: the Chapel of Mary of the Mountain, which adjoined a convent just over the Italian border. Angelo's courier had already arranged for the Lucchese priest to marry us. Fortunately he was still sympathetic to Angelo and had argued long though to no avail that the Cenami and Grimaldi clans call an end to their hostilities. "Our union, the dear padre believes, is the will of God," Angelo said. "It will

eventually bring the end of hatred through the example of our love."

I prayed the padre was right, for indeed the power of love was strong. Love alone had sustained me those past few days, helping me rebel against all I was brought up to be, think, and do.

We lingered long in the garden until daylight began to fade and Evensong in the abbey chapel began.

That night I decided to shared our plans with Emilia. She listened as I explained that all four of us would continue on to Lucca after the wedding, where, hopefully Angelo's family would embrace me as his new bride and in doing so would ward off any further intrigue between our clans.

Instead of seeming relieved at hearing my news, Emilia grew even more skeptical. "Can a feud really be settled so easily?" She frowned. "And, signorina, if Angelo is so eager to wed you, why not have the priest marry you here?"

In my heart of hearts I'd had the same thought. "I'm not sure why. Perhaps he wants to leave France as quickly as possible. The priest who will marry us is Lucchese, like both our families. Perhaps that matters—perhaps a priest who did not already know Angelo and our families' histories would refuse to marry us without first posting bans in the church and having the permission of my parents."

"I hadn't thought of that last part," Emilia admitted.

Before she could voice any further objections, I began to tease her about Rodrigo. "And Rodrigo, is he set to marry you?"

Emilia chuckled. "No, marriage is not what I expect from him. When I marry, I don't want just a gentleman's man for a husband. I would prefer a journeyman like Hans or Johan, someone who will join a guild

and eventually ply a trade. I have the kind of business sense that would help the right man run his shop. As for Rodrigo," she added with a saucy laugh, "he's not the marrying sort; but he's certainly got the nicest turn of leg, and he's worth dallying with an evening or two." With those words she blew out the candle in our tiny chamber, but before she went to sleep she said, "Perhaps I shouldn't talk to you about such things. You are still . . . well . . . so innocent."

Under the cover of darkness, I blushed. My thoughts these past twenty-four hours had been anything but innocent. But fortunately, though Emilia knew me almost better than anyone, she was not a mind reader. I rolled over, back toward her in the narrow bed we shared, and mumbled, "No harm done, Emilia. I think that by tomorrow night I will be perhaps even wiser in the ways of love than you."

Emilia barely muffled a loud guffaw into her pillow. "If you say so, signorina. If you say so."

With Emilia's laughter still ringing in my ears, I fell asleep that night full of hope.

Betrayed

The next morning I woke from a fitful sleep filled with despair. Remnants of dreams I couldn't recall troubled me. As I dressed, the Angelus bell tolled in the abbey tower and the grave, solemn sound filled me with portents of some kind of disaster lying in wait on the road ahead.

Not feelings suitable for a bride on her wedding day.

I was reluctant to share them with Emilia, who woke up singing and cheerful but who, I sensed, was still suspicious of Angelo's intentions.

I myself actually longed to be back in dreary Bruges, tucked under my coverlet, waiting for Emilia to bring me a cup of mulled wine. I missed the warmth of Rags, snuggled at my feet in bed and playfully nipping at my toes. I missed knowing that Matilde was in the kitchen, chopping vegetables for the day's stew. Why, I even missed the sound of my father in one of his rages as the first messengers from his house of business arrived with some dire news about shipments, bankers, and dye lots ruined by the new apprentice's mistake.

Part of me wished I could turn back the clock to before the duke's feast, the last day when I still felt like a little girl.

But without the Duke of Burgundy and Herr van Eyck, I would never have laid eyes on Angelo. I would never have heard his love song. Without the proposed betrothal to Signor Arnolfini, I would never have tasted Angelo's kisses or felt his hands on my waist, holding me, promising to love me truly, forever.

The four of us quickly broke our fast, and I helped Emilia repack our clothes while Rodrigo retrieved our horses, plus two more Angelo had arranged to borrow from the monastery stable. The abbot had supplemented our provisions with bread, cheese, and wine.

While Rodrigo secured the new supply of food to our packhorse and saddled our mounts, the abbot stood at the abbey gates, trying to persuade Angelo to delay our departure.

Indeed, as Rodrigo checked the horses' shoes, the leaden skies and icy wind promised snow.

"Not just snow," the abbot warned Angelo as he tightened the girths on his saddle. "But a true blizzard. The mountain passes are dangerous this time of year, young sir. You are welcome to our hospitality until the weather clears."

Angelo shook off the abbot's warnings. "I do not believe conditions are as dire as you predict, good father; but in any event we must meet up with the rest of our party at the Convent of Mary of the Mountain. We already are greatly delayed in our journey from Bruges, and it is crucial we make this connection."

"A late or missed connection is preferable, my son, to being caught in higher passes in the sort of blizzard this sky promises. What if there's an avalanche? A whole party was lost that way, in a late storm only last spring. Even without an avalanche, the snow could be so heavy, your

horses will falter. You will be forced to dismount and lead them by foot. You and the friar and your older servant might manage, but your younger boy here does not seem made of the sturdiest stuff." The abbot looked directly at me. I lowered my eyes quickly and kicked the toe of my boot in the dirt the way servant boys did at home.

And so, against the abbot's advice we set off, with me on a small but lively gray palfrey and poor Emilia straddling a gentle but rather large bay. She looked so uncomfortable and terrified that while we were still within earshot of the abbot, Rodrigo joked loudly and somewhat crudely about how this particular friar was the worst example of horsemanship he'd ever seen. Angelo kept us to a walk until we were around the first bend and out of sight of the abbey. Then, with Rodrigo holding the reins of Emilia's horse, and Angelo taking charge of the pack animal, we set off at a brisk gallop up the road. Emilia clung for dear life to her saddle horn, but managed to keep her seat, and looking back over my shoulder from time to time, I found myself proud of her.

At first our luck seemed to be holding. As the morning progressed, the gray skies brightened slightly. Angelo pressed our horses until I feared the poor beasts would collapse from the effort. We had traveled close to three hours before the first snowflakes fell.

Angelo slowed our pace slightly, then dropped back to talk with Rodrigo. I took the reins of Emilia's horse, and for the first time got a really good look at my maid. The cowl of her monk's robe had fallen back. Her face was pale, and she looked frightened.

"You were right last night," she murmured as our horses trotted side by side. "We are being followed. I spotted someone on the road just beyond the last curve."

"Probably just another traveler," I said. After all, this pass was a

well-traveled road linking trade centers in Italy to those in Burgundy, France, and the German Empire to the north. So far we hadn't encountered any of the merchant caravans that usually frequented this route—either because most merchants were already at the Lyon fair, or because winter was setting in and would soon close the mountain passes.

"Then why did he drop back when he saw us? And I'm not sure he was alone."

"It can't be my father's men," I assured her. "They would pursue us like demons."

"Then they be brigands," she said, casting a terrified glance over her shoulder. "And we travel with only two men. Surely thieves will discover you and I are women, and we will be brutalized." Before I could answer, she called out for Angelo and shared her suspicions.

He tried to dismiss them, but he finally admitted that he too had seen someone behind us. He explained the presence away, saying that whoever was traveling this road alone probably took us for the brigands Emilia feared. Then we resumed our original riding order, with Angelo and me in the lead and Rodrigo and Emilia behind.

Before long the wind began to rise, the flurries turned to a steady snow, and the evil weather the abbot had predicted set in. As we climbed higher into the mountains, the road grew more rutted. The snow had glazed the cobbled stones, and we were forced to slow our horses to a walk. Whenever I looked back on Emilia, I found it more difficult to see her and Rodrigo through the swirling snow. From the look of concentration on Angelo's face, I could see he was worried, though whenever our horses drew next to each other, he'd smile and try to sound cheerful.

Suddenly a shout went up from behind us. Rodrigo's voice barely carried over the howl of the wind.

"Something's happened!" Angelo said, and wheeled his horse around. I followed him back down the hill. To my dismay Emilia was standing by her horse. "It's gone lame!" she cried, shivering.

I jumped off my horse and sank into snow halfway up my boots. Surely this was the blizzard the abbot had predicted. The wind gusted, blowing open my cloak. I clutched it closed and trembled. If we lingered long on this mountainside, surely we'd all freeze.

Angelo peeled off his gloves and bent down to examine the horse's hoof. "Of all the rotten luck," he said. "It's not just lame. It threw a shoe."

Emilia turned on Rodrigo. Her voice shook with cold, but she was furious. "I saw you check those shoes back at the abbey! How could this happen?"

Angelo straightened up and turned on Rodrigo. "Yes, how?"

Rodrigo shook his head and looked miserable. "I don't know. Everything seemed in order back there."

Angelo's face was creased with a deep frown.

"What do we do now?" Rodrigo said.

Sounding almost relieved, Emilia suggested that she ride on Rodrigo's horse until they reach the next way station, or inn, or farm where they could procure fresh horses. "I'd be more comfortable that way."

Rodrigo and Angelo exchanged a worried glance.

"It's the only way, Signor Grimaldi," Rodrigo said.

Angelo paced a little and kicked at the snow. "But that will surely slow us down, and we must reach the convent and chapel before nightfall. Padre Antonio will only be there for the night. I learned from my courier that he has been called back to Lucca by his bishop."

"But, Angelo," I said, touching his arm, "there must be another priest who will marry us. And if not, then we will wait until we reach Italy. Surely this storm is worsening by the hour, and our chances of arriving at the convent before nightfall are slim."

"She has a point," Rodrigo said. "Isn't there a small inn half a league from here? It's not the most reputable of places, but I recall that for a good sum of money, they will provide us with food, lodging, and a fresh horse—or have their smithy shoe this one."

"What are you thinking, Rodrigo? By now our flight from Lyon has definitely been discovered, and the Cenami mercenaries are surely in pursuit. We cannot afford to linger anywhere. Signorina Cenami and I must be legally wed before her family finds us or there will be dire consequences for her, as well as for ourselves."

"Whoever's been following us will be delayed by this same storm, sir," Emilia said.

Rodrigo took her hand. "I'm afraid Signor Grimaldi is right. Men of the Cenami guard, unencumbered by packhorses and also without the burden of women can travel long and hard, no matter the weather."

"So what can we do?" I asked, my own fear mounting. Discovery before Angelo and I wed would be a disaster.

Angelo pressed his hands to his temples and paced. When he looked up, his expression was grave. "We must split up. You will take Emilia on your horse and lead the lame one to the inn. It is not more than half a league hence. "I will ride on ahead with my lady. We will tell them of your plight, and if they can spare a man and a horse, they will come back to help you. Meanwhile we will stop only long enough to drink something hot, and we'll continue to the convent. If we do not stop

again, or only briefly, surely we will reach it by nightfall."

"No!" Emilia shouted. "No. I will not leave the signorina alone with you—not until you are wed!"

"Emilia!" Angelo and I cried out in unison.

Angelo spoke up first. "Your concern for your mistress is touching, dear girl. But I promise on my mother's grave that I will not harm or dishonor her. We will be wed at the latest by morning."

"Emilia, please. If my father catches us, I fear he will kill me—and Angelo. Please trust us." Then lowering my voice so only she could hear me, I added. "I will not dishonor myself or my family. Trust me."

Emilia's eyes narrowed. Her reply was whispered. "It's not you I don't trust."

And so it was that within the hour Angelo and I had forged ahead, forcing our horses through the deepening drifts. We stopped at the inn, our mounts exhausted. A large sign, sporting the faded image of a charging wild boar, dangled from one chain over the entrance to the badly kept inn yard. The place seemed more a proper haunt for brigands and bandits than for honest souls such as ourselves.

Angelo finally summoned the innkeeper, an ill-favored man who reeked of beer and onions and looked as if he would end his years on the gallows. He haggled with Angelo before letting us in out of the storm.

At a truly outrageous price, we were able to obtain the last two fresh horses from the stable. We told him to expect the friar and Rodrigo. Then we warmed ourselves in front of a puny fire, in a public room that was littered with filth. In one corner, three mangy hounds growled and fought over a pan of stinking bones. The innkeeper fed us each a bowl of foul-tasting stew—made of what meat I dared not guess. But

I was famished and forced down a few spoonfuls.

Rodrigo and Emilia had still not appeared by the time we were ready to resume our journey. Unlike the abbot, the innkeeper didn't urge us to stay. He seemed happy to be rid of us, though for what reason I couldn't hazard a guess. I was already mounted on my horse when Angelo took him aside to gave him instructions, as well as a purse fat with ducats.

"You bribed the innkeeper after what we paid for these horses?" I asked as we plunged back into the heart of the storm.

"He's a poor excuse for a man, but he has his own twisted sense of honor. For a hefty price he will take care of our friends when they arrive and probably not bother to rob them. However, he has no more fresh horses to spare. Emilia and Rodrigo will have to wait for their own mounts to rest and for the smithy to shoe the lame horse."

Conversation after that became limited. With heads bent into the wind, our horses plowed their way slowly through the mounting drifts. Soon the road became close to impassable. We had traveled less than two miles when Angelo neared my horse and shouted over the howl of the wind, "We cannot go farther. . . .I should have listened to Rodrigo . . . and stayed back at that vile hostelry."

"Can we turn back?" I yelled.

Angelo shook his head. "We'll never make it. But there's shelter just ahead." He paused to catch his breath. "I've traveled this road many times. There's a side road that leads to a hamlet about two miles hence. But not far down the side road I noticed some outbuildings last time I journeyed this way. They are part of a local lord's holding, used in summer for grazing his sheep. At least we'll be sheltered through the night, through the worst of the storm."

We spurred our horses onward. They were slow and reluctant, but suddenly, they sensed shelter ahead—and the presence of other livestock. Just around the bend and a quarter of a mile farther, we saw the first of the outbuildings. It was a sturdy stone barn. Angelo dismounted and, leading his horse, used his body to plow a path to the entrance.

I slipped down from my palfrey, and though I was shivering and thought my heart had frozen in my chest, I frantically began to help him clear the deep snowdrifts away from the low wooden door.

At first it wouldn't open, but Angelo threw his body against it full force and finally it gave way. Chickens squawked and scattered before the open door. We led our horses inside and slammed the door behind us. The barn was warm and steamy with the breath of animals.

"Someone must be tending these beasts," I suggested, wiping the snow from my face. Icicles rimmed my hood, and my skin felt raw from riding hours in the driving snow.

Angelo immediately began unsaddling our horses.

My legs were shaky as I checked the nearest stall. A wide-eyed ox returned my gaze, and a cow in the next stall looked up from chewing her cud and mooed. Further inspection revealed two donkeys, a goat, and a couple of docile sheep. They seemed content and recently fed.

"Most likely no one's around." Angelo looked up from rubbing down his horse. "The lord's vassals probably live in the hamlet just north of here. No doubt they saw the storm brewing, tended the beasts, then went back to their cottages to wait out the weather."

"But they'll be back and find us, yes?"

Angelo led his horse to a stall. He smiled ruefully at me over the wooden slats. "They don't know to look for us, Giovanna. No one

does. We're off the main road now. We've no choice but to wait out the storm here and then resume our journey when the skies clear."

"But what about the priest who expects us to arrive this evening at the convent?"

"He surely will be aware of this storm. In fact, I doubt he himself will be able to travel. The Convent of Mary of the Mountains lies at an even higher altitude. The passes will be closed for several days. Weather will force him to wait for us."

For the first time I felt angry at Angelo. "Why didn't you think of this earlier? We could have all stayed at the abbey—"

"And waited for your father's men to turn up?" He laughed tightly. "I don't think so." He went over to my horse and began to loosen the girth.

"Of course you're right," I responded meekly. In my fear of freezing to death in the storm, I had forgotten all about my father and how he would be sure to pursue us, if for no other reason than to have an excuse to murder Angelo and get back at the whole Grimaldi family. What he would do to me if he found me before I wed was something I feared to even imagine. But perhaps he wouldn't get the chance to find me. "This storm will slow their progress too."

"Indeed—or at least whatever men they have sent along this route to Lucca. There are other roads, you know, some more southerly and open deeper into the winter."

I hadn't thought of that. "So they might not even look for us here." I couldn't tell if the fluttering in my stomach came from anxiety or relief. I reminded myself not to worry. Angelo would take care of me as he promised in front of the Virgin's statue in the Lyon cathedral.

He dried off the bridles and tack with a rag, then hung the saddles over the sides of the stalls to dry before currying the horses. "Not here in this barn, thank God, but surely there are always spies on all the roads leading out of any big town like Lyon. Our passing will be noted, as were our disguises. Patrons of the Chanticleer will certainly remember the rosy-cheeked friar and his servant, wearing Grimaldi livery, making their way past the gates the other night. At least one search party has surely reached the abbey by now."

Despite my nerves I had to laugh. "Even disguised we were rather eye-catching."

Grinning, Angelo walked up to me and took my hand. "It's good to see you smile. You haven't all day. I was beginning to fear that you regretted coming with me. That you would have preferred to be safely back in Lyon, even if it meant marrying Giovanni Arnolfini."

At those words my smile faded. "I have no regrets, Angelo, and not because I have escaped my betrothal. Or because I long to spend my life with you," I added, lowering my eyes for fear he'd read the desire there. I took a deep breath, then met his glance. "When we wed we will give both our families a chance for a new beginning. All the discomfort and cold and pain of this journey is certainly worth that. Isn't it?"

"It's worth everything," he answered. "But you are cold. I am so sorry I could not protect you from this storm."

I touched his hand, but moved away. Being so close to him, alone like this, weakened my knees as well as my resolve to remain a virgin until the good priest pronounced us man and wife. "I need to change my clothes. I am wet through," I told him, turning slightly away so he would not see the color rise to my cheeks. "Must I remain in this disguise?"

"No need just now. We are alone." He favored me with a gallant bow, then he took himself to one of the horse stalls and called out. "I will not offend your modesty, for I too am soaked to the bone and must change."

There were no more empty stalls, so after I retrieved my shift, my undergown, and other garments, I crouched behind a pile of hay and dressed. My hair was wet, so I shook it loose and combed it with my fingers. When I stepped out from behind the haystack, Angelo approached me. He touched my hair, then ran his hand down its length to where it dangled three handspans below my waist.

"It is so thick and fair," he murmured. I swallowed hard and tried to step back from him, but my feet had a will of their own, as suddenly did my lips, and I longed to kiss him.

I took a small step toward him. Angelo drew me close and lightly traced the outline of my lips with his finger. Then he proceeded to kiss me, showering my brow, my eyes, and finally my lips with feathery kisses that truly felt like the brush of an angel's wings.

Gradually his kisses deepened, and his tongue gently forced open my mouth. I felt a powerful stirring in my loins that was new yet not totally unfamiliar to me. Against my will my body arched toward his, wanting to close the space between us. A warning voice seemed to go off somewhere in my head, but it was weak and my knees waxed even weaker. I felt my legs begin to buckle.

Before I slipped to the floor, Angelo picked me up in his arms and brought me over to the empty stall where he had changed his clothes. As he carried me, he continued to kiss my face, my throat, my shoulders. He murmured my name, again and again. "Giovanna, Giovanna." The words sounded like a poem on his lips.

He'd already fashioned a bed by heaping hay into the stall, then laying our damp fur-lined cloaks on top. Gently he put me down upon it, showering me with kisses, caresses, and tender words. His fingers smoothed my hair, and his hands began to travel—down my face, to my neck, back up to my brow, and then back down again, tracing through my bodice the outline of my breasts.

I felt limp, and dizzy, and whereas minutes before I had been chilled to the core, now I felt as if every part of me were on fire. Perhaps it was the image of fire that brought me to my senses. For surely if we continued like this, unwed, not even betrothed, it would be hell's fire I'd feel lapping at my limbs, and not the flames of bodily love.

Summoning up the last shreds of my will, I gently pushed against Angelo's chest. He was breathing heavily, as was I. "Angelo, please, stop," I gasped. "This is wrong. We are not yet wed. Please . . ."

He continued to kiss me, and as he did my whole body seemed to melt like sealing wax. "Tell me, do you really want me to stop?"

Of course I didn't, but for the sake of my immortal soul I had to. "Yes, we must stop, now," I murmured, and this time managed to push against him using a bit more force.

But it was as if Angelo's passion had taken possession of him, for instead of drawing back, he pulled me closer and pressed his whole hard body against me. I felt as if my ribs were being crushed.

"Angelo!" I cried out, panic rising in my chest. Surely he would not ravage me against my will—or had he passed the point of reasoning? Oh, had I only listened to Emilia more carefully when she told her tales of how she meted out her favors to her male admirers, keeping them just enough in check to leave them interested and her virtue intact.

"Stop!" I screamed this time, and tried to shove him back, but he had pinned my arms behind my head and I felt one of his hands beneath my skirt, fumbling with my clothing. I tried to scream again, but he forced his mouth against mine, drowning out my cry for help.

All at once the door to the barn burst open, letting in a blast of snow and cold air. Horses in the stalls neighed, chickens fluttered from their roosts.

"In here!" a rough voice cried in Flemish. Then hands pried Angelo off me and flung him out of the stall and halfway across the barn.

Horrified, I saw his breeches were already undone. At the open door were three men: Herr van Eyck, Signor Arnolfini, and my father.

"Signorina!" I heard Emilia's voice. At that moment it sounded like a voice from heaven on high. Someone shoved her toward me, and I caught a glimpse of Herr van Eyck's man Hans behind her, glaring over her shoulder at Angelo.

Emilia was nearly as disheveled as myself. She still wore her friars' robes beneath her cloak, but her hair streamed wet behind her. She threw her own snow-crusted cloak around me, covering my breasts, which were half bare. She shielded me from the eyes of the men and bundled me into a far corner of the stall.

She wept like a mad woman as she helped me straighten my clothes. "I told them he was up to no good. He used Rodrigo to trick us. Rodrigo loosened the horse's shoe, somewhere between the abbey and that inn. Fortunately Herr van Eyck's men caught wind of the scheme and set out looking for us, even before we left Lyon," she babbled. "Those riders you saw trailing us, they were Grimaldi guards, making sure that no one found us before . . . before this. Apparently the whole family was in

on this vile scheme . . . oh, I am so sorry, I am so sorry."

I could make no sense of what she was saying, and at the moment I didn't care. For I saw that my father had his sword pressed against Angelo's throat.

"Please, please, do not hurt him," I begged, pushing Emilia away. I stumbled toward my father. Signor Arnolfini blocked my way. I looked in desperation from him, to Herr van Eyck. "Please, he did not mean to hurt me. Please, we were to be wed tomorrow. Ask him about the Convent of Mary, and the priest waiting there, and how we did this to end the feud. Tell him, Angelo . . ."

The words had barely passed my lips when Angelo looked at me. His handsome face was twisted into a mixture of pity, contempt, and scorn. "Oh, you truly are a little fool. This is part of the scheme, the part Herr van Eyck had no knowledge of—"

"No!" I cried, and would have stumbled toward him, begging him to take the words back. But Emilia held me in her arms.

Angelo just laughed. "I did mean to hurt you and your wretched clan, from the moment I saw you at the duke's palace. Oh, yes, you, foolish girl, were easy prey to my scheme. I'm only sorry we were interrupted. I find you a most enjoyable wench."

I reeled back as if he had struck me.

"You vile son of a whore!" Signor Arnolfini cried, ripping the sword from my father's hand and charging Angelo.

But Angelo was swift and lithe as a cat. He nabbed a sword from one of the guards and held it to my throat.

Fearing for my life, my father motioned the other men back.

"Do what you will with me," Angelo challenged with a sneer.

Keeping his sword close to my neck, he reached down with his other hand for his cloak. "Not that she's worth fighting over."

He backed toward the barn door, then shoved me toward my father. "She's damaged goods now. I've just cheated you, Signor Cenami, of the last possibility of winning back your fortune. No man of honor will have a ravaged woman as a wife. No one will bail you out of debt now."

With that he sprang onto the bare back of the nearest horse. It reared up, nostrils flaring, then plunged with its rider through the open barn door, past my father's guard and into the heart of the raging storm.

"After him!" my father roared, and charged out the door, waving his broadsword like a madman.

"William, stop!" Signor Arnolfini dashed after him. Herr van Eyck motioned toward Hans, who swiftly followed Arnolfini and my father.

Within seconds my father returned, followed by Signor Arnolfini. Herr van Eyck sheathed his sword. "He will not get far. My guard is posted at every road. We will deal with him later. For now you had best tend to the girl."

Herr van Eyck did not look in my direction, nor did Signor Arnolfini. My father, however, dropped his sword and approached me. As he neared, I backed into the farthest corner of the horse stall. I held my arm across my face, bracing myself for his blow.

"Giovanetta," he said. When I opened my eyes, he held out both his arms. He waited for me to take the first step forward. When I did, he folded me into him, rocking me back and forth like my old nurse Anna, and I could not tell where his tears began and mine ended.

Disgraced

The rest of that day is still a blur in my mind. Somehow our whole party—Signor Arnolfini, Herr van Eyck, Hans, Emilia, my father, and myself, accompanied by a goodly number of guards—fought our way through the storm, back to the main road, and finally to a modest, drafty castle perched on the mountainside half a league or so farther north. It belonged to the lord whose holdings included the summer pastures, the outbuildings, and the barn where I had been disgraced.

By dusk, when we arrived, the blizzard was waning. The lord of the castle, whose name I never learned, opened his home to us and showered us with hospitality. His food, like his sheets, was coarse, his means modest for a lord, and yet he was generous and did not question the strange makeup of our party, nor the request that Emilia and I be given a room high in the tower, where we could be well protected and guarded.

I do not know if I would have bared my soul to Emilia that night, but against that chance my father drugged my wine with a strong sleeping draught. I barely remember her hugging me as if I were a baby, and pillowed in her arms I must have fallen asleep. When I woke the next day

it was nearly noon, and Emilia and all her belongings were gone. It was a fortnight before I learned her fate, but my father's stern expression when I was led down to break my fast in the castle's great room broached no questions.

Not that I was tempted to ask. After the intense emotions of the past few days, I had no feelings left. I might as well have been a piece of dead wood or a rock. Now, much later, I realize that I was simply in a state of shock. It would be a day or two more before I woke to the horror and shame of what had happened.

Meanwhile it was decided that as soon as the weather cleared, I'd return to Bruges. So would my father and Signor Arnolfini. Herr van Eyck would follow a few days later, as he had some business to finish in Lyon.

No one asked me if I objected. No one asked me anything. Though I was in the room, the men discussed my future as if I were a piece of furniture, without ears, or heart, or mind enough to care. And they were right.

My whole being, body and soul, felt numb—except my heart. As the days wore on, my heart began to ache. The dull, heavy pain in the center of my chest made it hard to breathe. I wondered vaguely if I would die from it. I almost prayed that I would.

What can I say about our trip back to Bruges? It was passing strange. I had no woman companion or maid to help me dress or do my hair, and I never saw Emilia again, though to this day I miss her—my dearest companion, and one true friend.

Eventually I learned, from my old nurse Anna, that my maid had been banished to Paris, where my family placed her with some distant cousins.

She managed to get one message to me a few months later, saying that she would be married in midsummer to a young baker, who had finished his journeyman's work and had just become a member of the bakers' guild.

I missed her terribly, but my father forbade me to contact her. I prayed for her and thanked the Lord that at least Emilia's dreams of a better future had come true.

Meanwhile, on our journey home, we stopped only at guesthouses of abbeys or convents. The fare was simple, the beds hard, and each night, alone, I cried myself to sleep.

At first I wept for Angelo. I admit that during those first few days on the road I still longed for him, despite how he had abused me. I had given him my whole heart and almost sacrificed my soul, and I felt as if my very flesh had been ripped away when he left.

Part of me refused to believe he had been party to the evil scheme to totally undermine my family: Apparently the Grimaldi clan thought that ruining my father's business was not enough revenge for whatever wrongs my family had done them in the past. Ruining my honor was to have been the final blow.

We were several days on the road before I recalled Herr van Eyck's warning to my father. There was another scheme in the works, calculated to be more devastating to our family, than the loss of the last of our precious inventory of silk from Lucca. That scheme, we now knew, was to disgrace his only daughter.

Well, Angelo hadn't gotten quite so far as to ruin my honor. But who would believe that now? Indeed, in the eyes of the world, I was damaged goods. He had declared for all the men to hear that he had ravaged me, even though in truth I was still a virgin. Who knew what he was saying

now back in Lucca? How could my family show their faces there—or in Paris, or in Bruges again? For gossip traveled with amazing speed from all corners of Burgundy, France, to the Italian peninsula . . . particularly when a notable merchant who had his share of enemies was concerned.

During the whole course of our journey, I didn't know if Signor Arnolfini was avoiding me, or if I was avoiding him, but we never spoke and were never alone. I shared most meals with nuns in the convent or in the women's quarters of monastery guesthouses. On the road I was flanked on all four sides by my father's and Signor Arnolfini's guard. Herr van Eyck had also left several of his burliest mercenaries in my father's charge. It felt more like riding to war then going home.

As it turned out it was only toward the end of the trip that I finally found myself face to face with Signor Arnolfini alone.

It occurred half a day's fast ride from Bruges. At midday we had stopped at an inn to change horses and take a light meal. My father was determined to reach Bruges by nightfall—after dark. Privately I was sure he wanted to enter town as inconspicuously as possible, to hide my shame and the family's disgrace.

I was sitting in the area of the dining room reserved for women travelers in front of the hearth. I was grateful for the warmth of the fire but had no appetite for the bowl of soup and hunk of bread on the table beside me. I was staring into the flames, wondering how I would face my father's whole household later that evening.

"You should eat, Giovanna." At the sound of the familiar dry voice, my whole body tightened. I took a deep breath, then forced myself to turn around.

I glanced up sharply. Signor Arnolfini was gazing down at me. He

had taken off his cloak and held a pair of fur-lined gloves in one hand. Beneath his frank gaze I shrank back into myself and dropped my eyes. I started to get up to curtsy, as custom demanded, but Signor Arnolfini put his hand on my shoulder and gently made me keep my seat.

"Please. There is no need to be so formal here. You need to rest before we set off again. Your father is pressing the horses, the guards, and certainly you, beyond what is healthful. He is all too eager to get you back to Bruges."

I didn't know how to reply to that.

"Look at me, please." His voice was low.

I summoned up the courage to raise my head and look directly at him. For one brief moment he held my glance, but before I looked away, what I saw in his eyes pierced my heart.

His eyes were filled not with blame but compassion. I had no other word for it. He did not look at me with hatred, or disgust, or anger, but with kindness—as if nothing at all had changed between us.

Yet everything had.

"No one blames you," he said softly.

At his words I looked up again. "Everyone will blame me," I blurted, tears choking my voice. I swallowed hard and went on. "I am such a fool."

"You are not a fool," he contradicted firmly. "You are just young."

"I'm old enough to marry. To be betrothed. I thought a marriage into his family would end the feud. I believed that he thought so too. Even you can't tell me that isn't foolish."

"Believing that people are good is not foolish."

"Even when you're so terribly wrong?"

"Even then," he said. He seemed about to say more. Instead he just touched my shoulder again. His hand felt warm, familiar, reassuring. I felt his kindness, and at that moment something inside my heart began to melt. But then I remembered who I was, what I had done. I turned away from him, ashamed, embarrassed, not worthy of his affections.

I moved farther down the bench, out of his reach.

He dropped his hand from my shoulder, sighed, then said softly, "Giovanna, I am still your friend." He sounded sad, as sad as I felt. "I will not abandon you, nor your family," he concluded.

And true to his word, he didn't.

A Wedding

A few weeks after we returned to Bruges my father received, quite unexpectedly, letters of credit from his Italian bankers—the very ones the Grimaldis had used to call in his debts. Merchandise replacing what had been lost at sea arrived unannounced at his warehouse in town. And rumor had it that with Signor Arnolfini's backing, Papa would be the co-owner of a new, seaworthy vessel. It would be outfitted by spring—at no expense to him—just in time to sail across the sea to obtain more Eastern goods.

But for me the major event was my formal betrothal.

Signor Arnolfini never spoke of it to me. Instead Anna told me he had requested my hand in marriage from my father, and my father agreed. I could not believe Signor Arnolfini would still want me, but apparently he did.

It was still a prospect I dreaded, not because of Angelo, or because of dreams of love, but because I was so embarrassed. For I was sure that Signor Arnolfini, as well as my father and Herr van Eyck, thought my virginity had been compromised. Indeed, even Anna seemed unduly curious about my monthly courses.

But as for Signor Arnolfini—new feelings for him stirred in my breast. I could not call them love, but there was the sense that somehow, some way I might have been happy with him had I never defied my father.

Signor Arnolfini was a man I could count on to defend me, to protect me, to be my friend. I did not feel for him the way I had felt for Angelo . . . and yet now I felt a perfect fool, rejecting his original offer of marriage. Had I obeyed my father, I would not have been so shamed.

Perhaps Zia Clara had been right: In time I would have learned to love Giovanni Arnolfini as a husband and not just as a friend. But now, how would he feel toward me? What would my life with him be like? I felt he had made his offer to help my father—not just financially but to save our family's honor.

After our encounter at the inn I never saw him alone again. He had avoided me since our return to Bruges. And despite all this he insisted on our union, though I did not see him again until the day of the event itself, a cold January day in the year 1434.

The wedding was a private affair. I wore only my second-best dress and no jewels, and there was no betrothal dinner. The ceremony itself was quick, with Herr van Eyck as one of three witnesses. The lawyers signed the documents, my dowry was paid, and my marriage chest was delivered to Signor Arnolfini's house.

I learned that day that my father and Signor Arnolfini wished to follow the latest custom: Our betrothal entitled us to the privileges, legal and physical, of man and wife; but we would also have our marriage solemnized in the spring in a church.

We drank a quick toast, then at noon Signor Arnolfini—I still refused

to call him Giovanni—set out again for Lucca. This time he traveled by boat, via Genoa, since the winter had made the mountain roads impassable. When he left, we had still spent no time alone.

Later that afternoon the cart came from Signor Arnolfini's house. I was escorted to his home by my father's guard. It felt strange returning here as the mistress of the elegant house. At the door I was greeted by Grete, Signor Arnolfini's housekeeper. She was a stout, comfortable woman with kind blue eyes. In a short time she became one of my saviors. If she, or any others of Signor Arnolfini's household, knew of my disgrace, they gave no hint of it.

Grete instructed the guards where to put my trunks, and we followed them up the narrow staircase.

At the top of the stairs, I heard a familiar whine coming from the other side of the door and my heart leaped in my chest. "Rags!" I cried, as Grete threw open the door and the little dog bounded into my arms. He licked my face and neck, and protested with a series of yelps when I tried to put him down.

"See, you already have a friend here—the first of many," Grete said gently. I buried my head in Rags's coat. The familiar wiry feel of his fur against my cheek triggered a flood of tears.

Grete shooed the rest of the servants away, gathered my belongings, and guided me to my chamber. It was a large, comfortable room—larger than any I had had before. It adjoined the second bedroom. There was a door between with no lock on either side.

Grete followed my glance and said quietly, "He will be gone for at least two months now. You will have a nice space of time to find your way around this house and learn to manage the staff, though I of course

will always help. By the time he returns, you will be settled in nicely."

With that Grete left me to my dog, my tears, and the light repast someone had brought up from the kitchen. I think that day my battered spirits began to heal, for Grete had taken me in, and loved me like a lost kitten.

Friends Indeed

But what truly healed me wasn't Rags, or Grete—and certainly not the letters from Giovanni Arnolfini that came almost weekly from Lucca and which I refused to read or even open. It was the time spent in Herr van Eyck's studio.

I had not seen the painter since the betrothal. In fact, I had forgotten all about the portrait my father and Signor Arnolfini had commissioned before we had left in November for Lyon. Of course I had not realized then that it was to be a marriage portrait—and a most special one. By decree of the painters' guild, Herr van Eyck, like most official court painters, could only take on commissions for commoners like ourselves with the express permission of the duke.

That Signor Arnolfini had merited this distinction betrayed the fact that he was a man of power and position at the court, a man far more powerful than my father would ever grow to be. But of course I did not know that then.

It was a bright morning early in February when my father called at our house, bearing Herr van Eyck's summons. I was to come as quickly

as possible to his studio, to take advantage of the good light and unusu-
ally fair weather, to begin my sittings for the portrait.

"He is back from Spain and needs to begin your wedding portrait,"
my father said, instructing Grete to accompany me and my father's men
to the painter's quarters.

When Grete left the room I challenged my father. "You expect me to
go to his studio?" I was furious. As time had passed, my pain had grad-
ually turned to anger, directed against myself, against Angelo, and even
against Herr van Eyck for letting that viper into my life.

"You have no choice in this, Giovanna."

I was so tangled in my own feelings that I didn't notice that though we
crossed the same bridge leading to the house where I had visited Herr van
Eyck before, we turned down a different street. I looked up and the sign
painted on the side of a corner building read RUE DE LA MAIN D'OR.
Then we stopped in front of an unfamiliar house. It was a stone-and-
brick building overhanging the grand canal. The second floor jutted out
over the first floor, casting a deep shadow on the street. Vines, brown with
frost and dusted with snow, dangled from window box above our heads.

One of Herr van Eyck's servants answered the door. She told us to go
right upstairs to the Master's studio. Even though I had never climbed
this particular staircase before, my step was heavy, reluctant, for the nar-
row steps reminded too strongly of Angelo. It was in Herr van Eyck's
studio that I had seen the portrait of Angelo. And in a narrow stairway
very like this, he had brushed by me, and caught my eye, and sealed
my doom.

At the top of the stairs, Luigi knocked.

"Come in!" Herr van Eyck's familiar voice beckoned in Flemish.

Luigi pushed open the door, stepping aside for me to pass. Grete followed close behind.

As we entered, it was Margaret van Eyck who rushed to greet us. Unlike the first time we met, she was not dressed for work. Her gown was simple and mended but of good quality, the kind of formerly "best" clothing people of our class usually wore at home.

"Signora Arnolfini," she said, taking both my hands and kissing my forehead. "I hear you are betrothed since we last met." Her words were innocent, and I realized she had no idea what had transpired over the past eight or nine weeks.

I looked past her shoulder at Herr van Eyck. Swathed in a workman's tunic, he wiped his hands on a rag as he approached. He met my eye, and true to my father's words I saw no judgment in his face. His expression, in fact, betrayed nothing but happiness to see me.

"Giovanna, you are looking well," he remarked, as Grete took off my cloak and hung it with hers behind the studio door.

I curtsied, but did not know how to respond. Was I looking well? I'd scarcely peered in a mirror since my return to Bruges. I was afraid to see the woman I'd become.

As before, Herr van Eyck sent the guard to the local tavern but quickly provided Luigi as well as Grete with a chair. I sensed he had arranged with my father, and perhaps with Signor Arnolfini, that one condition of these sessions at his studio was the presence of a guard as well as a chaperone.

"Ah, Giovanna," he said, "you have come not a moment too late. The light is wonderful just now. I haven't forgotten my promise, that I

would show you more of my studio, and how a painter works—before I do your portrait."

"It seems you've drawn her portrait already." Luigi had meandered over to the drawing table. "When did you do these?" He sounded suspicious.

"In Lyon, after that dinner with the signora!" He was polite enough, but something in his tone warned Luigi that even thinking that I had been to this studio since my return to Bruges, without proper escort, was nothing other than, well, unthinkable!

Clearly not convinced, Luigi grunted and retreated toward the door. Leaning against the door frame, he kept a watchful eye on me, the Master, and the table of drawings.

I crept closer to the worktable to see what had ruffled Luigi's feathers. At the sight of the papers spread across the table, I gasped. Staring back at me from the sheets of paper were several versions of my face. I only recalled Herr van Eyck drawing one likeness that evening in Lyon. But he had cleverly repeated the drawing time and time again, positioning my face first one way, then the other, the way a musician improvised variations on a theme. There were several sheets of sketches. Though the drawings were generally in dark chalk on gray paper, I recognized the cut of my good pink gown, the one I had worn that fateful evening at the Chanticleer. But I blushed with shame at the clear likeness of my face in another sketch that was clearly the Madonna. I deserved that honor less than any other girl in Bruges or Paris or anywhere in Christendom.

Already one of the portraits, penciled on one clean piece of paper, small, exact and incredibly detailed, was screened with small squares of lines.

Herr van Eyck then proceeded to show Grete around his workshop. That day a small wooden panel was propped on his easel. The panel's surface was pure white and smooth as silk. It was covered with gesso, the substance that he had explained to me on my first visit here. "After I transfer my drawing to this panel, I will begin to block in darker tones, leaving the lightest parts of my composition white. Then gradually over the course of a few weeks—or sometimes months—I will build up my colors with thin layers of oily paint. Painters from the times of the Egyptians have tried to paint this way, but always the materials failed them.

"But my dear departed brother, Hubert, and myself chanced upon a formula of oils and resins and varnish that have just the right properties—not too sticky, nor to slick—and that dries within weeks rather than years and doesn't seem to slide off the paint surface. Look, Giovanna, the result is color that is jewellike, full of light, and transparent."

He led me over to a small panel hanging on the wall. It was a portrait, commissioned, he said, by one of the ladies of the court. "It is only half finished, but you can see where I have layered lapis blue over the black underpainting of her dress. Even the shadows glow."

Hearing the pride and excitement in his voice as he explained his methods to me was thrilling. In his studio he seemed less the courtier, and even less the man who had brandished a sword at Angelo or who was supposed to be a spy. I wasn't sure I could trust him, and yet I trusted the truth of his paintings.

Just a then messenger came up the stairs. He was dressed in the livery of the court. Herr van Eyck excused himself. The messenger bowed low and handed the painter a parchment scroll tied with ribbon. The painter stepped aside to read the message.

While Herr van Eyck spoke with his visitor, his apprentice Piet caught my attention. He motioned for Grete and myself to come over to the table where he was working. Lined up in front of him were various sizes and shapes of corked glass bottles. They looked familiar, and some I am sure came from the apothecary shop in Lyon. Each one held a powdery substance of a different color. The colors were brilliant: vermilion red, blue, a verdigris green, a sulfurous yellow substance, and a most velvety black.

"This is how we make the colors," he told us. He showed us the tools on his table. Though his tunic was a mess, his work area was neat and organized. He pointed to a thick sheet of red stone on the table. "This is porphery," he explained. "It's like marble but harder and better for grinding paints on. And this is a muller."

The muller looked familiar. It was simply a larger, heavier version of the grinding stone we used to grind spices in the kitchen at home. The handle was thick; the grinder end of the stone was rounded on the sides and flat on the bottom.

Piet carefully spooned some blue powder onto the porphery slab. Using the muller he began to grind the dry powder with a rhythmic circular motion. After a few minutes he made a well in the ground powder. Picking up a beaker, he drizzled some oil into the well. He continued to grind, explaining as he worked that the longer he ground, the more beautiful the color. As I watched, the blue paste grew smoother and more brilliant with every stroke of the muller.

"Ah, Piet!" Herr van Eyck said as he rejoined us. "Are you giving the secrets of our trade away?" His expression was stern, but his tone was teasing.

"No, Meister!" Piet pretended to cower, but as the painter led me back to the window, Piet caught my eye and winked.

Herr van Eyck positioned me in a chair, angling first one way, then the other to catch the light. "I want to make a preliminary painted sketch, just to check your skin tones." He motioned for Grete to also sit by the light. "You can do your needlework while Giovanna models for me."

For the rest of an hour he barely spoke another word. He seemed lost in a world of his own. Only when his housekeeper brought up cakes and ale did he remember to tell me I could move. By then I was stiff as a plank and felt as if my neck would snap off.

For the first time he seemed to realize that I was sore and tired. "Sorry, Giovanna, I became lost in my work. You can move about the room and relax. I'm not sure how much more I will need you today, the light is fading." Then he turned back to his drawing board and studied the day's work.

Soon he sent me home. "I will come by your house during the next fortnight," he said, "before I leave for Paris. I will be gone only a month or so, but on my return I will be able to commence the actual painting."

And so commenced a series of visits. Sometimes he came to my house, sometimes I went to his studio. At each visit he revealed more about his methods, though little about himself. I learned that he used a brush with a single squirrel's hair to paint the tiny details in his work. Yet I never learned where he came from, nor did he ever speak about his wife.

I learned his own apprenticeship began as a miniature painter, illuminating manuscripts. But he never told me for whom he had worked. And he rarely mentioned his beloved older brother, Hubert, who before his death had been far more revered than Jan van Eyck himself.

In his studio, where it was cold and damp, I learned to sit patiently while he sketched my hands or modeled a twin-peaked headdress. But at my house he worked in front of the hearth, fortified by warm, watered wine, his portable drawing table propped on his lap. One time he asked me to bring him a pair of my very best slippers; another time he sorted through a chest of my veils, selecting a plain one of finest linen but with carefully pleated edges.

Over the course of several visits he sketched one of Signor Arnolfini's tall, black felt hats, and a pair of his wooden pattens. He told me he wanted to paint those particular shoes because he loved the shape of them. But I was to tell no one *that* secret. For a serious painter, each object or set of objects in a marriage portrait had to have some meaning, be a symbol of something. In this case, the shoes, which would be lying on the floor, not covering Giovanni's feet, would signify that this betrothal was a holy event. Oranges promised fertility. The mirror would refer to the mirror of the soul, or the light of truth. Together, he confided, the oranges and mirror would also show that we were wealthy and that my husband could afford to support me in a manner suitable to my station. Sometimes when he spoke like this I felt lost, and unschooled, and painfully ignorant.

With each visit we grew closer, more easily able to converse. We usually talked of small, insignificant things. He would tell me delightful stories of mishaps at the court, usually involving one of his projects. I learned that he was expected to provide new designs for banners almost weekly, and I laughed over the terrible if comical disasters that happened when an apprentice mistakenly dyed all the duke's livery a most precious blue—when the duke had ordered his whole court to be clothed in black.

It was on one of these visits to our house, the last one before he would leave for Paris, that Herr van Eyck finally broached the subject we had been avoiding for weeks. It was the third session he'd spent drawing Rags—apparently my little dog represented faithfulness as well as for some reason fertility in marriage, a symbol Herr van Eyck seemed shy to explain.

He waited until Grete had left the room to fetch a plate of bread and cheese and a jug of wine. "You have never asked me about Angelo," he said, not looking up from his sketchbook. His gaze shifted quickly from the dog to the drawing, then back to Rags, who, stuffed with the remnants of that night's roast, was sound asleep and snoring loudly on the hearth rug.

"What should I ask?" The steadiness of my voice surprised me. Less than a month ago I would have practically choked—with sorrow or anger I cannot say—on Angelo's name.

"How I knew him or, more to the point, what he was doing there in Lyon."

I took a few more stitches in the fine lawn chemise I was mending. "Shall I ask you now?" I looked up and found he was looking at me carefully.

"I work at times for the Spanish court."

I smiled half to myself. "I have heard that . . . actually, I think it was Angelo who told me that it was not just in the role of court artist. Am I to believe him? Nothing else he said was true."

"Ah, you either don't do him justice or give him too much credit, young lady. It is true I work for the court—shall we say, in various capacities, some to do with art and some with what people might call gossip. At the same time I am in Duke Philip's employ. I need other . . . gossip

gatherers, as I like to call them, to help me understand the politics of Spain and Burgundy."

"So Angelo worked for you—as a spy."

Herr van Eyck arched his fine eyebrows. "Yes, as a spy. But he proved to be more wily than I ever suspected, and totally immoral. He used me, and my position, to draw close to your family. It was all part of a plan hatched by his father and uncle, who hate your father with a passion that surpasses my understanding."

I put aside my sewing and stood up. "Herr van Eyck, I myself do not understand why you are telling me this."

"Because I want you to know I have a hold on the boy. He will never betray your secret. His very life would be compromised. To put it bluntly, he has worked as spy and counterspy. Not very savory occupations in his case. Were his past activities to be revealed, his whole family would be targeted by powerful forces in several courts as well as in the merchants' guilds. Whatever plots your own family might have hatched against his would seem like child's play by comparison."

We had barely finished the conversation when a commotion rose from below. Rags jumped up and raced toward the door. I heard an unfamiliar footstep on the stairs. Then the door opened, and Signor Arnolfini walked in. Rags danced around his feet as Grete hurried into the room and took his cloak.

Herr van Eyck stood, and after a moment I too slowly rose. I curtsied, conscious that I had not laid eyes on my future husband since the day of our betrothal. To my surprise, my heart leaped up to see him.

"Jan!" He took Herr van Eyck's hands between his and shook them heartily.

Then he turned to me. I held my breath, afraid of what I might see

in his face. His smile was tentative but warm. "Giovanna, I'm back."

"Yes" was all I could muster, and then, excusing myself, I gathered up my sewing and fled to my room, confused by my reaction at seeing him again.

Inside my chamber I stood a moment with my back pressed against the door, my heart racing. I glanced over at the bed—a bed I had not yet shared with my betrothed—and found myself remembering that day at the inn. I put my hand on my shoulder where he had touched me. I could recall the warmth and suddenly wanted to lean into his kind hands . . . to feel his lips on mine.

And then I remembered Angelo, how his kisses had turned from kind to rough, and how he had hurt me, and suddenly I wasn't sure I ever wanted a man to kiss me again.

That night when I blew out my candle, I lay in the dark, listening. I listened to Signor Arnolfini come into the next room. I heard him give instructions to his man, Roger. Then I heard him move about his chamber. I lay still, waiting, terrified to move, wondering if he would open the door that joined our two rooms. I wondered if this was the night, whether I willed it or not, that he would bed me and officially make me his wife.

But I didn't see him again until the next afternoon. I was helping Grete sort some linen in the laundry room next to the kitchen when Signor Arnolfini strolled in. Grete dipped into a deep bow, and I also curtsied.

"Giovanna, we've both been cooped up all day. The weather is rare and clear, and I thought to go skating on the canal. Would you join me?"

He might as well have asked me if I'd go to the moon. My jaw dropped. We hadn't skated together since I was a child, in Paris, the time the river Seine froze over and all the businesses in town had closed and the city celebrated in the snow as if it were a holiday.

"Do you have skates here?" Grete asked me.

"In my trunk. I haven't unpacked them."

"Then there is no better time than now," Signor Arnolfini said, and within half an hour we set out together, a discreet distance between us, he carrying my skates and I totally tongue-tied. The streets were crowded, with people bustling about their business. But even in the midst of a busy day, skaters packed the frozen canals and children indulged in snowball fights and pulled one another's sleds down the flat, snow-packed streets.

"You never used to find it so hard to speak with me," he said finally, breaking the silence. "We are not strangers, Giovanna. Nothing has really changed between us."

I stopped walking. "Nothing?" I couldn't believe my ears. "How can you say that? Everything is changed. I am no longer your friend. I'm your wife."

"Not quite," he countered quickly. Then he must have read the expression on my face. "Forgive me. That was almost cruel." He guided me out of the heart of the crowd and onto one of the low, arched bridges. Holding my arm, he lowered his voice. "Giovanna, I did not want to marry you for your dowry, or to save your father's business. I wanted you for—well, you. I have loved you for years, but that love changed as you grew. I approached your father two years ago now, asking him for your hand. We knew you were far too young then, and I sensed that perhaps he wanted a more prestigious match than I could have given your family."

Hearing the longing, the feeling in his voice unnerved me. "I don't deserve that love, Signor Arnolfini."

"Your mistake changes nothing for me, Giovanna. Nothing."

I finally looked up from studying my hands. "But for me it does. It

has. We are already betrothed, and in the end I had no say in the matter."

"I'm giving you that say now." He looked down at me.

"I don't understand."

He took both my hands in his. "If you truly do not want me, I will free you from this contract. We have not yet lived as man and wife. Until we share a bed, the contract isn't binding. Think on it, though. Don't answer now. Give it all a bit more time. I don't expect you to love me, but perhaps we can share a life filled with kindness and friendship. It is all I ask of you."

I couldn't believe my ears. Was there truly a way out of this betrothal? "But what happens to my father, and his goods and his loans and all that you have guaranteed, if we break the contract?" As an after-thought I added, "And what about Herr van Eyck's portrait? It is already partly paid for."

"I wish him to continue with the portrait. In fact, nothing will change. I am still your father's friend, and whatever you decide, I hope to remain yours."

With these words we started back for home. Skating suddenly seemed too frivolous and all wrong. We walked in silence until he opened the front door. He turned to go to his office. I called after him. "Giovanni, I will think about it. And . . . and thank you." I didn't know what else to say. I had known Giovanni Arnolfini for years, and yet as I watched him walk down the hall, I wondered to myself, who exactly was this man? Wondering this, I suddenly realized I had just called him Giovanni, for the first time in my life.

Giovanna's Choice

I did not make my decision quickly. I felt I owed Giovanni that much, to at least pretend to take my time. We spoke pleasantly to each other over meals but continued to sleep in separate rooms and seldom spent time together in the house. If Grete and the other servants noticed that we had never consummated our marriage, they at least were discreet in front of me.

Giovanni's business was thriving, and he worked long hours in his office at the warehouse every day. Yet he always made some time for me. Twice more we skated, though neither of us spoke again of our marriage contract. Often I would go to my room in the evening to find a little gift propped on my dressing table: a small necklace, a nosegay of dried flowers, an illustrated Book of Hours as beautiful as the one Zia Clara had had. I felt he was wooing me, and I knew I did not deserve it.

Meanwhile Herr van Eyck was briefly back in town. Giovanni spent whatever free time he had in the painter's studio, sitting for his half of the double portrait. Herr van Eyck had barely finished capturing Giovanni's likeness when a crisis rose with Giovanni's bankers in Ghent. He was forced to leave town and did not return for a month.

It was the day after Giovanni's departure that I first saw the dress. It was in Herr van Eyck's studio, draped on a dressmaker's form that was slight and similar in figure to my own. I admit, I fell in love with it at first sight. It was dyed the most exquisite green and made of the finest woven English wool. I recognized the fabric as the most highly-prized of my father's stock, material he hoarded and sold at great price to the court. The sleeves were lined with gray squirrel fur—the height of courtly fashion—and trimmed with the most beautiful cutwork.

Herr van Eyck arrived at the studio shortly after me. "Do you like it?" he asked.

"I think she loves it!" his sister exclaimed. "And I think it will suit her well."

"Suit me? This is for me? Where did it come from?"

"The fabric and fur were part of your dowry, but Giovanni hired a seamstress to make it. It's for your wedding portrait. Today you get to try it on, to model it. I need to see the way it drapes on you. I will block in the general lines of it, then work from the dress as it hangs on the dress form. Later, toward the end of the painting, I will have you wear it once again, to put in the finer details."

I slipped behind a screen, and Margaret helped me change into the dress. The undergown was blue and flattered my fair skin. Still wearing my outdoor shoes, I carefully crossed the studio, holding up my skirt so as not to soil it.

It was the first time, but far from the last, that I had to pose standing. Herr van Eyck had me place my hand on a post with my palm facing upward. When I asked him why, he said it would symbolize the union between a man and a woman. He had already painted Giovanni's half of

the portrait and his hand. In the finished picture my hand would lay open in his.

As I listened to him explain this, and how the burning bridal candle showed the hope that our union would be blessed with children, and many other worldly topics, I marveled at his knowledge of matters far beyond the realm of paints, and varnishes, and gilding, and all the other material crafts in which he and his workshop excelled. He was a learned man, and at moments I actually believed he was touched in ways by God.

Eventually there came the day when the painting was finished. It was the same day Giovanni returned. I took that as a good sign. Herr van Eyck had invited us to his studio the next week to see our portraits before the official unveiling—an event to be attended not just by us, but by the duke and his retinue, as well as by my father.

But before our private viewing I had to tell Giovanni of my decision. For months, not weeks, had passed, and finally I was sure of my answer.

It was a Sunday, and we had walked to church. After mass I asked him to linger in the lady chapel of the cathedral. Gradually the parishioners dispersed, leaving the cathedral to us and a few wimpled nuns keeping a novena.

I led us to a long, narrow bench against the chapel wall. Out of respect for the place, I kept my voice low. "Giovanni, I have decided."

At my words, his body tensed.

"I thought long and hard about the reasons I should stay married to you. All of them seemed wrong. . . ."

He put his hand to my lips. "You need not say more." He rose, and it hurt my heart to see how wounded he looked.

"No, Giovanni, I'm not finished. I would not stay with you only because no other man would have me now. But that is not a reason to stay with you. You are too kind. You deserve more from a wife.

"Only one reason matters. There must be love. Over these months I have learned you are the kindest of men. You have forgiven me when I deserved no forgiveness. You have continued to be—and have promised always to stay—my friend. I could do worse in a marriage and a husband, but I can do no better than you—no woman could. For surely you are the kindest man in all of Bruges.

"I must confess I do not know if I love you yet as a wife should love her husband, but I care for you deeply . . . and perhaps in time that caring will grow into something stronger."

"Then the answer is yes?" Disbelief was written all over his face.

"Yes. Yes. Yes. If you will still have me."

He did not kiss me then, for we were in church in front of the statue of Our Lady and unlike Angelo, he was a man of honor and respect.

But that night, when he opened the door between our rooms, I did not let him close it again until dawn.

Reflections

For our private showing of the painting, Herr van Eyck uncorked his best bottle of wine. We gathered in the studio: Giovanni and myself, and only the painter, his sister, Piet, Johan, and Hans.

Herr van Eyck poured generous portions of the rich, dark liquid into finely tooled gold goblets of his own workmanship and design. We toasted one another, and then he pulled off the cloth draped over the panel on the easel.

For a moment there was a stunned silence, then slowly we all began to clap.

"A masterpiece," Johan marveled, and he looked about to genuflect in front of his master.

Tears streamed down Margaret's face.

Piet stood speechless, while Hans let out an appreciative whistle.

But to me it was a picture of my soul. I looked younger than I felt, and sad. I looked like a girl who was not sure of her future. I looked like who I had become since last November.

Seeing my own image staring back at me, I had to shift my gaze to the rest of the painting. Every detail was so real—the way the candelabra

gleamed, the glint of light on Giovanni's betrothal ring, the mirror with its circle of tiny miniatures depicting the passion of Christ. Finally I wrenched my eyes away from the painting and looked at Herr van Eyck.

"It's beautiful," I said, finally finding my voice.

"You are so beautiful," Giovanni murmured. He looked from the painting back to me and smiled like the angel Angelo never was.

Embarrassed, I joked, "And you"—I took his hand—"you look so solemn, so old! People will think you are a man who doesn't know how to laugh."

"Or skate," he teased. Then he turned to the Master. "Tell me all about it. Why is Rags in the painting, and who is in the mirror?"

"Ah, Rags is in the painting because he is your favorite dog—" Herr van Eyck started to explain.

"And because he symbolizes faithfulness," I added, eager to show off my newly acquired knowledge.

"What I like," Piet said, coming within a nose length of the panel, "is the mirror. You painted yourself in it, Master. As well as the Arnolfinis from the back. But who's the other man?"

"The notary?" I guessed, though I could not remember if the notary's doublet the day of our wedding was blue.

"I see Saint Margaret," his sister noted. "She's the patron saint of childbirth." Margaret grinned at me.

And so we spent the morning, drinking wine, celebrating a remarkable painting. Someday soon it would hang in our house, but of course only after the duke had viewed it in the painter's studio, and the duke's retinue had applauded the Master and bestowed him with honors.

Epilogue

*L*ove I discovered today, is a strange thing. It can ravage you like a fast-burning fire, or it can take root slowly, the way an acorn, given time, grows from a tiny germ into a mighty oak. I will not say our love has grown into anything as mighty or tall or old as a tree, but it has, I think, blossomed with spring, into a beautiful thing.

Today is our wedding day—the day we go before God in His Church and consecrate the marriage. Early this morning we rose and rode to the Convent of the Angels, which lies on the outskirts of town. There in the chapel we took turns and confessed our sins to the priest.

I am waiting for Giovanni to finish his penance. I have strolled in the cloister garden. The air is full of birdsong and the heady scent of blossoms. I am glad for this time alone, before the guests arrive.

I need to speak to Giovanni. Several months have passed since the unveiling of our painting, and the true beginning of our life as man and wife.

It is important that I tell him the wonderful news here, alone, before the festivities and the celebration. I am wearing my green dress with my

blue undergown for the first time. It is a cool spring day, and I am grateful for the fur lining of my sleeves. Today the dress is tighter across my bosom than in Herr van Eyck's painting. I wonder if Giovanni will notice.

"Giovanetta!" he calls out. A moment later he emerges from the shadows of the cloister walk into the bright light of the garden.

He starts toward me, then he sees. His eyes widen. His step quickens.

I stay where I am a moment longer only to watch a huge smile spread across his still-too-thin face. But suddenly my feet sprout wings and I race into his arms.

"Yes, Giovanni," I whisper into the soft fabric of his cloak. "Yes—I am with child."

"The fruit of our love."

I step back and smile through my tears. "Yes, Giovanni. Our love. At last, I know this is love."

Jan van Eyck's Life and Art

Although more is known about Jan van Eyck than any other fifteenth-century Flemish painter, hard facts about the life of the artist are scarce.

We do know he was born in the southern Netherlands near a city called Maastricht, sometime between 1385 and 1400. His older brother, Hubert, was perhaps more famous than Jan during his lifetime. Hubert collaborated with him on the great Ghent altarpiece, which Jan completed after his brother's death. Jan also had a younger brother, Lambert, about whom we know almost nothing; and he possibly had a sister, Margaret, who, like all three Van Eyck brothers at one time during their careers, illuminated manuscripts. No illuminated manuscripts or books have survived that can definitely be attributed to any of the Van Eycks.

Jan van Eyck must have been well educated. We know this directly from clues in his paintings and from the fact that he was considered by Duke Philip the Good to be an expert in science and map making. The painter was also familiar with ancient literature and myth, and could read and write Latin. Because literacy was generally limited to the nobility, upper merchant classes, and clergy, in the Middle Ages and early

Renaissance some historians think that the Van Eycks were possibly from a noble family and had their own crest. At the very least they were from the middle class—though again no facts are known to support this. During Van Eyck's life, his courtly patrons paid him enough money to live a good middle-class life, but there is no indication that he himself was rich or a man of independent means.

The first mention of Jan van Eyck is in 1422, as an artist employed by John of Bavaria, an unconsecrated bishop who lived in a town called Liege in the Netherlands. Jan, and probably his brother Hubert, along with other artists and artisans, were employed by the bishop to decorate his castle. At this point Jan was already a master painter in The Hague, also in the Netherlands, for he had his own workshop and apprentices. Scholars assume that Jan and Hubert had themselves been apprenticed to manuscript illuminators as young men.

After John of Bavaria died, Jan van Eyck found a new and even wealthier patron: Philip the Good, Duke of Burgundy. Philip had palaces in Paris and Bruges, as well as in other towns and cities throughout modern-day France, Belgium, and part of the Netherlands.

Like other Burgundian royalty, Duke Philip was a passionate collector of art and of illuminated manuscripts (the books of the time). He spent a royal fortune on elegant and meticulously crafted objects such as jewel cases, jewelry, reliquaries (containers that were popular in the Middle Ages and early Renaissance for holding relics of Jesus, Mary, and the saints), tableware, and tapestries. The duke's passion provided work for the most talented artists and artisans of Burgundian France and Flanders. Court records indicate that even when the duke was having financial and political troubles, he took special notice of Jan van Eyck

and made sure he kept him employed and on salary even when cutting down on the rest of his retinue.

Van Eyck became a valued member of the duke's household—with the title of *valet de chambre*. He was neither a valet in the modern sense of the term, nor did he have anything to do with the duke's chambers in a castle. Instead he was the duke's personal court artist, responsible for designing, then executing—with the help of various apprentices and artisans—numerous artifacts, designs for the duke's tapestries, theatrical presentations, the livery of the ducal court, and the banners and flags and floats for the jousting tournaments sponsored by the duke. He probably also painted some panel paintings for the court and for dignitaries within the duke's circle. We know that a portrait of Isabella of Portugal was commissioned by the duke, because a seventeenth-century copy of it still exists, although the original has been lost.

Van Eyck frequently traveled on the duke's business—at least once on what was termed "a secret matter." He was supposedly one of the duke's trusted spies or agents.

Although the Guild of St. Luke, the painters' guild to which Van Eyck had to belong, didn't usually permit court artists to accept commissions outside of the court, they seemed to have made exceptions for wealthy functionaries connected with the duke's household and business, including Giovanni Arnolfini and his bride.

Van Eyck has often been called the Father of Oil Painting. The Italian Renaissance art historian Vasari, in his *Lives of the Most Eminent Painters, Sculptors, and Architects* (1550; rev. ed. 1568) credits Van Eyck with its invention. However, Van Eyck did not *invent* the medium, he perfected it.

Oil painting existed at least as far back as the early Middle Ages as practiced by monks in monasteries, and it is even possible that ancient Egyptians tried their hands at mixing paint pigments with various oils. But until Van Eyck's time, painters were unable to work out the technical problems: Some oils they used changed the color of the paint; some oils made the paint surface dry far too slowly; some varnishes remained sticky or severely darkened and dulled the paint surface.

Jan van Eyck and his brother experimented until they figured out the kind of oils and mixtures of oil and varnishes that make oil painting work not just better, but beautifully. They perfected the medium and made it capable of giving oil paintings lustrous, luminous effects that endure. By using his own combination of oils and varnishes, Van Eyck was able to achieve the extraordinary detail, fine brushwork, and brilliant, lasting colors that make his paintings seem as fresh today as when he painted them more than five hundred years ago.

Van Eyck was certainly among the first painters, to make use of all the wonderful possibilities of the oil painting medium: the smooth liquid quality of the paint itself, the use of thin oil glazes (where the paint is thinned with a combination of oil, varnish, and solvent, such as turpentine). Glazing, as this technique is called, allows the paint to be applied in transparent layers that results in a kind of glow of color and light that seems to come from inside the painting itself.

Van Eyck used the perfected oil painting medium to create the extraordinary details visible in his canvases, for instance, the fur inside the sleeves of Giovanna's dress in *The Arnolfini Portrait*. His paintings are so exact that we have a very good idea of what the world—the interiors, the clothing, the furnishings—of fifteenth-century Flanders looked liked.

On the other hand he was the master of the symbolism that was part of the painting style of the times. Religious symbolism abounds in his work (the little dog in the painting symbolizes faith) religious faith as well as faithfulness to marriage vows. The oranges on the windowsill symbolize the Lord's bounty, as well as the hoped for fertility of the couple in the picture, and the material wealth they obviously possessed. Hints of the religious significance of the painting exist throughout; most obvious are the carved images from the life of Christ on the wooden frame of the mirror behind the couple's heads. The removal of the shoes indicates that the ceremony has a built-in sacredness and might be viewed as an act of humility on the part of the people involved.

There is a tiny snickering gargoyle behind the couple's joined hands. Scholars still debate what it might symbolize. Perhaps it is the fact that things are often not the way they seem, or maybe that this couple who is promising to be faithful to each other in marriage will most likely stray. Or perhaps it is something else—what do you think? It's fun to guess.

Part of Van Eyck's genius is the way his paintings are often about the real world and at the same time hint at mysteries, which to this day no one has really solved.

In the end perhaps the best way to look at this painting is to simply let your eyes travel across its colorful surface. Slowly let its magic seep into you the way it must have the first time the Arnolfinis saw it when they came to the Van Eycks' workshop. Perhaps their first reaction was a stunned, awed silence, which must have pleased Master Jan van Eyck more than any courtly or learned words of praise uttered then or in the centuries since.

A Timeline of Jan van Eyck's Life

Born 1385–1400 (?) Exact date of birth uncertain. Van Eyck was born in Maastricht, a city in the southern Netherlands.

1420 Presents a painting of the Madonna's head to the Guild of Antwerp.

1422 Decorates a paschal (Easter) candle for the cathedral of Cambrai.

1422–1424 Works at The Hague in the service of John of Bavaria, prince-bishop of Liège.

1425 After John's death, was appointed valet de chambre in the household of Duke Philip the Good of Burgundy, *"pour cause de l'excellent ouvrage son mestier qu'il fait"* ("on account of the excellent work in his craft that he made"). Spends a short time in Bruges, then moves to Lille to execute some work for the duke in that city.

1426 His brother Hubert dies.

1428–1429 Travels to Iberia (Spain and Portugal) as one of the envoys sent to negotiate the marriage between Isabelle of Portugal and Philip the Good.

Paints a portrait of Isabelle of Portugal "true to life."

1431 Goes to Hesdin, in France, to supervise work on one of Philip the Good's castles. Returns to Bruges, where he spends most of the rest of his life.

1432 May 6. Completes the Ghent altarpiece (in the Church of St. Bavo), which was begun with his brother Hubert van Eyck before Hubert's death.

Finishes polychroming (gilding with gold) statues of the counts of Flanders for the city of Bruges.

Ca. 1432 Marries Margaret (maiden name unknown).

1433 Purchases a house in the Rue de la Main d'Or (Street of the Golden Hand).

The Duke of Burgundy becomes godfather to Van Eyck's child.

Paints the self-portrait *Man with the Red Turban*.

1433–1434 Paints the *Rolin Madonna* (with portrait of Nicolas Rolin, chancellor to the Duke of Burgundy).

1434 His child (perhaps his only child) is baptized.

Paints *The Arnolfini Portrait*, a double portrait of Giovanni Arnolfini and Giovanna Cenami.

1436 Paints *Portrait of Jan de Leewe* and *The Virgin* (with kneeling figure of Canon George van der Paele).

1437 Paints *Saint Barbara*.

1438 Paints the *Head of Christ*.

1439 Paints Portrait of *Margaret van Eyck* and *The Virgin*.

1441 Dies in the city of Bruges.

There are no biographies of Jan van Eyck for younger readers in print at this time. But if you would like to learn more about him, the history of oil painting, or life in France, Burgundy, Flanders, and northern Italy during the fifteenth century, an enormous amount of readable information can be found in encyclopedias at your local or school libraries and by using search engines on the Internet.

Some useful Internet sites to learn more about Van Eyck and painting in general include:

http://www.metmuseum.org This site has links to many other sites, including the National Gallery in London, where the original of this painting hangs.

http://www.arthistory.cc/auth/eyck

http://www.umass.edu/chronicle/archives/00/04-14/harbison28.html

http://www.newadvent.org/cathen/05732a.htm

These are just a few of the many Web sites I found useful while researching this book. Two books that might be of interest though they are not geared toward younger readers are:

The Craftsman's Handbook "Il Libro del'Arte" by Cennino D'Andrea Cennini, translated by Daniel V. Thompson, Jr.

This handbook holds the secrets to most techniques of late medieval and Renaissance painting, sculpture, and other arts. It is hard reading in some places, but very informative and sometimes very funny, such as how to cast a very important person in plaster when making a sculpture.

The Golden Age of Burgundy: The Magnificent Dukes and their Courts by Joseph Calmette (Phoenix Press: London, 1962)

If you are interested in history and don't mind taking the time to learn and unravel all the complications of French, English, and Burgundian politics of the late fourteenth through the late fifteenth centuries, this is a very readable book. There is a whole section on the arts and artists in the courts of the dukes of Burgundy.

Last but not least: A beautiful print of this painting can be obtained by contacting the National Gallery in London. Use your search engine to go to one of the many National Gallery sites, or go to the link provided by the Metropolitan Museum site and learn how to purchase a print or poster of this wonderful painting to frame for your desk or hang in your room.

Teacher's guide available at www.wgpub.com.